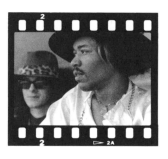

LINDA McCARTNEY

SIXTIES

PORTRAIT OF AN ERA

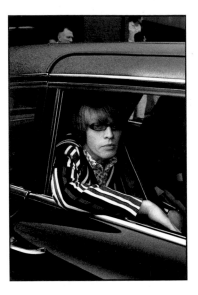

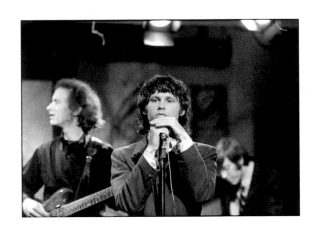

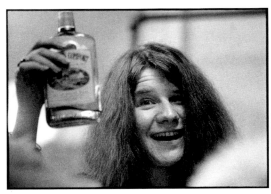
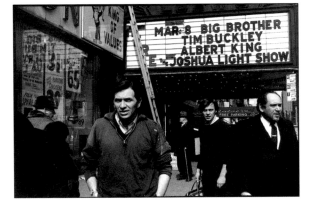

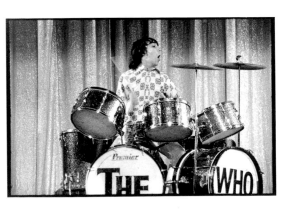

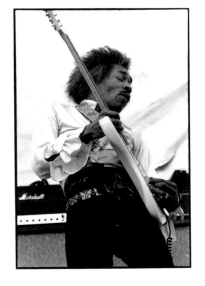

LINDA McCARTNEY'S

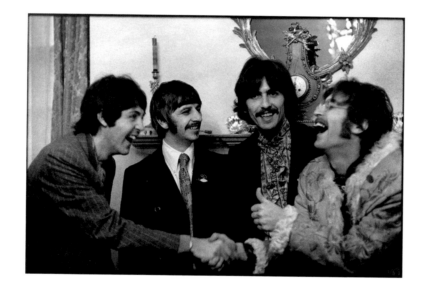

SIXTIES

PORTRAIT OF AN ERA

A BULFINCH PRESS BOOK

LITTLE, BROWN AND COMPANY

BOSTON • TORONTO • LONDON

WRITTEN IN ASSOCIATION WITH STEVE TURNER

FRONTISPIECE PICTURES

LEFT TO RIGHT: TOP ROW: BRIAN JONES; FILLMORE EAST OPENING NIGHT BANNER; ROBBY KRIEGER AND JIM MORRISON; MICHAEL J. POLLARD. MIDDLE ROW: SAM SHEPARD; JANIS JOPLIN; BILL GRAHAM (FILLMORE EAST OPENING NIGHT); JOHN LENNON AND PAUL MCCARTNEY. BOTTOM ROW: KEITH MOON; TODD RUNDGREN; JIMI HENDRIX; LOMAX ALLIANCE

First North American Edition

Third printing, 1992

Library of Congress Cataloging-in-Publication Data

McCartney, Linda
 Linda McCartney's sixties : portrait of an era.
 p. cm.
ISBN 0-8212-1971-5 (deluxe limited ed.)
ISBN 0-8212-1959-6 (hardcover ed.)
 1. Rock musicians - Portraits. 2. Rock music - 1961-1970 - Pictorial works.
 I. Title
ML87.M4 1992
781.66'09'046 - dc20 92-53068

Bulfinch Press is an imprint and trademark of
Little, Brown and Company (Inc.)

Published simultaneously in Canada by
Little, Brown & Company (Canada) Limited

DESIGNED BY BOBBIE COLGATE-STONE

EDITED BY SIAN FACER

PRINTED IN ITALY

CONTENTS

FOREWORD BY DAVID BAILEY · 6
INTRODUCTION BY PAUL McCARTNEY · 7

INTRODUCTION · 8

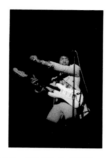

EAST COAST · 12

THE ROLLING STONES · THE DOORS · THE WHO · CREAM · SIMON AND GARFUNKEL · B.B. KING · BUFFALO SPRINGFIELD
TODD RUNDGREN · THE ANIMALS · THE YOUNG RASCALS · THE MAMAS AND PAPAS
JACKSON BROWNE · BLUE CHEER · THE BYRDS · JIMI HENDRIX · BOB DYLAN · FRANK ZAPPA · THE YARDBIRDS
BLOOMFIELD/QUICKSILVER · OTIS REDDING · TIM BUCKLEY

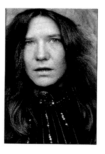

WEST COAST · 89

BIG BROTHER AND THE HOLDING COMPANY · COUNTRY JOE AND THE FISH · THE ASSOCIATION · THE YOUNGBLOODS · NICO
THE BEACH BOYS · RAY CHARLES · THE GRATEFUL DEAD · JEFFERSON AIRPLANE · ARETHA FRANKLIN

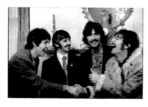

ENGLAND · 137

THE KINKS · TRAFFIC · THE HOLLIES · MICKIE MOST · THE BEATLES · PAUL

FOREWORD BY DAVID BAILEY

I ONCE TOLD LINDA that she should stop taking so many pictures of Paul and her family and concentrate on other subjects. I think I was wrong. The more pictures I take of my family confirms this. I don't know if it is art or not, but I do know that as a social document they are far more important than pictures of the rich and famous. Linda's collection of pictures in this book is of a rock and roll family. The intimacy of a family can only be revealed by an intimate member of the group who is accepted and trusted. This trust gives Linda access and an intimacy that would be denied to most. She is in a unique position to record and reveal the rock family. Many of the characters she freezes on film are rich and famous. They are not famous for being famous as so many were in the late 1980's, but their fame is born of talent and riches are a by-product of this. Linda could have sat down like so many in a privileged position and done nothing, but she didn't. She kept at it, in many directions other than music and photography and held her own. Linda is her own person as the pictures in this book show, not just Mrs McCartney although I'm sure she would be proud of just that.

INTRODUCTION BY PAUL McCARTNEY

I FIRST MET HER during the time these photographs were being taken. Linda Eastman . . . New York photographer. Later when we married she became, in the eyes of the tabloid newspapers one Linda Eastman Kodak. "Paul marries an heiress . . .". Well it's been a hard story to shake off, but in fact she isn't anything to do with that famous film family. She's just a photographer and a very good one.

Of course I'm biased, but I think she has the definitive collection of Sixties rock and roll pictures. She captures the period, and with an intimacy that is impossible to ignore. Having experienced her lens I know that she knows when to click. Not just before or after the special moment, but right on it!

When John Lennon was asked for a quote about one of Linda's books, he wanted to say that "She has an eye for an eye", but in the circumstances felt it might be misinterpreted as sarcasm. He was right, she has an eye for the moment. Since the Sixties she has developed as a woman, a photographer, musician, cook and don't ask what else, but her integrity as a picture taker is still completely intact. She has made Sun Prints . . . Blue and brown visions of another time. She has saved landscapes, caught boyshapes and so much more. But for now she looks back to her Sixties. And I for one say . . . Good luck, darlin'!!!

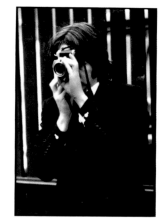

Paul.

INTRODUCTION

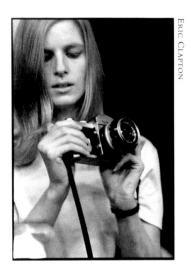

ERIC CLAPTON

I WOULD HAVE BEEN a photographer anyway, taking black-and-white pictures of things that interested me, but in 1966 I started photographing rock and roll groups, and I found I could make a living from it. It gave me the independence I needed, it provided me with an exciting life and, although I didn't make a fortune, it enabled me to pay my rent, buy food and look after my little daughter. What more could a young girl want?

Looking back over my life I can see that pictures and music had played an important part in my upbringing. My father was a lawyer who represented both musicians and fine artists, so I grew up knowing painters like Willem de Kooning, and songwriters like Hoagy Carmichael and Harold Arlen. These people came over to eat at our house.

I became a teenager just around the time that the disc jockey Alan Freed coined the term "rock and roll" to describe the sort of rhythm and blues music he was playing on his WINS radio shows. Hearing this music on the radio every evening meant so much to me that it changed my life.

It was through Freed that I first heard people like the Penguins, the Moonglows, Chuck Berry and Bo Diddley. He staged shows at the Brooklyn Paramount where on one single bill you would get Buddy Holly and the Crickets, Little Richard, Fats Domino, Big Bopper, Screaming Jay Hawkins, The Dells, and more! I used to sneak out to the Paramount and I don't think my mother and father ever knew the things I was getting up to.

So, by the time I left school I had a keen visual sense and a great love of rock and roll, although I had no idea what I wanted to do as a career. At college I majored in History of Art and developed an interest in black-and-white films from Italy and France, but I didn't get into stills photography until much later, when I had moved out to live in Arizona.

JIM MORRISON

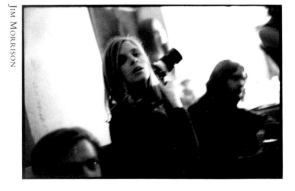

8

A friend I met there invited me to a photography course at the local Arts Center and so I went for the first night. The woman who was leading the course, Hazel Archer, was showing the class some work of Dorothea Lange and Walker Evans, who took pictures of migrant farm workers during the Great Depression,

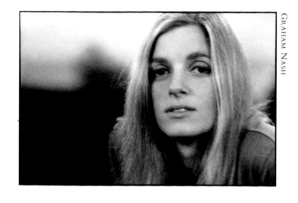

and these photographs inspired me, even though, at the time, I didn't even own a camera.

Hazel asked us to go out and take photographs the following week. I borrowed a Canon from a friend, took some pictures and had them developed in the dark room at the back of a local record shop. When I showed my pictures to Hazel the next week she told me I had a good eye and that I should keep photographing. I did keep going, but I never went back on the course.

The earliest pictures I took were of my daughter, Heather, and of nature. Then a friend who was reporting on a Royal Academy of Dramatic Art "Shakespeare in the Desert" event for a local newspaper asked me to come along with her. While I was taking pictures one of the actors asked if I would take a photo of him for the British actors' directory *Spotlight*. I did, and that was the first time I was ever published!

The photographs of Walker Evans and Dorothea Lange continued to inspire me. They were real artists and showed you the character of the people they were dealing with, and even though I went on to photograph a lot of rock and roll musicians I was always more interested in their character than their public image. I wanted to get beneath the skin.

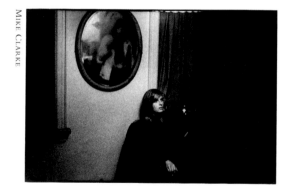

I moved to New York in 1965 and rented a small apartment on East 83rd Street, while holding down an office job on a magazine. I started spending a lot of my lunchtimes in the photographic section of the Museum of Modern Art where the curator was the photographer Edward Steichen who was a hero of mine.

It was shortly after arriving in the city that I photographed my first group – The Dave Clarke Five. We met up at a Holiday Inn and I took pictures of them on the balcony. What I didn't know at the time was that

9

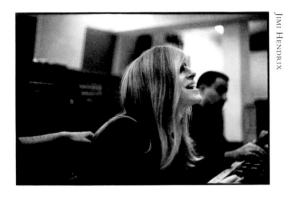
JIMI HENDRIX

this was going to be my life for the next few years and that I was going to be photographing some of the most influential rock and roll musicians of the Sixties.

It was an incredible time for all of us. There was a lot of hope in the air. We were all young and away from home for the first time in our lives. We were also all working for ourselves. It felt like being in Hollywood at the time when Hollywood was relatively innocent. We all knew something was happening but it hadn't been discovered yet.

These were the days when Jimi Hendrix would walk up to see me at my apartment, and when Jim Morrison and I would go down to Chinatown to eat. I can remember going out to buy peanut butter with Janis Joplin for a late-night feast and traveling out on the subway with Jackson Browne. People who later became icons were on the brink of their careers wondering whether anybody was ever going to notice them.

That's what made it exciting to be taking photographs. It was before the self-consciousness set in. I wanted to record what was there – every blemish, every bit of beauty, every emotion. I wasn't interested in manufacturing a show business image. I would rather photograph a wrinkled apple than a made-up, smooth, glamorous man. Hence the reason I never got into fashion photography.

My whole approach to my work was instinctive. My pictures came out of my friendship with the musicians. I don't think any of them ever felt they were turning up for a "shoot" with a "photographer." I was just a friend and we would arrange to meet, and I would have my camera with me and would take pictures as we hung out. Although I eventually earned my living from it, I somehow never thought of it as a job. I was just doing what I enjoyed doing, and getting paid for it.

None of the pictures in this book were taken using flash. I would only ever use available light because I felt that setting up lights created an artificial look, and flash is almost always an intrusion. It's impossible to hang back and observe in a recording studio, for example, if you're continually popping flash bulbs.

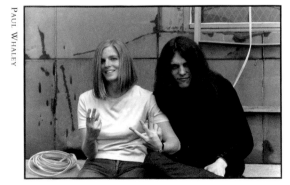
PAUL WHALEY

10

My father thought that I should either work with an established photographer or study photography, but I just wanted to go out and do it. I had no time for formal learning and I still have a very limited knowledge of the technical side of photography. I prefer to work by trial and error because some of my best pictures have come precisely because I didn't know enough. By having the "wrong" setting I've actually come up with something good. This is why I empathize so much with John Lennon, Paul McCartney or Bob Dylan, none of

JIM MORRISON

whom read or write music. It's the innocence that's important to them. Picasso once said that as an artist gets older he loses his innocence, and the one thing he tried to keep hold of was his innocence. I'm probably the same person now as I was then.

As far as knowing when to shoot, I always relied totally on my instinct. I believed I could feel when there was a good picture. Because I used natural light I was often using a very fast film and needed an incredibly steady hand to avoid camera shake. The slightest shiver would result in a blurred photograph.

The Sixties was a very magical period. By 1969 though, a lot of bad things were happening. Big business was taking over and a lot of free spirits were being run into the ground.

The drugs were getting harder, and looking at these photographs today it's sad to realize how many people have died. A lot of them were vulnerable and sensitive, and they found themselves being over-indulged.

But the strongest feeling I get when I see all these faces again is of great friendships, many of which have continued, and of great fun. It was a very stimulating, hopeful time of life and it has never really left me.

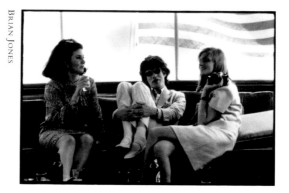

BRIAN JONES

EAST COAST

THE ROLLING STONES

My big break was in June 1966 with The Rolling Stones. This was a session which came about more or less by accident, as did so many other good things at that time. The group had come to New York to promote the album *Aftermath* and the single "Mother's Little Helper." I was working at *Town and Country*, a glossy society magazine, where I opened the mail and helped around the office in order to make enough money to pay my rent.

One day I opened an invitation to a press reception for the Stones, scheduled to take place on board the luxury yacht SS *Sea Panther*, which would be cruising on the Hudson River. It wasn't an invitation addressed to me but I took it and hid it in my drawer, knowing that no one else on the magazine would really have wanted to go anyway, because to them The Rolling Stones were a yawn. They were into other things.

I suspect *Town and Country* had only been invited because it had used a David Bailey photograph of The Rolling Stones with a New York débutante on the June 1966 cover. This was quite controversial at the time because previously the Stones had been confined to teenage magazines and to sensational newspaper stories about "unruly" behavior. Here they were pictured with fresh-faced Alexandra E. Chase, who was dressed in a yellow evening gown, while Keith Richard was wearing a leather jacket and scarf and Brian Jones smoked a cigarette.

When, on the afternoon of 24 June I went along to the 79th Street Marina, it was mobbed

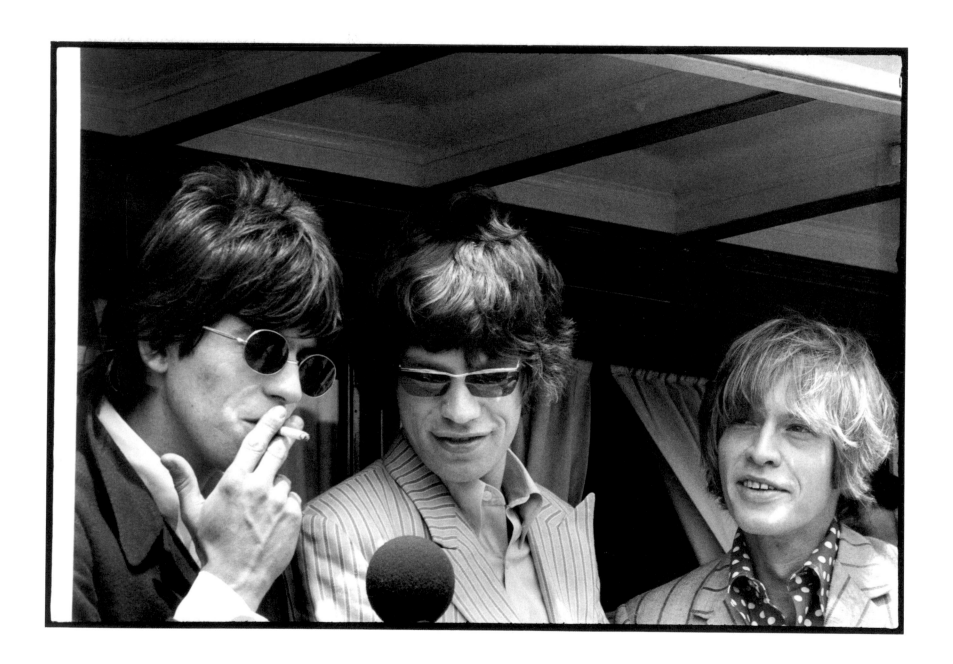

with journalists and photographers, while the Stones were leaning over the guard rails of the boat with drinks in their hands. At sailing time, the photographers were told to remain on the quayside while the journalists scrambled aboard for the working lunch. So the only pictures the official photographers got were distant shots of the group standing on the deck.

For some reason, even though I had my camera hanging around my neck, I was ushered on to the boat by Betsy Doster, who worked for the Stones' management, and I was allowed to be the lone photographer. Maybe it was because they felt favorably disposed towards *Town and Country* after having a front cover. Maybe it was because the Stones fancied a young, blond-haired

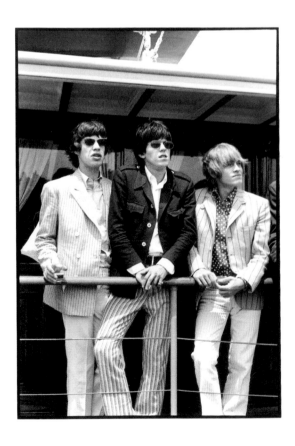

girl on board as, in those days, the press they had to face was largely made up of older men who knew little about rock and roll. One journalist reportedly asked Brian Jones, "Which one are you?" and Brian just turned and walked away.

I seized the moment and began shooting. I was very green as a photographer and really only knew how to click and how to focus. When it came to the light setting I would just guess, which is why most of the color film I took didn't come out – I had forgotten to adjust the ASA setting after changing from black and white.

The Stones were very flirtatious, especially Mick Jagger. Like me, they were on a roll, excited to be where they were and enjoying every minute of it. They were lapping up the attention, even though they were being asked questions like "What's the difference between the Stones and The Beatles?" and "Are American journalists more cooperative than British ones?"

They were very much the fashion plates of the moment, dressed in what we thought of as eccentric English clothes, and journalists were sometimes taken aback by their abruptness and their refusal to play what was then the normal media game.

Lillian Roxon, one of the journalists whom I later supplied with photographs, wrote a story on the cruise for a magazine and she was shocked by the group's "frank" language. "All of the Stones," she wrote, " – especially Brian Jones – use four-letter words like they're going out of business."

Mick was very aware of being photographed, even when he was doing apparently casual things like chewing the arm of his sunglasses. Charlie Watts, on the other hand, couldn't be bothered to pose and spent most of the time quietly sitting at the stern of the boat. Brian had an incredibly sea-worthy face, and it was this shot of him lolling back with his legs apart that, twelve months later, caught the eye of Brian Epstein and led to my first meeting with The Beatles.

When the SS *Sea Panther* arrived back at the Marina after its voyage around Manhattan, I was besieged by journalists who wanted to buy anything that I'd taken. They were saying that they'd got the story they wanted, but had no photographs. I was happy to help them out. I didn't even think to ask for a fee.

Editors began to see these pictures and I started getting more offers of work. Allen Klein was then managing the Stones and he would frequently send someone over to *Town and Country* to try and buy the negatives from me. He was obviously wishing that he had hired his own photographer and had kept the copyright. I told him that he could have any number of prints but that I wasn't selling the negatives.

Soon I was able to give up my office job and make my way as a freelance photographer. It was scary at first because the freelance game is notoriously precarious. But at last I was making my living at something I enjoyed. That one afternoon was to set the course of my life.

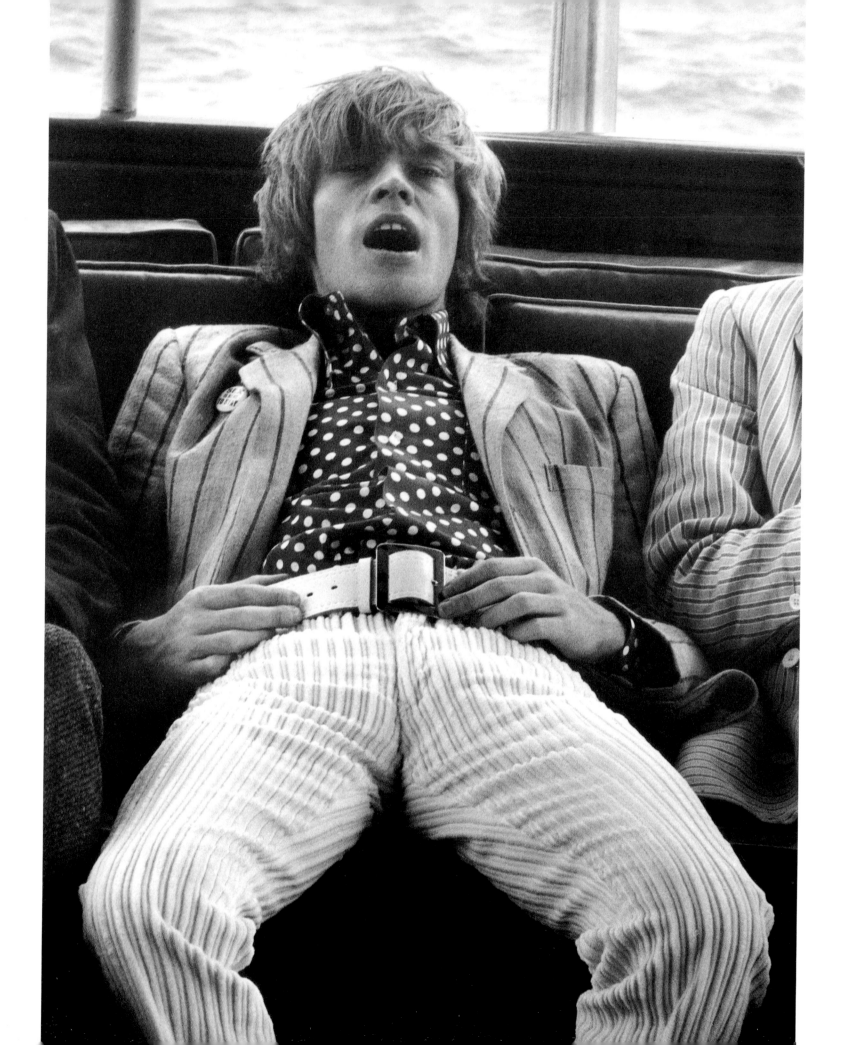

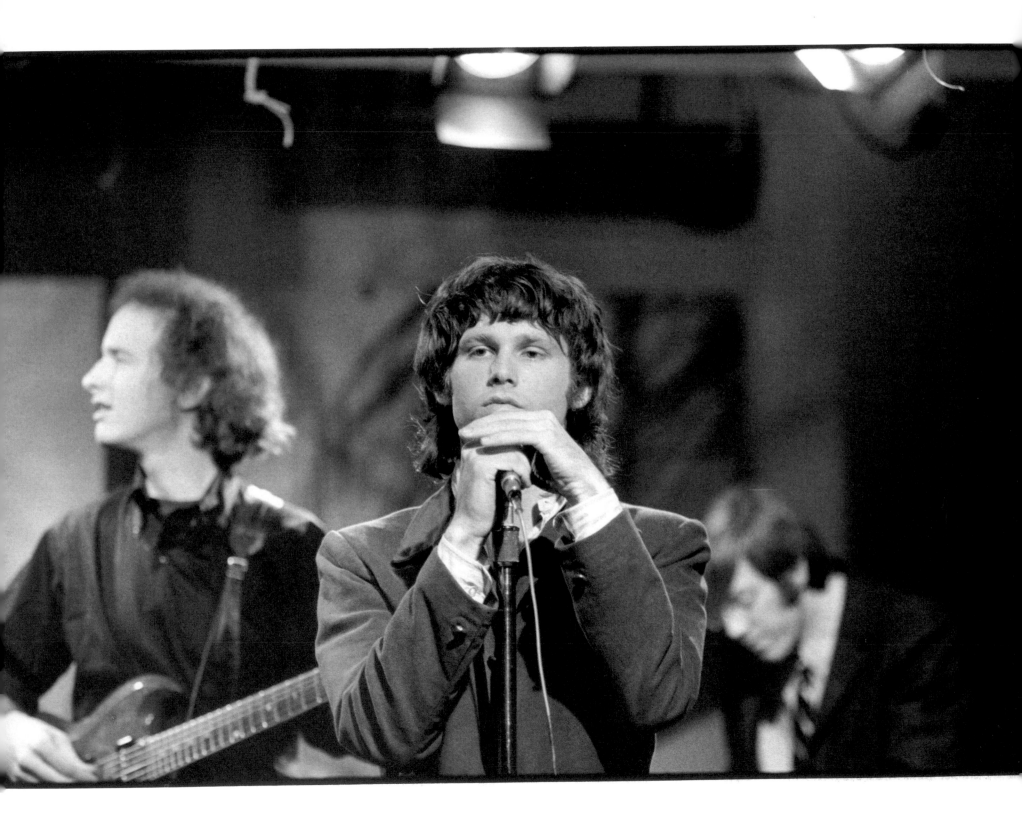

THE DOORS

I first photographed The Doors at a small New York club, close to the 59th Street Bridge, called Ondine's, which was a favorite place for out-of-town bands to come and play residencies. It was the winter of 1966 and I was down there with some friends to see a Los Angeles band that Elektra Records had recently signed. I had my camera with me and started taking pictures of them as they played.

No one in New York had heard of The Doors. They had never performed outside of Los Angeles and hadn't released any records. Because they were unknown and the club was so intimate I had the unique opportunity of being able to get up really close as they played.

It wasn't Jim Morrison's looks that struck me first about him. It was the poetry of his songs and the way he would get completely lost in the music. He had this habit of cupping his hand behind his ear so that he could hear his vocals in the way that traditional folk singers did. I thought the whole band was great; Ray Manzarek, Robby Krieger and John Densmore were all very creative musicians.

Word about the band soon spread. I even remember one night Paul Newman came down

to the Scene Club. I learned later that he was checking Jim out for a film role. He sat there watching everything he did with a really intense look. I never found out what film it was, but it obviously didn't materialize.

They returned to Ondine's in March 1967 by which time their début album *The Doors* and their first single "Break On Through" had been released, and they were getting national attention. In May they played their last residency in New York – three weeks at Steve Paul's Scene Club.

Because they were from out of town I spent a lot of time just hanging out with them. We'd maybe go down to Chinatown to eat, we'd look around bookstores or they would simply come back to my apartment.

I got to know Jim Morrison particularly well during this time. He had been at the UCLA film school with the keyboard player Ray Manzarek, so we shared a common love of visual images. The Doors had made some short experimental promotional films for their singles. One I remember showed Jim on the beach tied to a stake with flames dancing around him. Even though they were primitive they were very effective. Jim was a very thoughtful person and

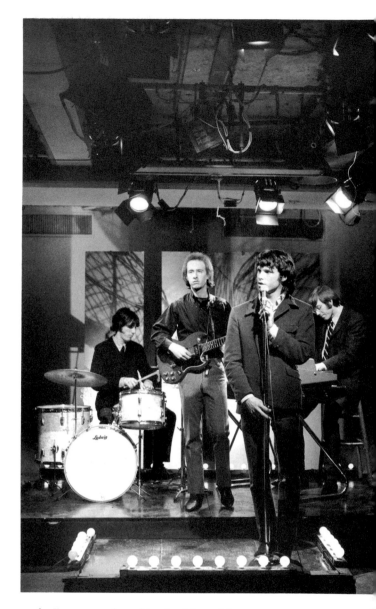

we became very deep friends. A lot of that was due to the photography connection.

The image of Jim as a Christ-figure that is now being handed down to us is pathetic. I find it unbelievable. Jim would have hated it. You can tell that by the way he deliberately allowed

 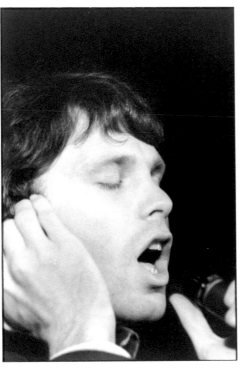 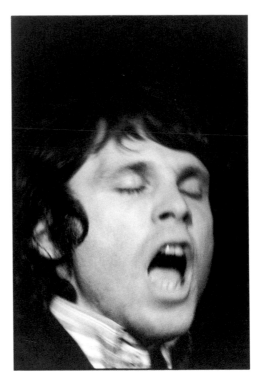 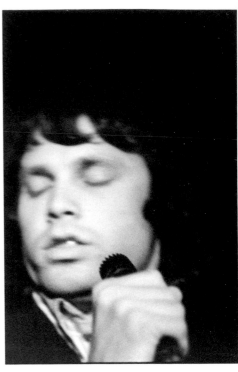

himself to get fat and grow a beard toward the end of his life. He wanted to be respected as a poet and a musician, and he believed that this image of him as a sex god was interfering with people's perception of him as a true artist.

It really all came about through a great looking picture that Joel Brodsky took of him where he was stripped to the waist and wearing black leather jeans. That brought him a lot of attention. I think Jim was encouraged by it at first. He started to read what people were saying about him and then tried to live up to what was being said. There were certain aspects of success that he really enjoyed.

But at the same time he resented it. I can remember him coming to me one day in a very disturbed state. He told me all about his background as the son of a Rear Admiral in the US Navy and how much he hated everything that it represented. He also told me that he'd grown up as the fat kid that no one wanted to know and that this had caused him a lot of emotional pain.

Then he explained what had brought it all to the surface. Apparently he had been walking around Greenwich Village that morning and a girl who he knew as a child had spotted him and started going crazy over him. That bothered him

because he sensed the hypocrisy of it all. When he was a fat military brat these people had rejected and ignored him but now, because of his new public image, they were fawning over him.

Jim was essentially a shy person. He never thought of himself as resembling the glamorous image that made him appear so confident. Like most of us, he had hang-ups. Maybe he felt deprived of real meaningful love.

Some performers experience rejection in their childhood and they perform to win the love they feel they've been denied. But what kind of love is it that you get in this way? Who really wants the love of strangers who you neither

respect nor admire? It's a vicious circle. Many then reject this admiration as shallow and hypocritical and, with Jim, that's where the drugs and drink began to take over.

When I was taking pictures of Jim with The Doors I never thought I was photographing a rock idol. To me he was an unknown singer with an interesting mind who shared my love of the visual arts. In return I think he saw me as someone who could capture him as he really was, rather than a showbiz person who would add to the glamor surrounding him.

In a funny way this frightened him too. Jim wanted to bare himself in his art and he wanted to be real, but he was unsure as to whether people would love what he revealed. Maybe people would reject his deepest feelings as expressed in his poetry just as they had rejected his overweight body as a boy.

When he first came to my apartment he looked through all my work and he told me that he wasn't sure that he wanted me to take pictures of him because he could see that I really captured the characters of my subjects.

My approach was to take personal, casual shots. I never intruded. I would never set up false situations. I was just there recording what happened. I became like a band member whose chosen instrument was the camera.

The last pictures I took of Jim were in March 1968 when The Doors played the Fillmore East. *Life* magazine was planning a front-cover story and wanted me to take color shots of him. I took him to the Cloisters, a monastery outside New York, which was a place I liked to hang out in when I felt pressured by Manhattan. It was pouring with rain and so we stayed inside, and Jim sat in a window and the light from the courtyard lit his face. The pictures were beautifully poignant.

Martin Luther King was killed two weeks later and so Jim never made the cover.

 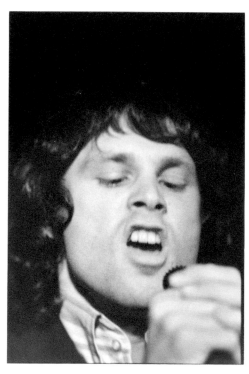 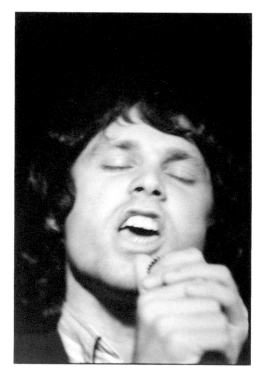 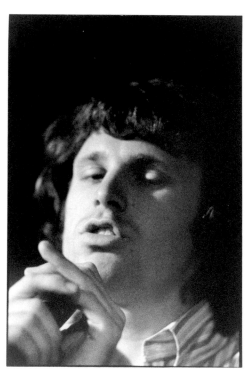

THE WHO

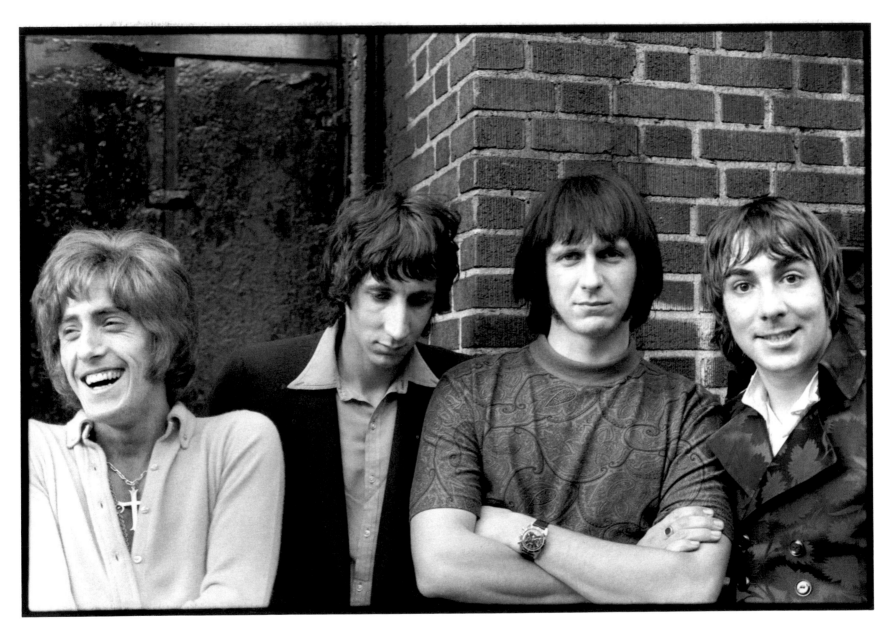

THIS WAS TAKEN BEHIND THE FILLMORE EAST AFTER AN AFTERNOON SOUND CHECK. WE JUST WENT OUT AND TOOK A QUICK SNAP

The Who were one of my favorite British bands of the Sixties. I had copies of "I Can't Explain" and "My Generation" which had been hits in Britain, and I couldn't understand why they hadn't taken off in America.

I first met Pete Townshend at the Americana Hotel in New York where I was taking photos of Herman and the Hermits at a press reception. The Who did their first tour of America as a support to the Hermits, who'd been having number-one hits since 1965. Pete was skulking in the corner. Hardly anybody knew who he was. I was with Danny Fields, who was also a Who fan, and we both went up and started talking to him.

I remember Pete was bewildered by the lack of success they'd had in America at that point, and I started taking some pictures of him. Unfortunately, because there was no natural light in the room, the negatives were too thin so I never used them.

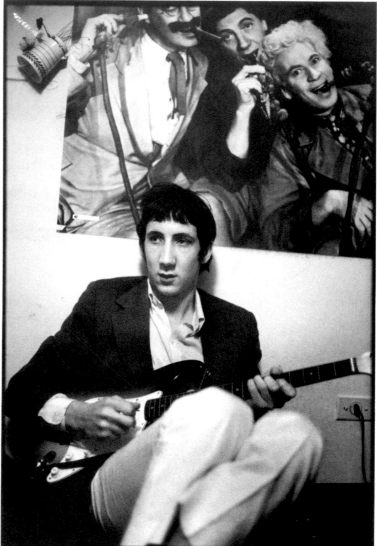

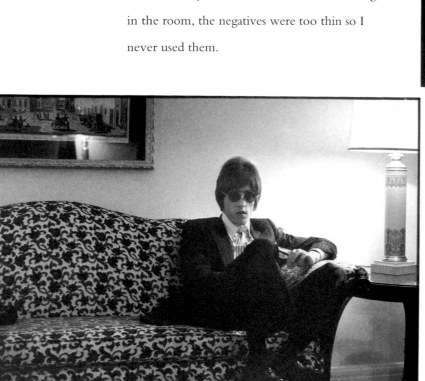

The first time I photographed The Who on stage was in March 1967 when they played a series of shows called "Murray the K's Fifth Dimension" at the RKO Theatre on 58th Street and Third Avenue. Murray was a radio disc jockey who had made his name after championing The Beatles in 1964 and calling himself the "Fifth Beatle."

The Fifth Dimension shows in 1967 are reckoned by some to have been one of the watershed events of the mid-Sixties in rock and

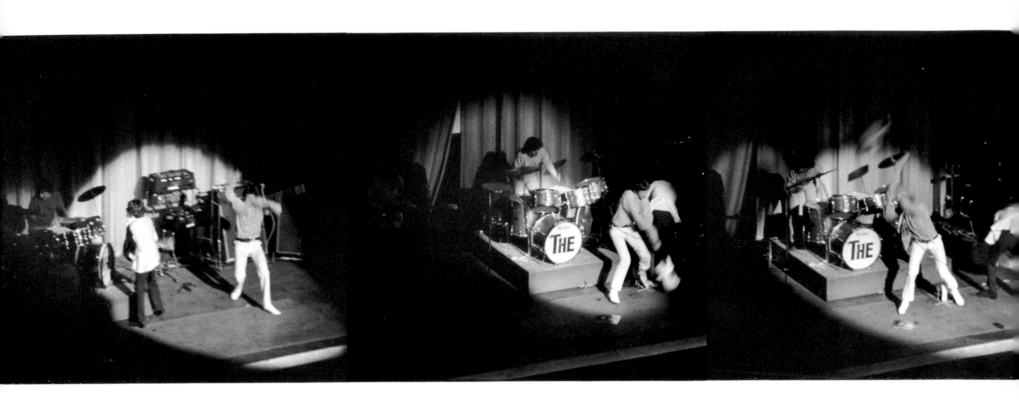

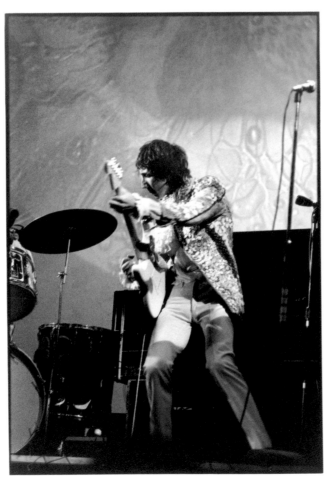

ABOVE: THE WHO DURING THE AFTERNOON
SOUND CHECK AT THE FILLMORE EAST

LEFT: PETE TOWNSHEND IN FULL FLIGHT
DURING THE EVENING CONCERT

22

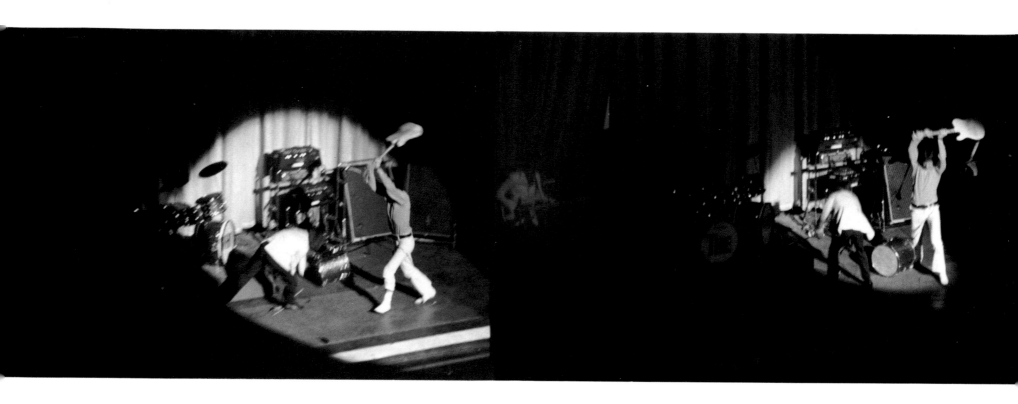

roll. The line-up was incredible. There was Mitch Ryder and the Detroit Wheels, the Blues Magoos, Wilson Pickett, the Blues Project, The Who, Cream and a comedy group called the Hardly Worthit Players. They had to play five concerts a day for nine days, and it really was the making of both The Who and Cream in America, and the dawning of a new era in rock.

The Who were one of the least-known acts on the bill. The posters of the Marx Brothers were hanging on their dressing room wall. I then took photos of Roger Daltrey and Keith Moon at the Drake Hotel, although I think they were actually staying at the Gorham Hotel.

The live sequence I took in April 1968 at the Fillmore East on the Lower East Side. Bill Graham had opened the original Fillmore Auditorium on Geary Street in San Francisco,

where he'd launched a lot of the West Coast bands like the Grateful Dead, Jefferson Airplane, and Big Brother and the Holding Company. In 1968 he moved to a larger location in San Francisco, renamed it the Fillmore West, and then renovated the old Village Theatre on New York's Second Avenue and called it the Fillmore East. I was hired as house photographer and then, on 8 March, it opened with a concert by Big Brother, Albert King and Tim Buckley.

Although I didn't get paid and they hardly used my photographs except for their posters, it was a unique opportunity. It meant that I had unlimited access, nobody hassled me and I was around for sound checks, rehearsals and shows. It meant that I was treated as just another crew member and got to know the bands as friends.

The Who came to the Fillmore East a

KEITH MOON AT THE DRAKE HOTEL, NEW YORK. FEW HOTELS IN THOSE DAYS WERE HAPPY ABOUT HAVING ROCK AND ROLL GROUPS AS GUESTS

SO I THINK THEY WERE ACTUALLY STAYING ELSEWHERE. THE PICTURE OF KEITH WITH THE LACE CRAVAT WAS ONE

OF THE TWO SHOTS BRIAN EPSTEIN BOUGHT FROM ME ON MY FIRST VISIT TO ENGLAND

24

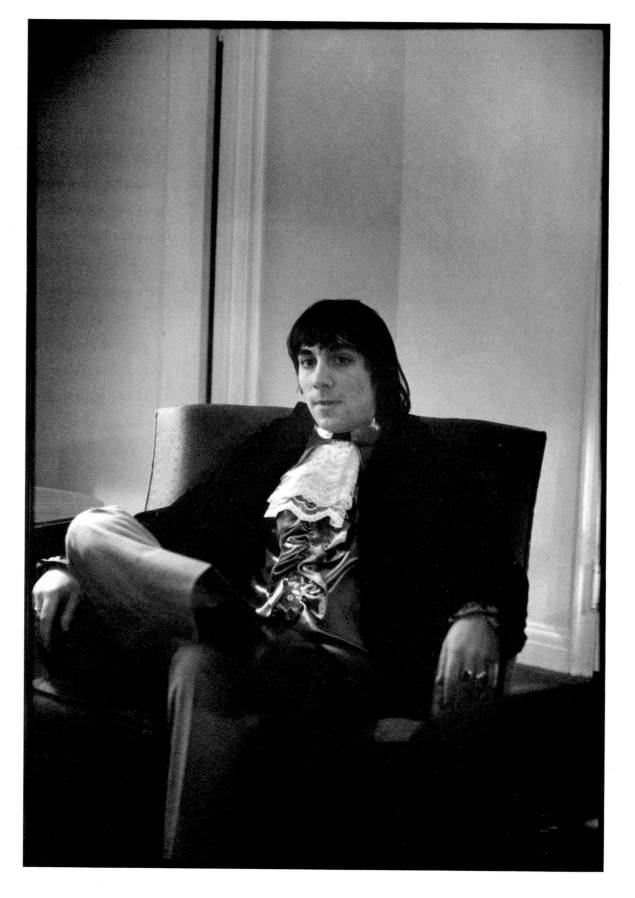

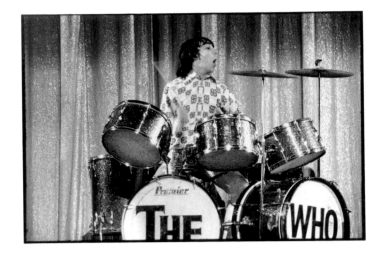

month after it opened and played a blistering set that really set the place alight. Moony kicked his drum set in and Pete smashed his guitar. The whole event was recorded for an album which I don't believe was ever released. The Who's biographer, Dave Marsh, heard the tapes many years later and wrote, "In many ways 'The Who Live At Fillmore East' would have been convincing proof that The Who was the greatest rock group in the world."

The picture sequence of Keith Moon captures his energetic drumming, but at the same time they're not flattering. I'm attracted by character, by faces that are craggy and lived in, where you can see the personality in the eyes.

I was always keener to capture the life of the

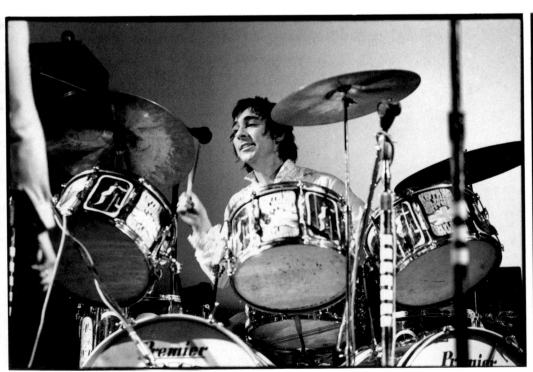

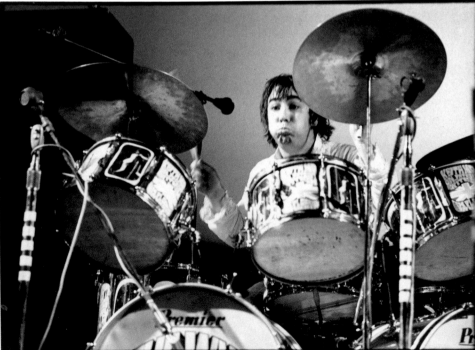

person I was photographing than I was in portraying the veneer. That was why I never had my own studio. I've never been interested in making people look better than they really are.

I got to know Moony and Pete best, along with Chris Stamp, who was then one of their managers. Pete was deep and intelligent, and Moony, despite his wild reputation, I always found to be a complete gentleman. My relationship with Pete has lasted through to the Nineties. I still see him, with his wife Karen and their children.

Moony, too, would continue to be a friend if he was still with us. We saw him regularly throughout the Seventies, often at music business parties or in recording studios, and I remember

him turning up at our home one day with two brand new boiler suits – a red one for Paul and a white one for me.

Paul and I were with him on the night that he died. We had put on one of our annual Buddy Holly evenings at Peppermint Park in London's Covent Garden and we'd shared a booth with him and the actor John Hurt.

He was in great spirits. He sang along with the Buddy Holly songs and was excited about an idea Paul had for Rockestra – an orchestra made up of rock musicians which would include three drummers. He was keen to join in and he left it that we would be in touch by phone. The first call we got the next morning was to say that he'd died after he got back home.

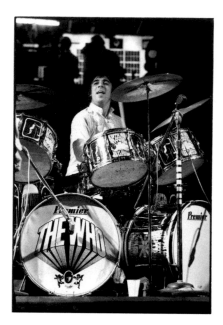

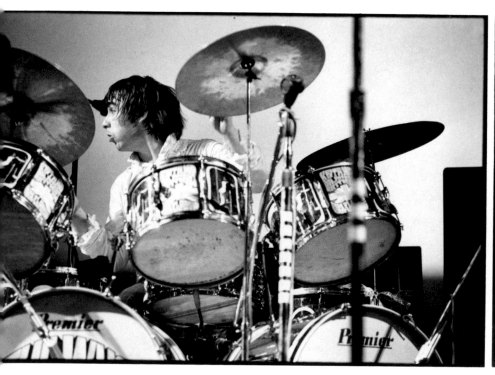 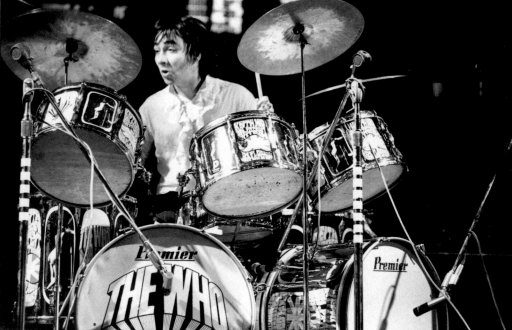

CREAM

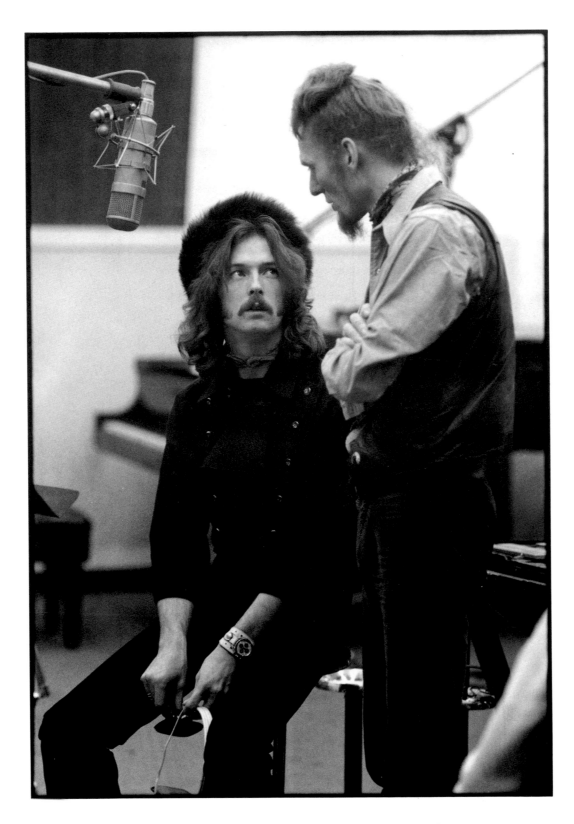

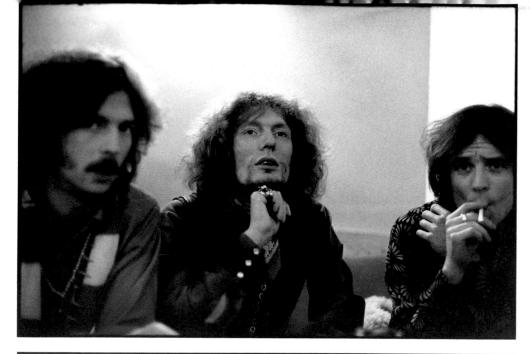

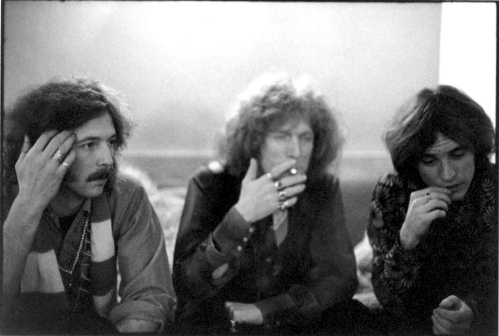

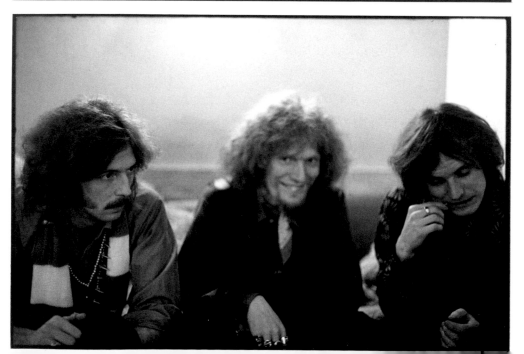

Groups often weren't together for very long in the Sixties. Cream formed in 1966 and by November 1968 it was all over.

I was in Atlantic Studios when they were recording *Disraeli Gears*, with Felix Papallardi producing. Jack Bruce put a surprising amount of work into that recording. Ginger Baker was like an amiable pirate with roguish looks and a strangled Cockney accent. Eric Clapton was, of course, a beautiful musician, and I was instantly impressed by his long graceful fingers. I told him I would like to photograph his hands. He didn't say any more about it, but one day, when I was taking pictures, he put his hands over his face and spread his fingers.

Jann Wenner came over to my apartment to see my work around this time. He took a lot of my black-and-whites away and used them in the first issue of a new magazine he was starting, called *Rolling Stone*. Later, he used photos from the *Disraeli Gears* session. He paid me $25 for every picture used; I had only expected a credit.

I saw Cream playing Murray The K's Fifth Dimension shows in 1967 and then, in 1968, I met up with them in London, when I came to take photographs for a book called *Rock and Other Four Letter Words*, which was being written for Bantam by a journalist called J. Marks. I got an advance for my part in the project and used most of it flying to San Francisco, Los Angeles and London to get pictures. It was a great opportunity to photograph all the bands I wanted to because

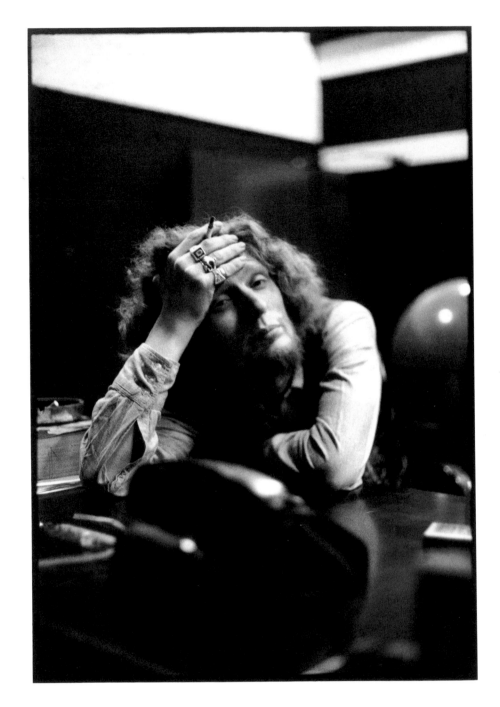

no restrictions were put on who I could include.

The sequence of Cream together was taken, I think, at the Cumberland Hotel near London's Marble Arch. They were being interviewed for the book. What I didn't know at the time was that they were on the verge of breaking up. It just wasn't working for them anymore. Knowing now what state of mind they must have been in, you can see the tension on their faces.

It was great taking pictures while an album like *Disraeli Gears* was being created. Songs like "Sunshine Of Your Love" and "Tales Of Brave Ulysses," with Eric's heavy psychedelic guitar, were such a breakthrough.

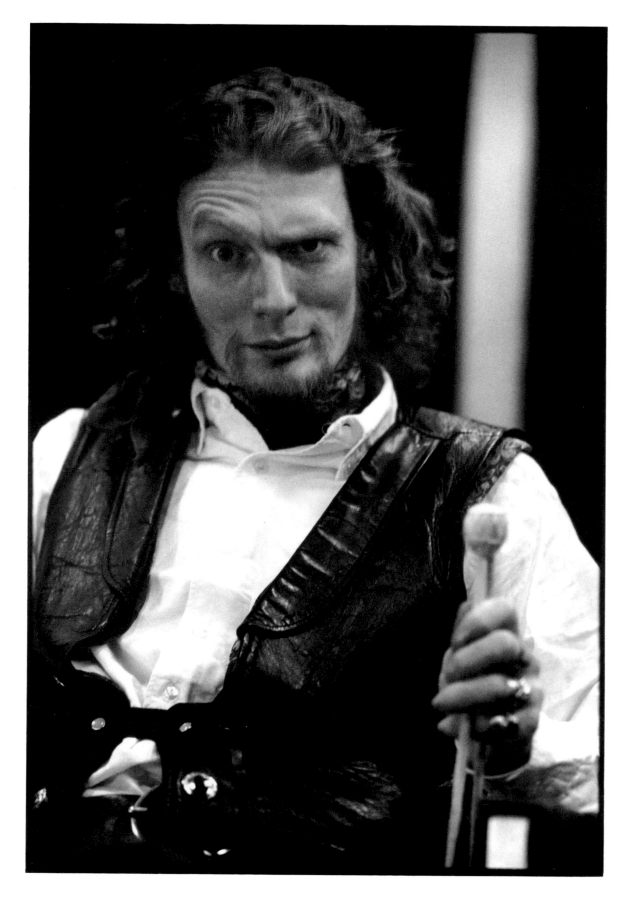

SIMON AND GARFUNKEL

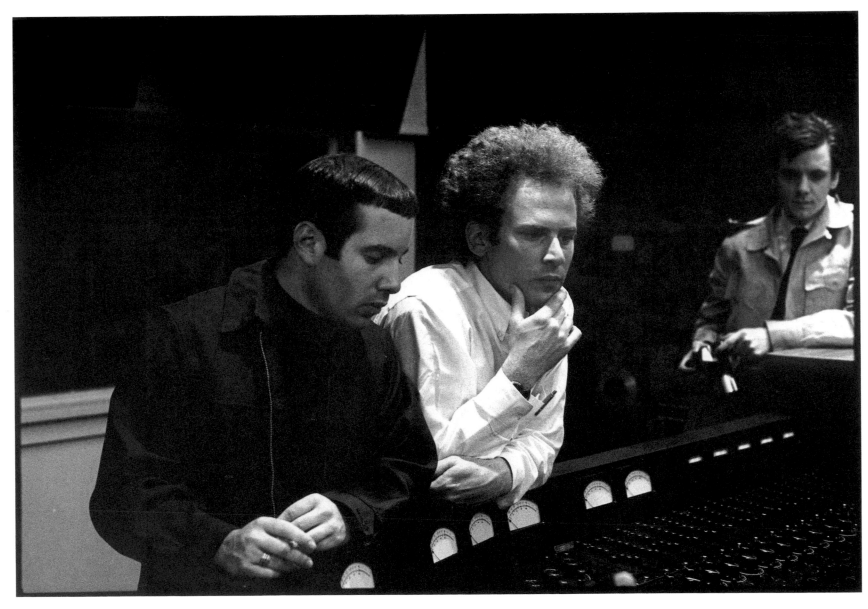

I first met Simon and Garfunkel one night in 1966, when a journalist friend invited me along to the CBS studios in New York when they were recording *Parsley, Sage, Rosemary and* *Thyme*, which was a very good album. They were working on the track "The Big Bright Green Pleasure Machine," with Bob Johnston producing and Roy Halee engineering, and I just wandered around the control room with a Pentax loaded with the fastest film I could find, making sure, of course, that I didn't interfere with what they were doing.

The live photo was taken at Forest Hills Tennis Stadium in Queens, where Simon and Garfunkel were being supported by The Doors. It was an open-air concert and I remember seeing Paul's parents there. The silhouettes were thrown by their own lighting.

I had gone to the concert with a producer friend called John Simon (no relation), and afterwards we went out with Paul to eat at a Spanish restaurant in the Village.

I met up again with them years later, and we had a fantastic time talking about the groups we heard on the radio as New York kids. We had all listened to Alan Freed who started on WINS in 1954 by playing rhythm and blues every week day between 7 pm and 10 pm, and then including more and more rock and roll. No one will ever know what Freed did to our teenage years – he saved mine. The records he played were magic, and if he liked a particular song he might play it ten times in one show.

After that meeting Art Garfunkel made up a tape of his favorite Fifties songs and sent it to me as a reminder.

B.B. KING

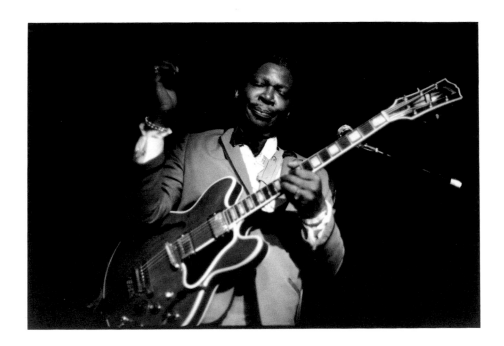

His music was honest and direct. It gave me hope. I grew up as a dreamer and I felt that things I was expected to learn were so complicated, whereas the blues was simple and expressed my inner feelings.

This shot of him on the right with his beloved guitar, Lucille, says it all for me. My three favorite photos from this period are The Beatles at the Sgt. Pepper reception where John and Paul are shaking hands, Jimi Hendrix in Central Park and this shot of B.B. where his head looks as though it's just about to go into orbit.

I photographed B. B. King so many times that it became like meeting the postman. He was the support act for every Tom, Dick and Harry that played the Fillmore East.

Although I loved his music, I never really got to know him because he was from a very different side of the business to the rock and roll acts I was used to mixing with. He was a generation older and came out of the Memphis blues scene. He had been playing since most of us were in kindergarten, and he was a lot less starry-eyed and innocent.

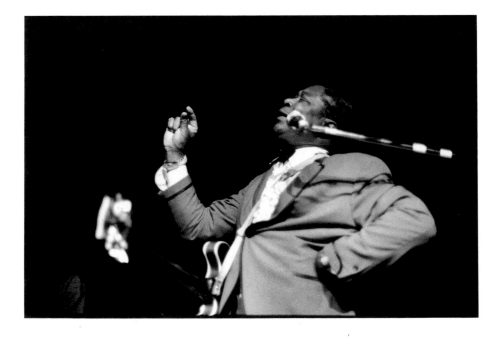

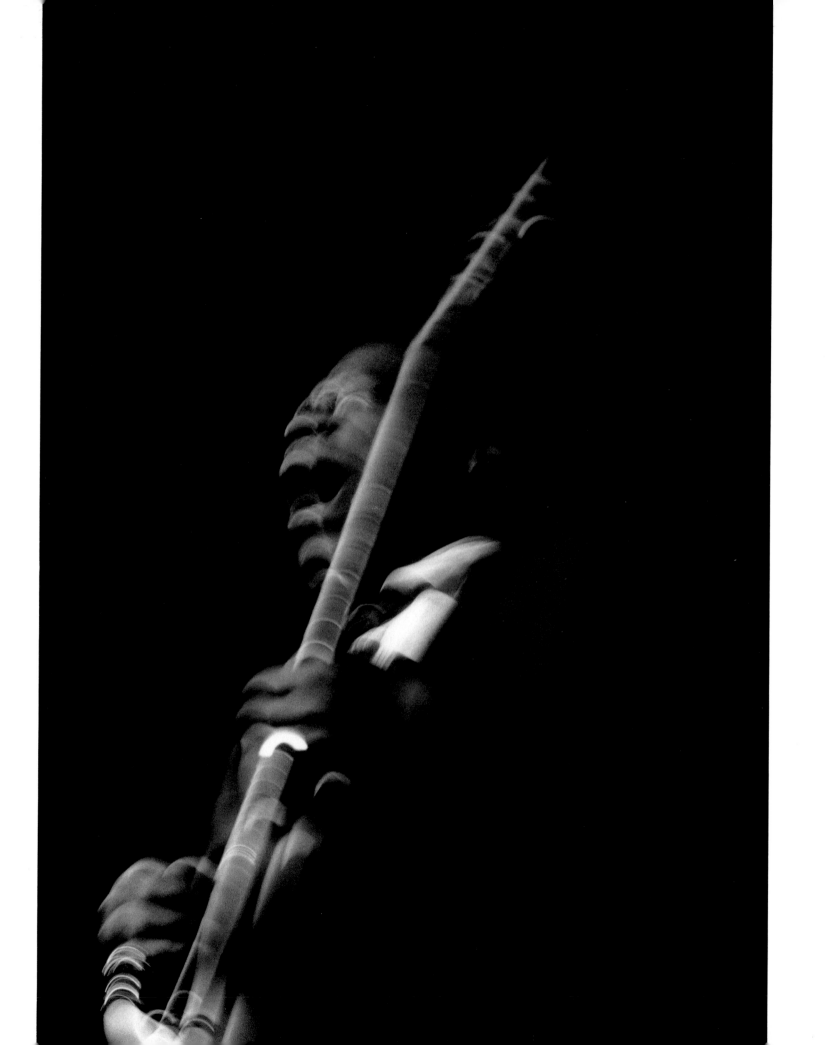

BUFFALO SPRINGFIELD

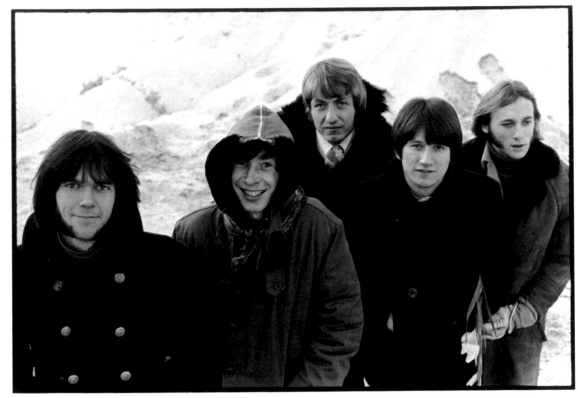

Some bands in the Sixties had reputations that were far greater than their commercial impact. Buffalo Springfield was one such band. Although they recorded a lot of great songs like "Expecting To Fly" and "For What It's Worth", Buffalo Springfield is now best known as the band that produced Neil Young and Stephen Stills, as well as Richie Furay of Poco.

I came across them one day when I was invited to see the Beach Boys at Nassau Coliseum, where they were the supporting act. I took pictures of them in their dressing room and we became firm friends from then on.

Neil and Stephen were like chalk and cheese. Stephen was from the South and showed

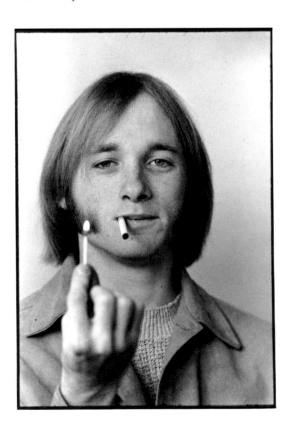

his confidence and ambition in a much more obvious way than Neil did. Stephen liked to be up-front and in charge, whereas Neil was much quieter and planned his moves without talking about them. Neil's subsequent career has been no surprise to me because he is well-rooted. He has always had a vision of his life and work, and he's stuck to it regardless of changing fashions. I am still a great admirer of his music.

I can remember them all sitting around discussing what they wanted for Buffalo Springfield. They wanted to be noticed and discovered. Stephen very much hoped the band would be famous, and he was willing to work very hard to achieve this.

The group shot and the photo of Neil were taken in Boston. I had flown up with them for a small club gig. The owner left before the end of the show and so they didn't get paid. We all stayed the night in a nondescript motel.

In the morning, as we were waiting to go to the airport, I took them round the back of the motel and had them stand in front of a pile of salt that was waiting to be sprinkled on the icy roads.

Stephen liked my work and was into photography himself, so he took some pictures at the same time with my brand new Hasselblad.

The photo of Stephen was taken in my apartment and begins a sequence of him lighting a cigarette and blowing smoke rings.

38

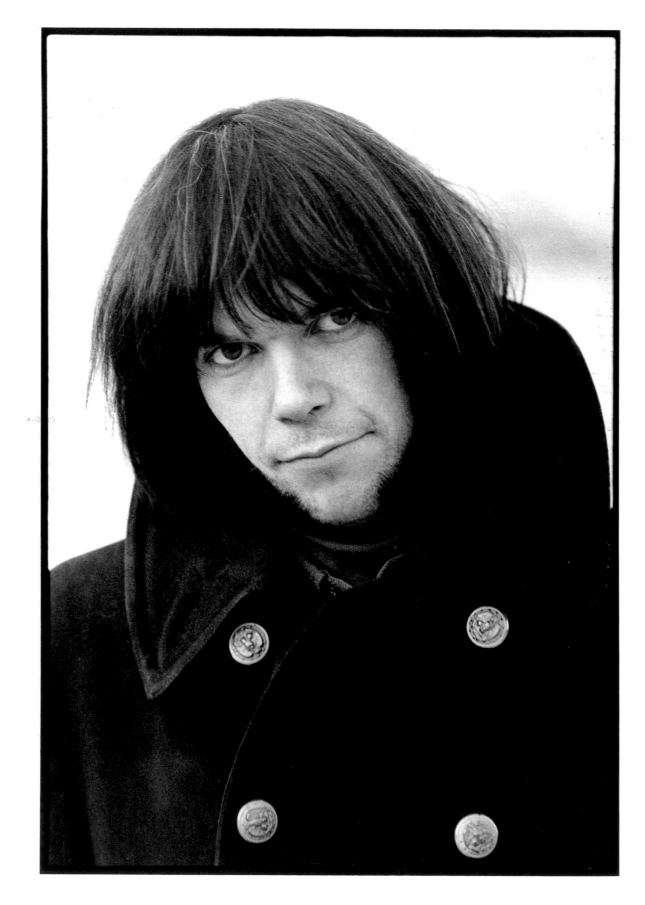

TODD RUNDGREN

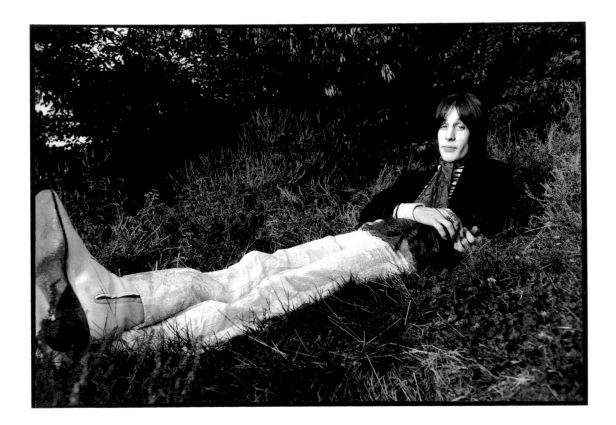

There was a band called The Nazz which everyone was talking about, and Todd Rundgren was the founder member. Their first live gig was supporting The Doors in 1967, and the following year they came out with their début album *Nazz*. I hadn't heard The Nazz play when I took these pictures of Todd.

Not having a studio of my own, I would walk, head off on the bus or go on the subway to find a spontaneous location when I wanted a change of background. These shots were taken in Central Park one afternoon. It was a beautiful day; we were in Manhattan but it felt like we were in the country.

Although Todd started recording in the Sixties, he really belonged to the next generation. Influenced by British bands like The Beatles, The Move and The Small Faces, he came into his own in the Seventies when he started recording under his own name and with Utopia.

I thought he had a very attractive face, and he was full of character. I liked him immediately, although I can't remember now how we first came to meet.

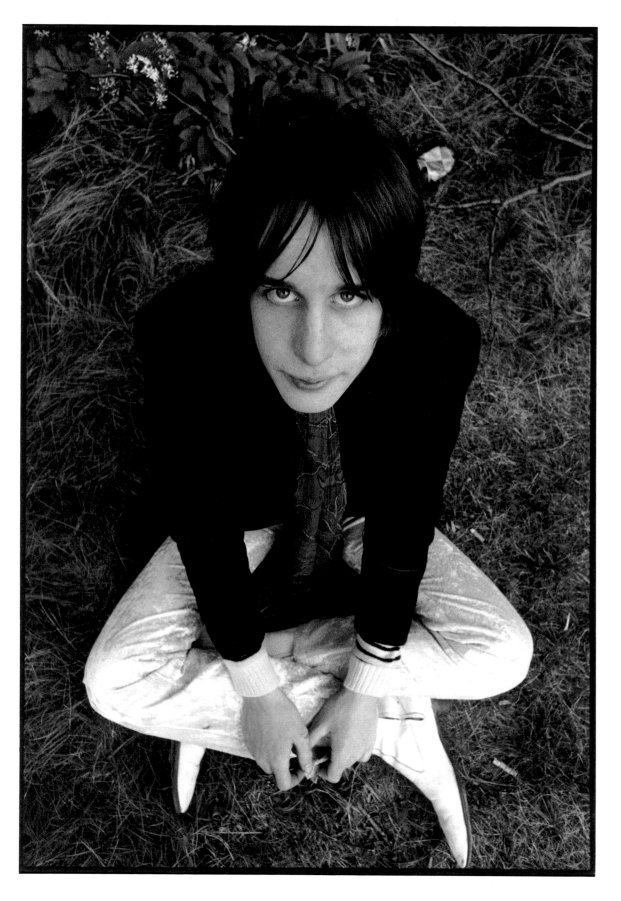

THE ANIMALS

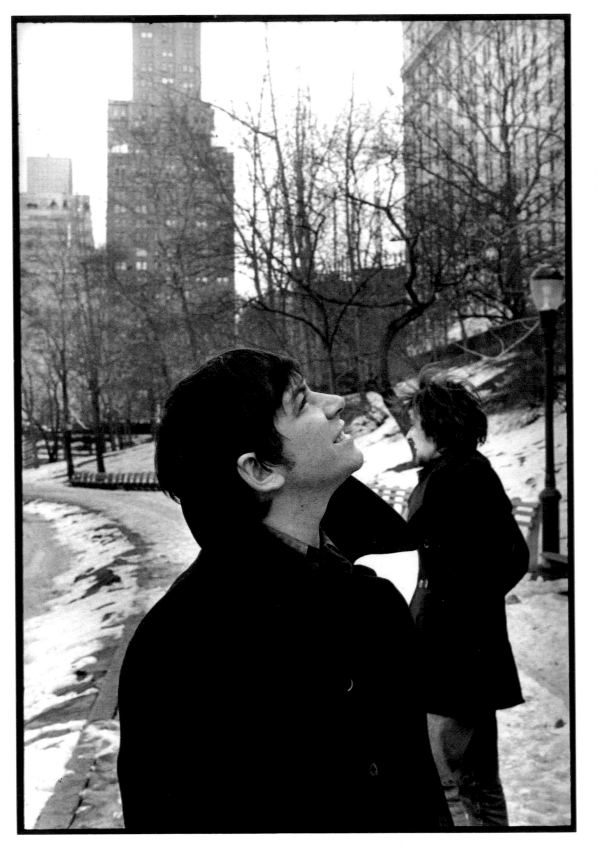

ERIC BURDON WALKING IN CENTRAL PARK WITH DRUMMER BARRY JENKINS IN THE BACKGROUND

America really took to The Animals and I photographed them over a long period. I became close friends with the group, and after photographing The Beatles at Shea Stadium from way back in the press box in August 1966, I went back to the hotel on West 57th Street where The Animals were staying, and we all went out clubbing in Harlem. That was back in the days when, as a single girl, I wasn't frightened to take the subway up to Harlem to shop at the Army & Navy store, or go and hear music.

Ebony magazine was doing a feature on The Animals at the time and a photographer followed us round Harlem. Later, a client of my father said to him, "Oh, I saw a photo of your daughter in *Ebony*. She was with these English pop musicians in a club in Harlem." Needless to say, my father wasn't too pleased; he was a respectable lawyer with a thriving practice in New York, and here was his daughter hanging out in Harlem with a bunch of what he used to call "longhairs."

Eric Burdon was a real soul brother. He loved black music and soul food. The guitarist Hilton Valentine had a fondness for LSD. He used to spend a lot of time just sitting in the corner, looking spaced out. He's absolutely fine now, running a business in Newcastle.

Chas Chandler, who was then the group's

bass player, discovered Jimi Hendrix while he was in New York for The Animals' farewell tour of America. I wasn't with him that night, but I do remember him playing a demo tape of Jimi singing "Hey Joe" to me, Chris Stamp and some other friends. We were all in a room of a Holiday Inn on the West Side and there was an Elvis film on TV, although someone had turned the sound down. I can remember thinking how Jimi's singing seemed to synchronize with the images of Elvis on the screen.

It was as a result of that tape that Chas became Jimi's manager, with Mike Jefferies, and brought him to Britain to launch his career.

ABOVE: ERIC BURDON SINGING WITH THE ANIMALS AT HUNTER COLLEGE AUDITORIUM, NEW YORK CITY

RIGHT: ERIC BURDON JAMMING AT THE CAFE AU GO GO WITH GUITARIST DANNY KALB OF THE BLUES PROJECT

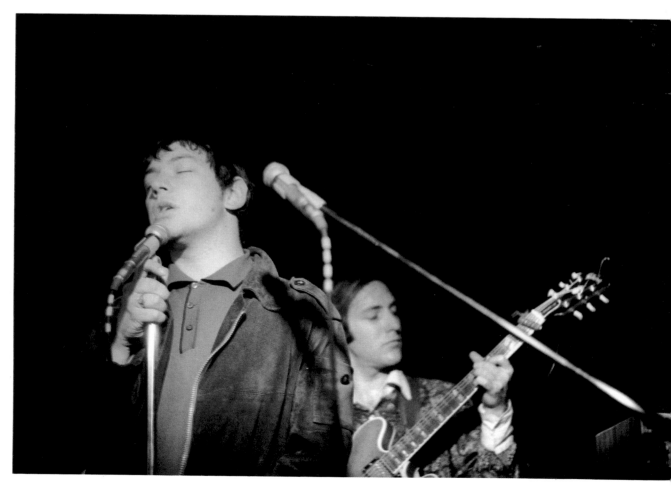

THE YOUNG RASCALS

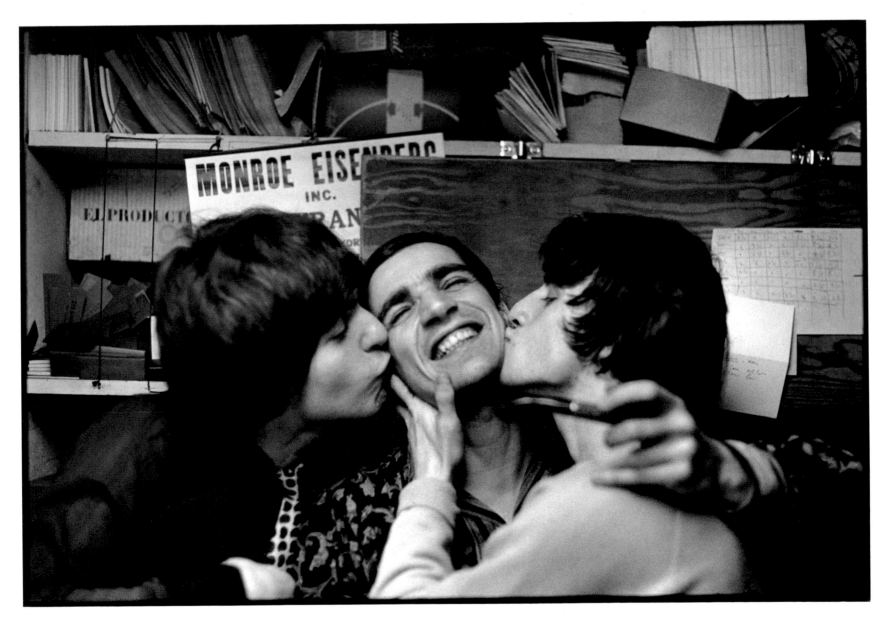

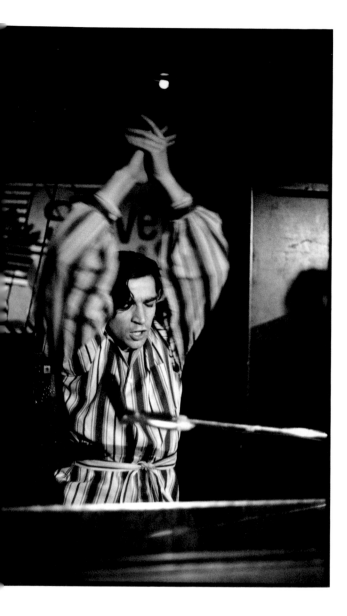

The Young Rascals were a great New York group who I always thought deserved to have done better. They played often at The Scene and had hits with "Groovin'," "Good Lovin'" and "A Girl Like You."

The shot of Felix Cavaliere being kissed by Dino Danelli and Eddie Brigati was taken at the office of their manager. They were messing about for me while I waited to take some photographs of them for a sunglasses manufacturer who wanted to use them in a promotion.

I really liked them as a group. Felix and Eddie wrote some great songs and in concert they would do versions of soul numbers like "Ride Your Pony" which would have given Wilson Pickett a run for his money.

ABOVE: FELIX CAVALIERE PLAYING KEYBOARDS
AT THE SCENE CLUB

RIGHT: EDDIE BRIGATI (LEFT) AND DINO DANELLI
IN THE CLUB'S DRESSING ROOM
BEFORE THE GIG

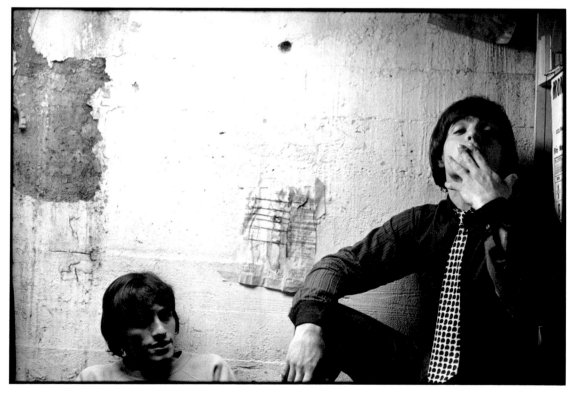

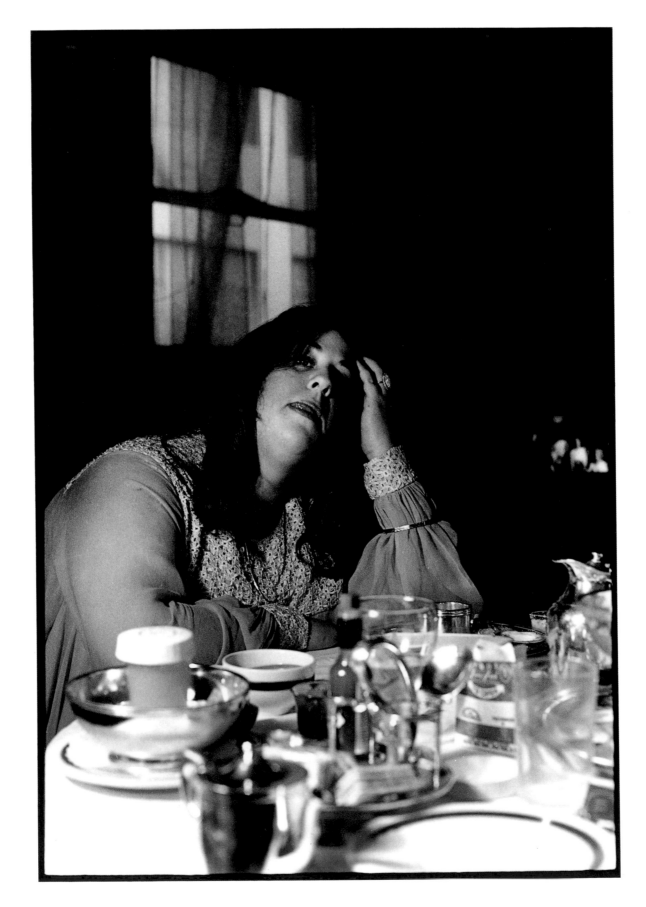

THE MAMAS AND PAPAS

I only took around ten shots of The Mamas and Papas. A New York journalist friend of mine, David Dalton, was writing a story on them and I was invited to take pictures. They were staying at the Sherry-Netherlands Hotel and I stopped by on my way home.

The impression I got was that their success was becoming a bit boring to them. The Susan Hayward film *I'll Cry Tomorrow* was on the TV and they were just lounging around and enjoying themselves. Michelle Phillips was brushing her hair, her husband John was playing his guitar, and Mama Cass, having finished off her own plate of oysters, was reaching out to start eating some of Denny Doherty's.

In retrospect I can see this was the beginning of the end for the group. They broke up the following year and in 1974 Mama Cass died.

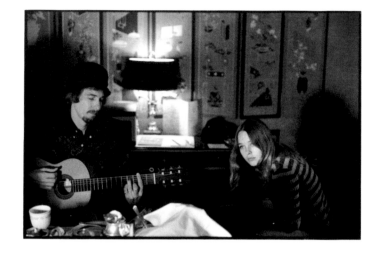

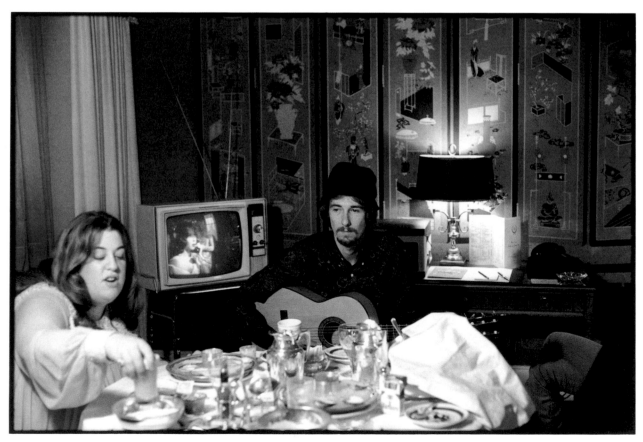

JACKSON BROWNE

These photos were taken on the Staten Island Ferry on one of my "hanging out" days. Jackson Browne was then an unknown nineteen-year-old songwriter who had recorded some demos for Elektra and had some songs published by them. I first met him in the winter of 1967 through my friend Danny Fields, who had been a journalist for *16* magazine but was now publicity officer for Elektra. We arranged to meet at the Carnegie Hall subway exit and went out to the Cloisters to take some photos. We

became friends then and remain so to this day.

There was a school of introspective and melodic songwriters developing in Los Angeles at that time. Another one was Steve Noonan, who recorded one album for Elektra and then quit the business because he didn't think it represented real life. He was a lovely soul.

Although Jackson had been playing songs since he was in high school, it wasn't until 1970 that he did the first concert tour, opening for Laura Nyro, and it was 1972 before he recorded his first album for David Geffen's Asylum label.

He had first come to New York in the winter of 1967 and stayed for two months. Apparently he had driven from California in an old Rambler station wagon. Tim Buckley is credited with getting him work in the Village as an accompanist to Nico who had just left The Velvet Underground.

I remember seeing him playing with Nico. He played electric guitar while silent 8mm movies played behind them on the walls.

It was a time when people thought more about experimenting than they did about making money, although I'm sure that, beneath it all, they were each waiting to be discovered.

Jackson was always a very kind and

thoughtful person. He was concerned about issues that really mattered. I think that his songs touched people because he managed to articulate the concerns they had never been able to put into words. He was a poet. And he was cute! He was a very good-looking young man.

The kindness and thoughtfulness I saw in him as a teenager have flowered in the decades since. He has been involved in many high profile causes, from demonstrations against nuclear arms to support for Amnesty International.

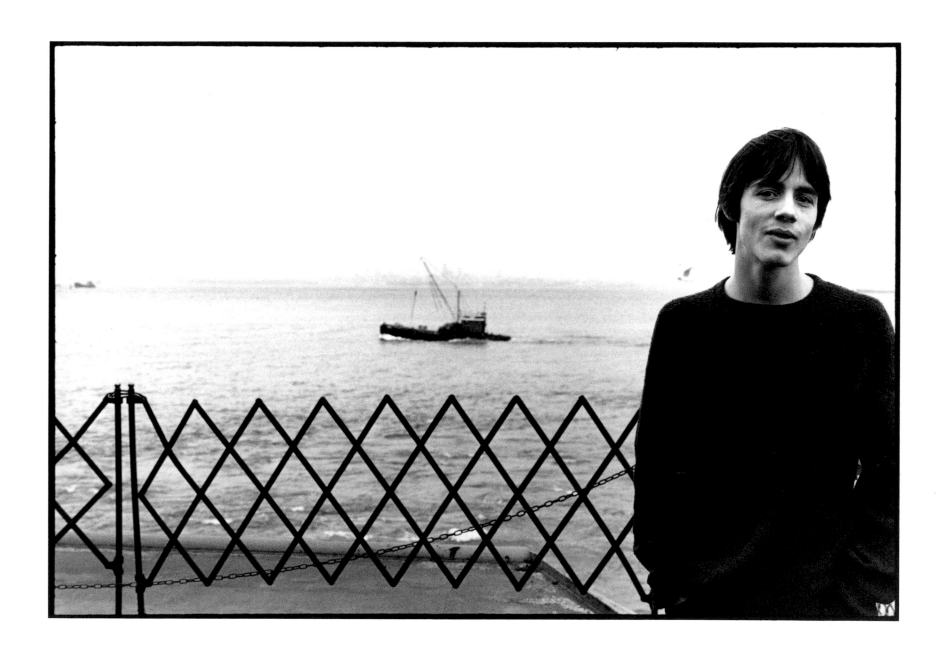

BLUE CHEER

Leigh Stephens was the lead guitarist, Dick Peterson played bass and the drummer was Paul Whaley. Their manager was known to everyone as Gut.

Blue Cheer's version of Eddie Cochran's "Summertime Blues" made the American top twenty during the spring of 1968 and when they put out their first album, *Vincebus Eruptus*. Augustus Owsley supplied the sleeve notes.

My friends could never understand why I liked the band, but I just loved their loudness and raw electricity. Their music was all over the place – it was LSD music – but I was a girl who had always loved guitar music right from the early days of The Ventures and Duane Eddy.

I think the first time I heard of them was through Janis Joplin, when she was standing in the entrance to the Fillmore East and saw them listed as a coming attraction. She told me that I should look out for them, and I did. Then, in September 1968, they came to New York to record their second album *Outside Inside*, and I brought my camera to the studios. I was invited to the sessions by their producer, Eddie Kramer, whom I had met as an engineer when he was working with Jimi Hendrix.

We got on well and as a result I went on tour with them all over the Mid West. We traveled by bus and stayed in cheap motels which is where I took the photograph on the left.

Before there was heavy metal there was Blue Cheer. They were a three-piece band from San Francisco, who boasted that they played the loudest rock and roll in the world, and who took their name from a particularly potent brand of LSD made by Augustus Stanley Owsley III.

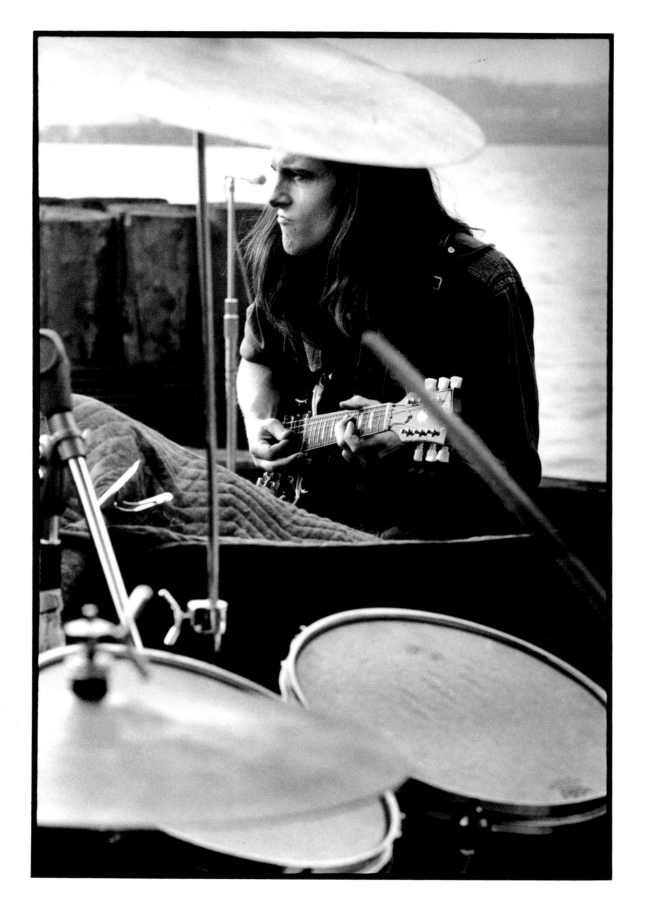

THE BYRDS

was then known as Jim McGuinn. David I got to know better over the years, and when Crosby, Stills and Nash formed, they were in London at the same time that The Beatles were recording *The White Album*. Graham Nash, who is a keen photographer himself, called me up and said he wanted me to be the first photographer to take group pictures of them. I said I'd be delighted to so we met up and drove out to Hampstead Heath where I took some shots.

ABOVE: ZAL YANOVSKY AND MIKE CLARKE

BELOW: JIM MCGUINN BEFORE HE BECAME ROGER

I got to know The Byrds over a long period but most of these pictures were taken during a two-week residency at the Café Au Go Go in New York. Except for the one of drummer Mike Clarke with Zal Yanovsky of the Lovin' Spoonful taken at Zal's apartment, they are all "waiting to go on stage" shots.

I liked The Byrds best when Gene Clark was singing with them, but by the time they came to the Café Au Go Go he had left. The group was really starting to fragment by this time. David Crosby was even staying in a separate hotel, and in the summer of 1967 he left the group.

Mike Clarke and Chris Hillman were the two Byrds I got to know best. Roger McGuinn

JIMI HENDRIX

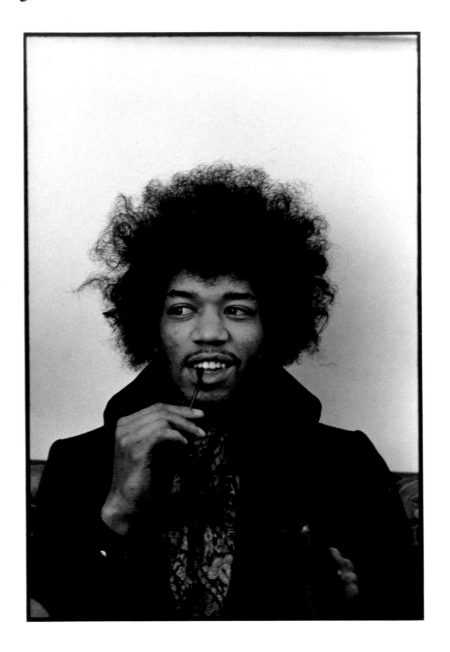

The first time I photographed Jimi Hendrix was in London during 1967 when I met him at Chas Chandler's flat. He hadn't yet returned to tour America and he was incredibly apprehensive because he wasn't sure that he would be accepted there. He always seemed very unsure of his talent.

I didn't see him play until that July when I was back in New York and he turned up to play the Rheingold Festival in the Central Park skating rink. They were on the same bill as The Young Rascals. That show provided me with one of my all-time favorite pictures which is the one opposite of Jimi thrusting his left arm out in line

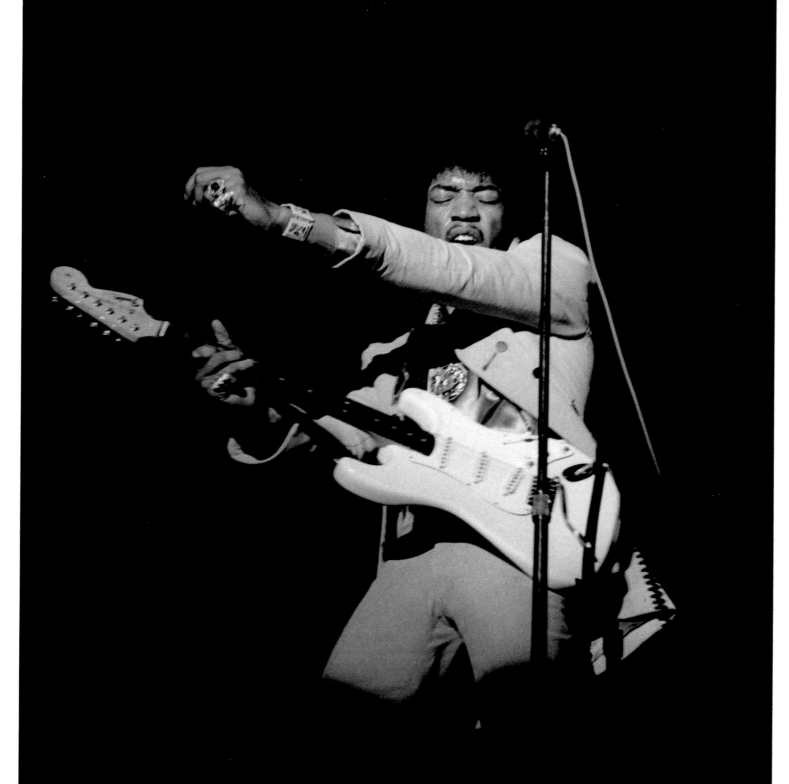

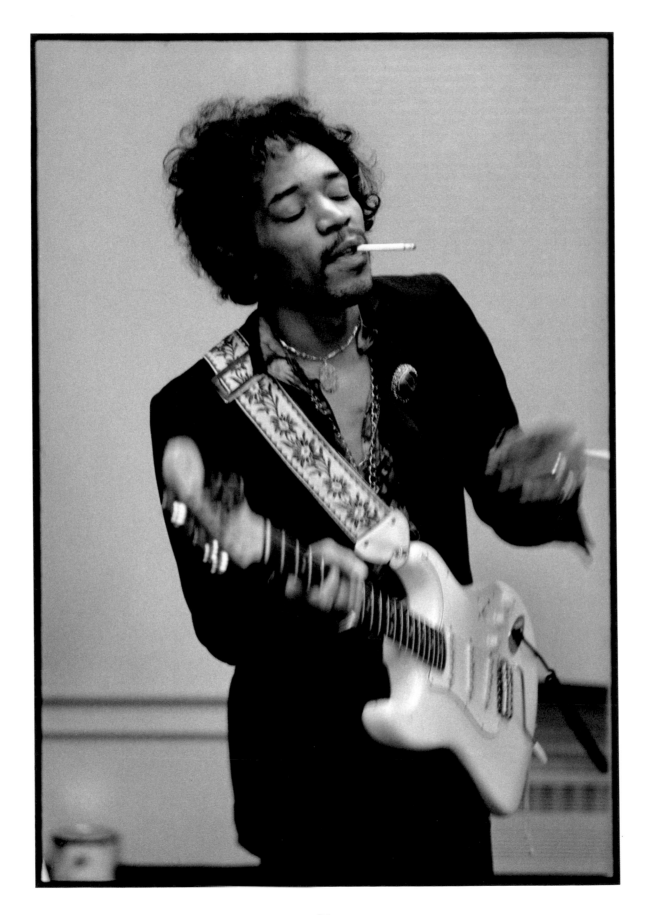

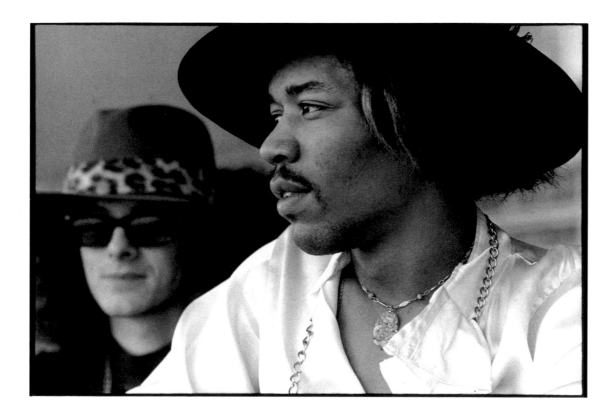

with the guitar neck – eyes soulfully closed.

That was the beginning. I photographed him numerous times and we stayed close friends up until the time I married Paul. The backstage photos were taken at London's Olympia where Jimi was part of a show called "Christmas On Earth Continued," with Eric Burdon and the Animals, The Who, The Move, Soft Machine,

Tomorrow and Pink Floyd. Traffic made their début that night. It was a fantastic show with a revolving stage to allow quick changeovers.

The later photos where Jimi has blond streaks in his hair were taken at the Miami Pop Festival which took place on the Gulf Stream racetrack in Hallandale. It wasn't a huge success but it had The Mothers of Invention, The Crazy

NOEL REDDING AND JIMI WATCHING SUPPORT ACTS AT THE MIAMI POP FESTIVAL, MAY 1968

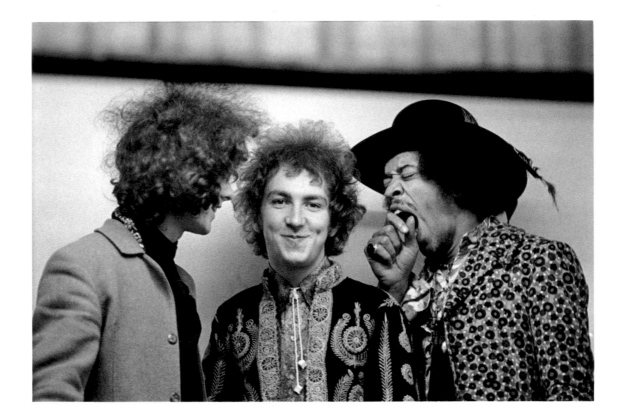

World of Arthur Brown, Chuck Berry and John Lee Hooker. The shot of Jimi with Noel on the previous page was taken in the half empty bleachers as they watched the other acts.

Jimi and I enjoyed a close relationship without ever having an affair. You can see the sort of friends we were in the photo I took of the group standing on a table in their manager's office. They had to stand on the table because the only available light was coming from a skylight and I had to get them as close to it as possible. But despite all this, you can see that Noel Redding and Mitch Mitchell are both laughing and Jimi is so relaxed he is starting to yawn. They had been working all day.

He loved my photographs and I would always let him have prints of any black-and-whites I had taken of him and he would then

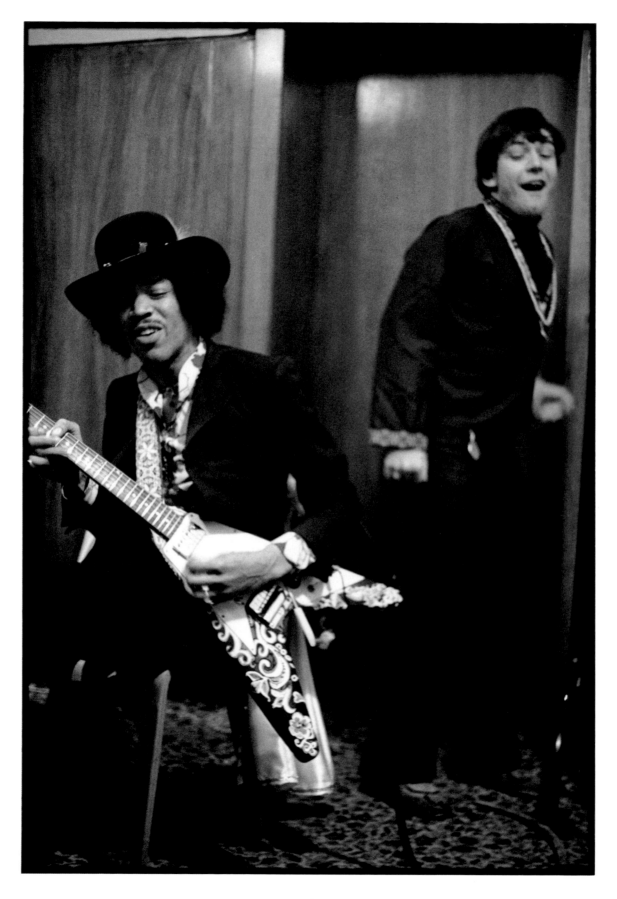

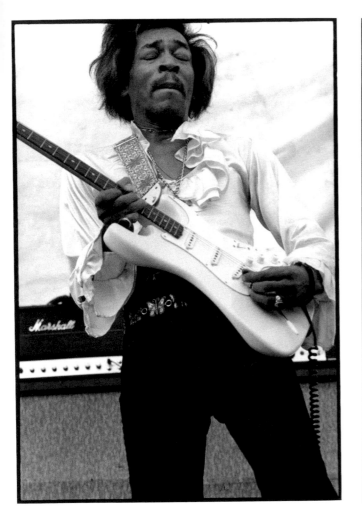

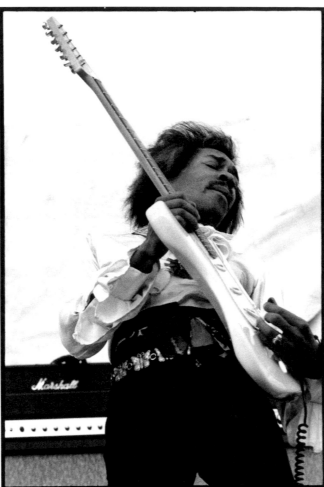

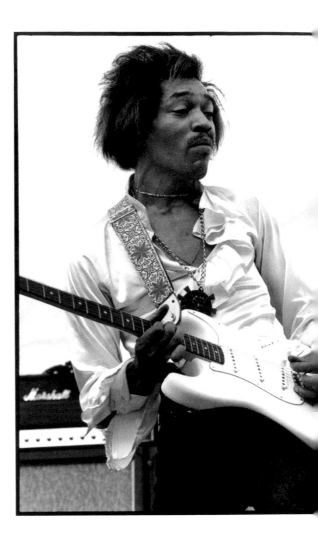

come over to my apartment to look through the color shots. He would arrive carrying a little black briefcase and he would hold the mounted transparencies up to the window and simply throw any that he liked into his case. That's how I ended up with all the rejects and he went off with all the good stuff for nothing. I never saw those original transparencies again.

Despite his wild looks he was one of the shyest and most sensitive people I have ever met. He didn't think he was any good. It was a deep friendship and I think he liked me because I could speak to him in an intelligent manner. He

thought he was getting a raw deal. He felt he was getting a lot of cars, a lot of girls, but no money, and it really stressed him.

He was the sort of man who would break down in tears if he felt moved. One night we were watching *The Hunchback of Notre Dame* on TV and he just started crying. Another time he asked me to do the cover for a double album he had just recorded. I had been in the studios for a lot of the recording and he told me that he wanted a photo of a little black boy flanked by two white boys, which would represent him flanked by Mitch and Noel. I said I was

60

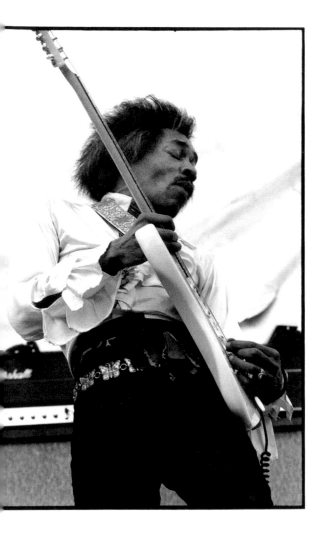 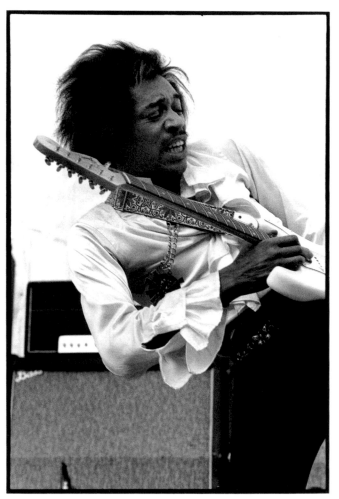 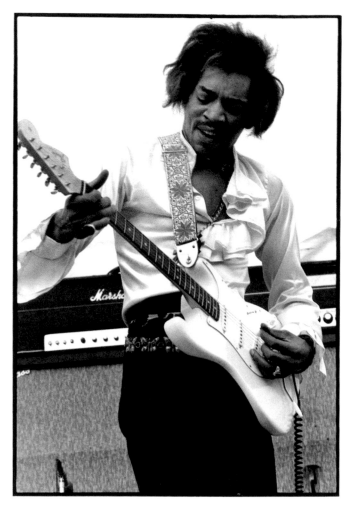

interested but I didn't realize he was up against a deadline. I went off traveling to do fashion and music spreads for *Mademoiselle* and then when I came back I found Jimi very upset. His new record was called *Electric Ladyland* and his record company had chosen their own cover with a group of naked women on it. He despised it.

He also hated burning the American flag during his shows and playing the guitar with his teeth. He loathed it; but it was his gimmick. He thought that if he stopped doing it the audience wouldn't love him any more. So many times when we were talking he would tell me how much he hated doing these things and would ask me whether he should stop. I would tell him that it was his guitar playing that mattered, his poetry and his emotional honesty.

After I left America in September 1968 to join Paul I didn't see him again until a reception for Mary Hopkin in February 1969 which was held at the top of London's Post Office Tower. Paul had produced Mary's album, and when Jimi saw us we kissed and hugged and said we had to meet up again.

Sadly, we never did. Only eighteen months later he was dead.

BOB
DYLAN

Although I had always bought Dylan's albums and admired his work, I had never seen him in concert. His motorcycle accident in July 1966 more or less coincided with my entry as a photographer into the world of rock and roll. He'd been living in Woodstock since then.

The first date he played after that was as part of a tribute concert to Woody Guthrie at Carnegie Hall in January 1968, just around the time of the *John Wesley Harding* album. Here, he was reunited with The Band and sang three Guthrie songs. It was a magic performance.

Only the official photographer, David Gahr, was allowed to take photographs.

During the concert there was some narration read by Will Geer and Robert Ryan, two Hollywood actors who had known Guthrie. After the show, Ryan threw a party in the Dakota. Dylan was there and I asked if I could take his photograph. He said he'd rather I didn't, and so I didn't. I was far too respectful.

I didn't see him again until I was with Paul, and he was living with Sara and his children in Greenwich Village. I was still a little apprehensive about taking photographs of him, although I'm sure he didn't mind and wouldn't have remembered the Dakota incident. I took this shot from quite a distance and didn't take nearly as many photos as I should have.

FRANK ZAPPA

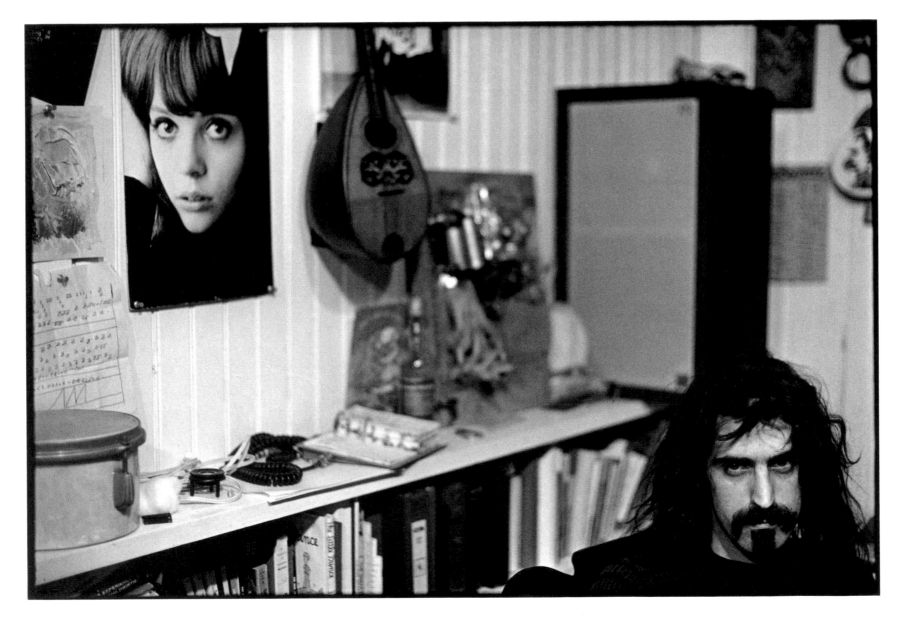

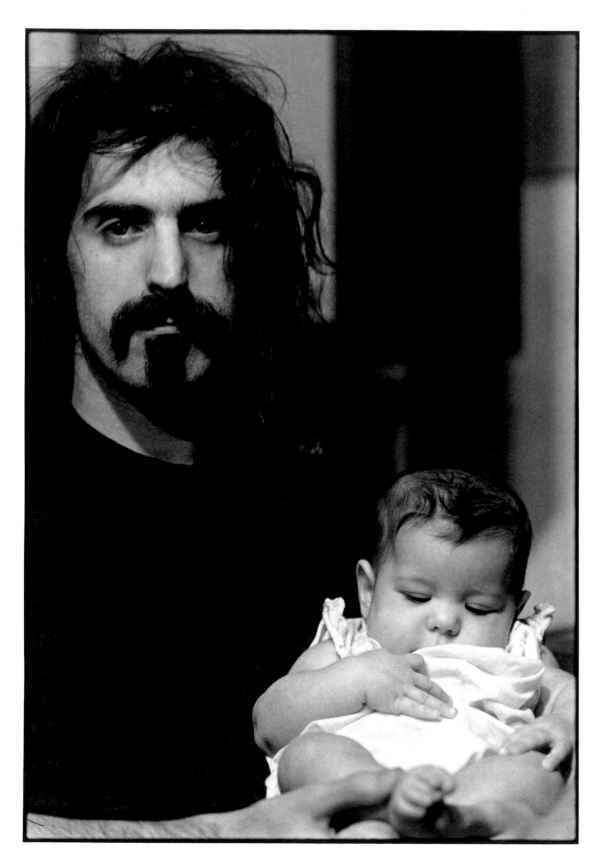

The Mothers of Invention were considered a very far-out group from California, but a lot of the freakish reputation came from their looks and sound. "These Mothers is crazy," it said in the sleeve notes of their 1966 album *Freak Out!* "You can tell by their clothes. One guy wears beads and they all smell bad." It was during the height of flower power. Some of them looked like Hell's Angels.

Frank Zappa, who wrote the songs as well as conducting and arranging the music, was recognized as the head Mother. He looked very different and weirdish at the time with his beard and long hair, but I think he knew what he was doing. I was later to be in recording studios when he was working, and I could tell that he was a lot more together in his approach than his appearance suggested. He has since proved to be an astute businessman and a talented composer.

These photographs of Frank were taken at his office in Greenwich Village. He may also have lived there. The little girl he is holding is his daughter, Moon Unit. I liked Frank a lot and enjoyed photographing him.

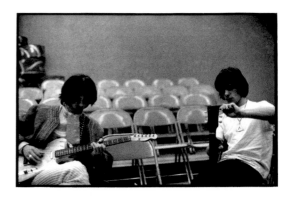

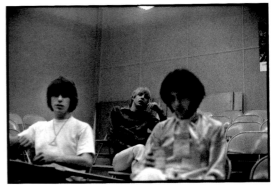

THE YARDBIRDS

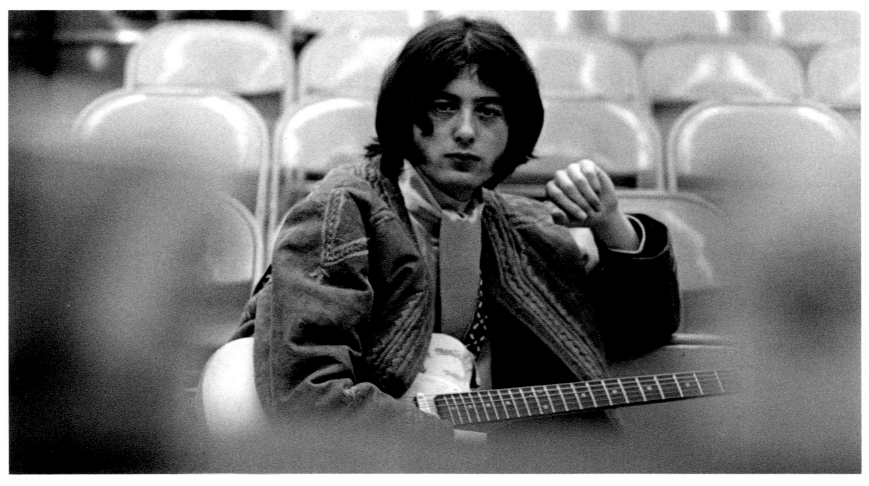

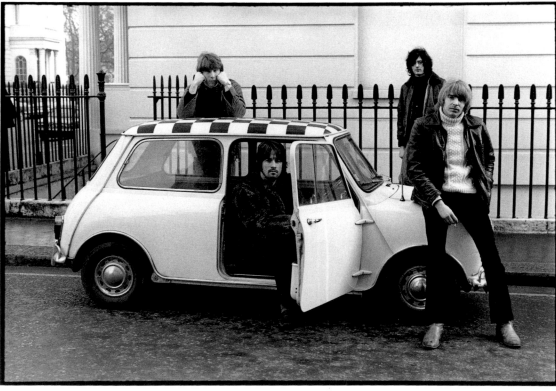

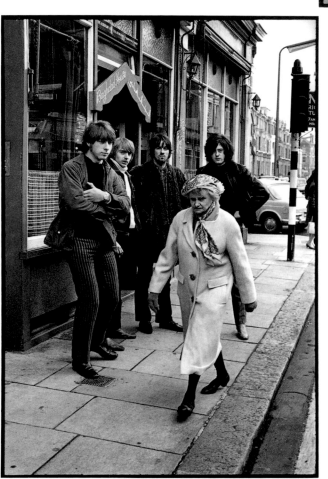

I loved The Yardbirds' music, and in October 1966 I heard that they were playing at a high school in Westport, Connecticut, so I drove up from New York to take photographs. When I arrived, the school's public address system had broken down, and the band had been forced to sit it out in the music room for hours while it was sorted out. That's where I took the pictures of Jimmy Page and Jeff Beck. In the time they waited, Jeff managed to break down and reassemble his Telecaster.

It was during this tour that Jeff left them to form another band with Ronnie Wood and Rod Stewart. The Yardbirds were a four-piece band when I met up again with them in London. After a photo shoot, they took me out to eat at the Baghdad House, a restaurant favored by English musicians, where you could have a discreet smoke without being hassled.

The bass player, Chris Dreja, became a photographer when the group broke up in 1968. I can remember him coming over to my place in New York, and asking me what life was like behind the camera and whether he should take it up. I told him that I loved it, and that if he wanted to do it badly enough, he could be a photographer. It was hard work for me at the time but it was paying my rent. I didn't have an agent or an assistant and I was getting calluses on my hands from carrying my portfolio and equipment around on public transport, but at least I was my own boss. I don't know if I affected his choice, but I do know that he's now a successful commercial photographer.

B L O O M F I E L D /
Q U I C K S I L V E R

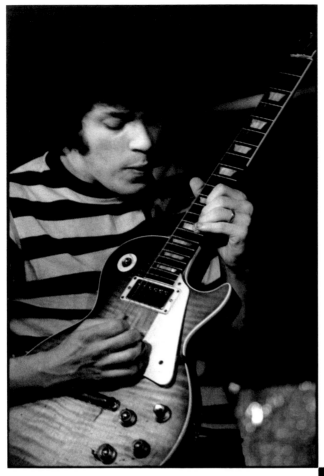

Mike Bloomfield was one of the first people to tell me about heroin. He told me that they could murder your wife in front of you and you wouldn't feel it, chop your legs off from the thigh down and you wouldn't feel any pain. He died a drug-related death in 1981.

When I first met him he was with the Paul Butterfield Blues band. He'd made a name for himself playing with Bob Dylan on the *Highway 61 Revisited* sessions, and at the Newport Folk Festival when Dylan first "went electric." Mike was a beautiful guitar player. He would hold his guitar like a baby and rock it in his arms.

After leaving Butterfield he formed Electric Flag with Buddy Miles, Barry Goldberg and Nick Gravenites, and they played the Fillmore East on the same bill with Quicksilver Messenger Service. It was two old pals getting together again when I photographed Mike with Quicksilver's rhythm guitarist, Gary Duncan, in the dressing room before the show.

Quicksilver were a real San Franciscan band and I took lots of photographs of them in Central Park. It was while we were doing this that the bass player, David Freiberg, taught me how to roll a joint.

THE SHOT OF QUICKSILVER'S LEAD GUITARIST, (OPPOSITE PAGE) JOHN CIPOLLINA, WAS TAKEN AT THE FILLMORE. I DIDN'T DELIBERATELY GO FOR THE BLURRED EFFECT. I JUST CAPTURED THE MOMENT.

CIPOLLINA WAS MOVEMENT AND SPEED WHEREAS BLOOMFIELD (ABOVE) WAS GENTLE AND PRECISE AND YOU CAN SEE THAT CONTRAST IN THE PICTURES

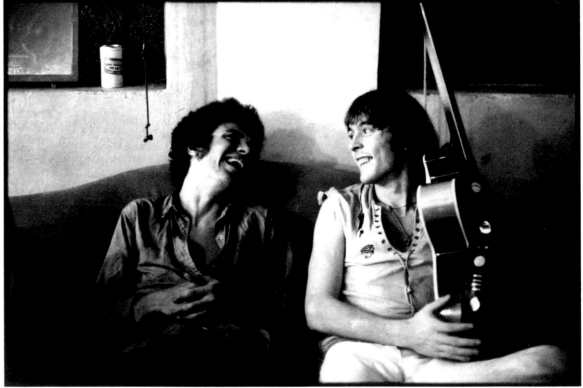

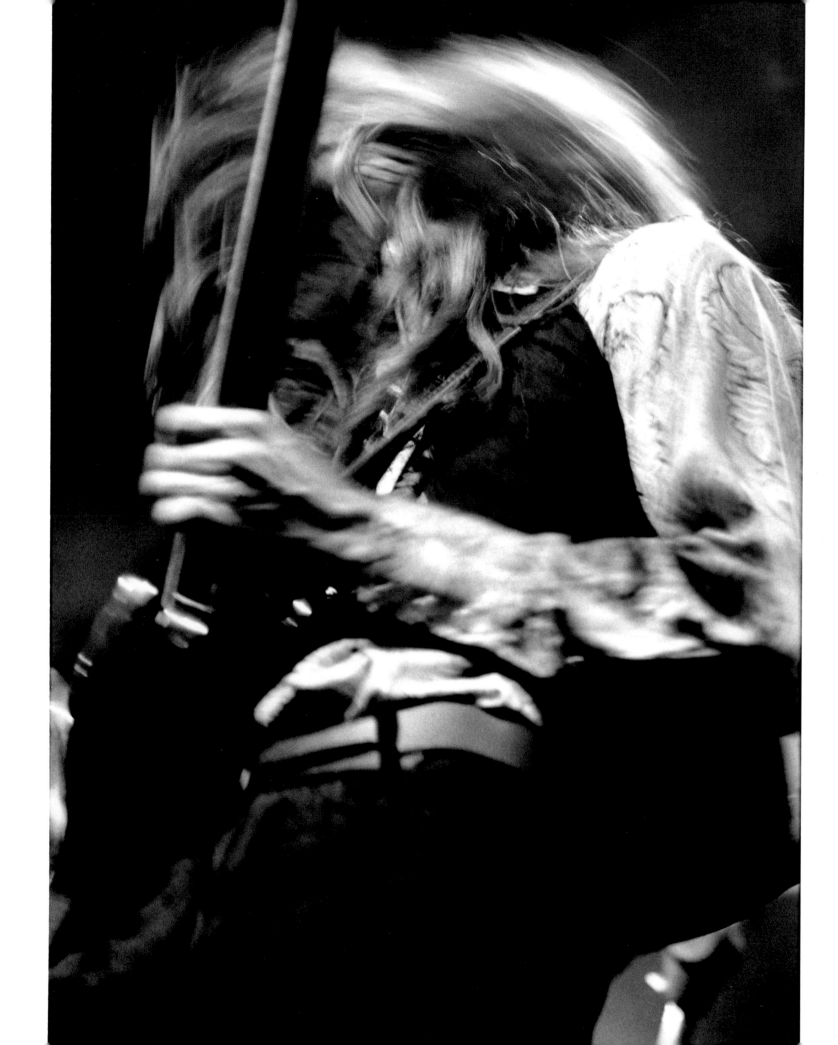

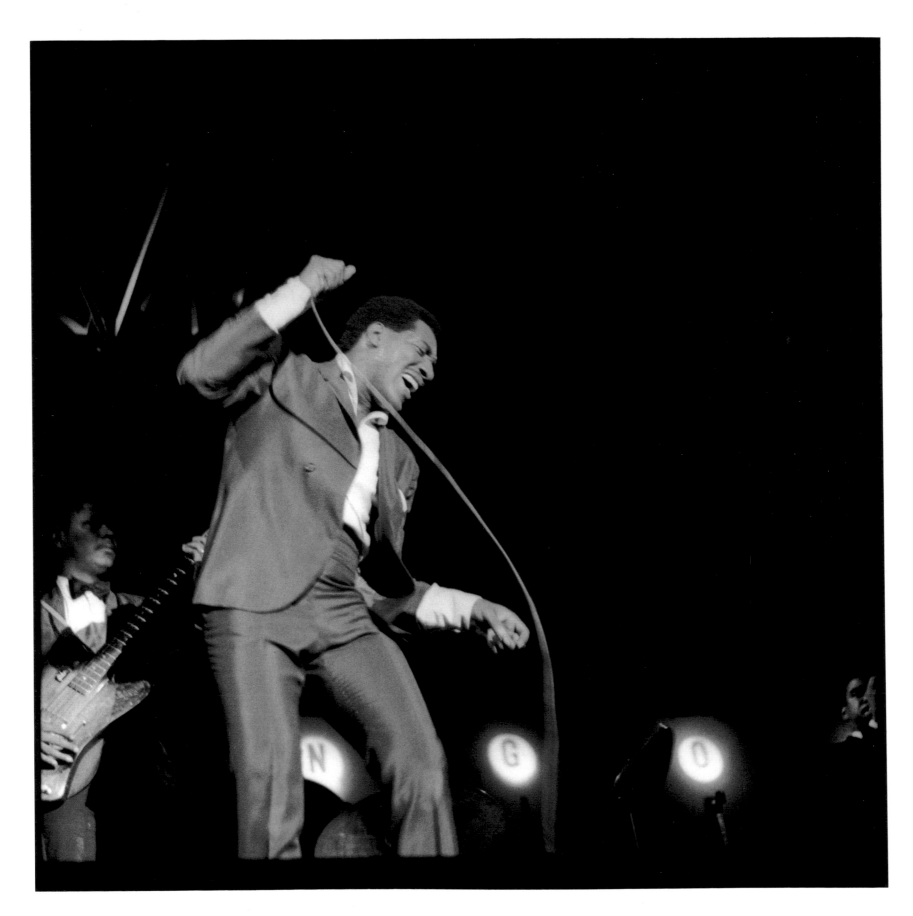

OTIS REDDING

I went along to see Otis Redding in Central Park with some of the guys from The Animals. We didn't have seats so we stood at the side of the stage and I got so caught up in the music that I ended up right in front of Otis, moving to the sounds of the Memphis Horns, and took a roll of film at the same time. He was a hero of mine. To me he was, and still is, the King. He was the epitome of real soul music. Asked to name my favorite singer I would have to say Otis Redding.

That was the first night I smoked pot. I remember seeing people going into the zoo and turning on the monkeys by blowing smoke in their cages.

The day he died I was visiting friends on 57th Street in New York. Dusk was falling as I left to catch the bus and I heard the news on a news vendor's radio. I can still see myself taking it in. I can still feel the same feelings. I went back home and looked through my Otis photographs and thought how lucky I had been to see him.

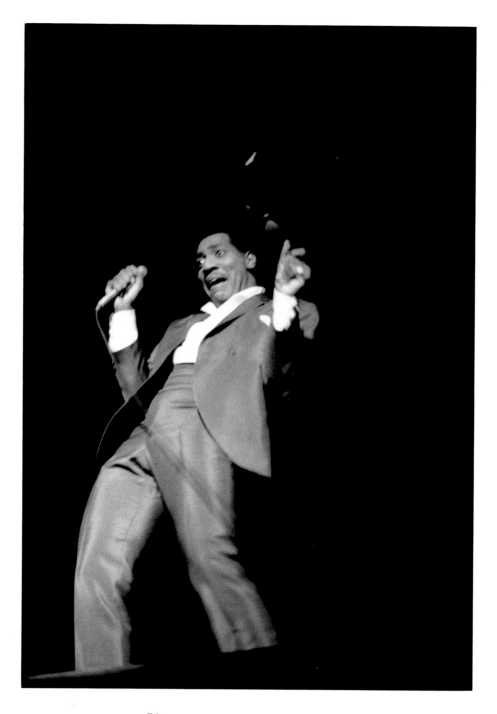

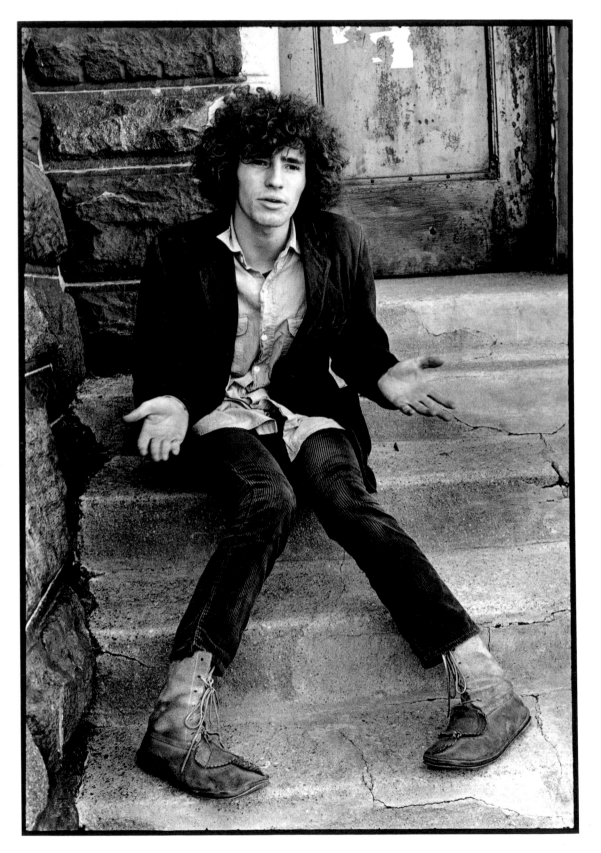

TIM BUCKLEY

Tim Buckley was a poet who played a twelve-string guitar. He was one of those artists who was well reviewed, and was admired by other artists for his unique vocal style, but who never was a commercial success. None of his albums ever made the top fifty. Nevertheless I loved his songs.

I met him in New York when he was nineteen years old. I took photos in Central Park where we would walk together and he would mess around climbing trees.

The picture on the left was taken near the water tower in Central Park and he was talking to me as I pointed my camera at him. I think it captures his personality perfectly because it shows his vulnerability.

A lot of musicians are easily destroyed because they are so innocent. Tim died in 1975 of an accidental drug overdose.

A friend of mine told me that Tim's son, who was born while he was in high school, has a copy of this photo hanging in his bedroom, and that it is his favorite image of his father.

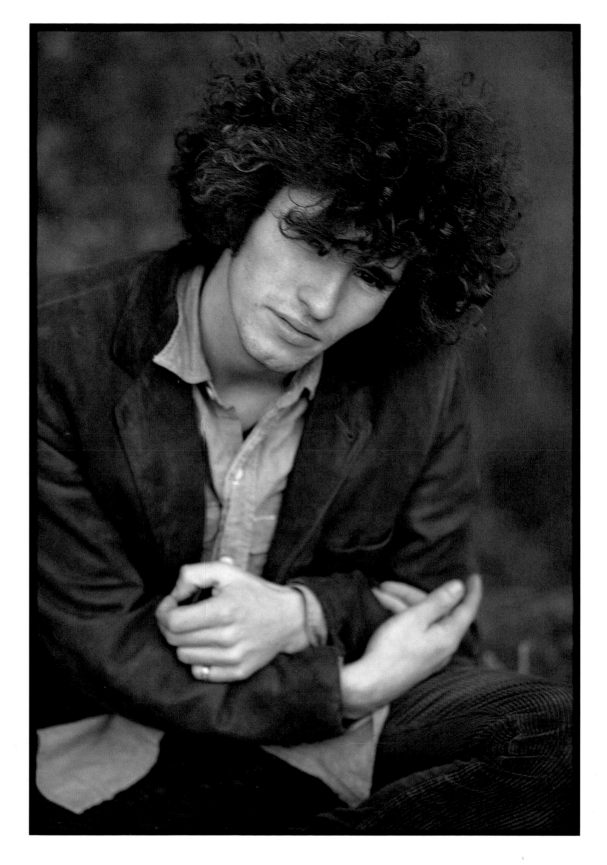

TIM BUCKLEY IN CENTRAL PARK

73

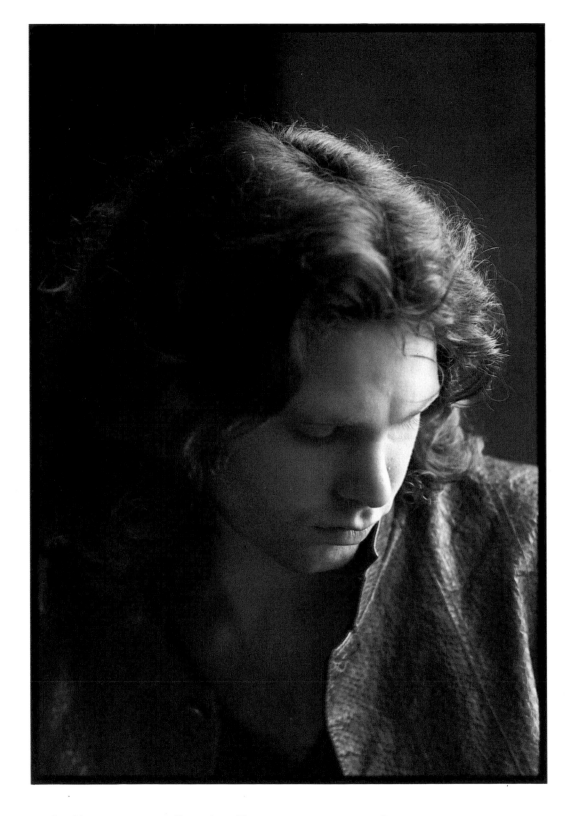

JIM MORRISON AT THE CLOISTERS. NATURAL LIGHT WAS USED. JIM WAS SITTING INSIDE THE

MUSEUM AND IT WAS POURING WITH RAIN OUTSIDE

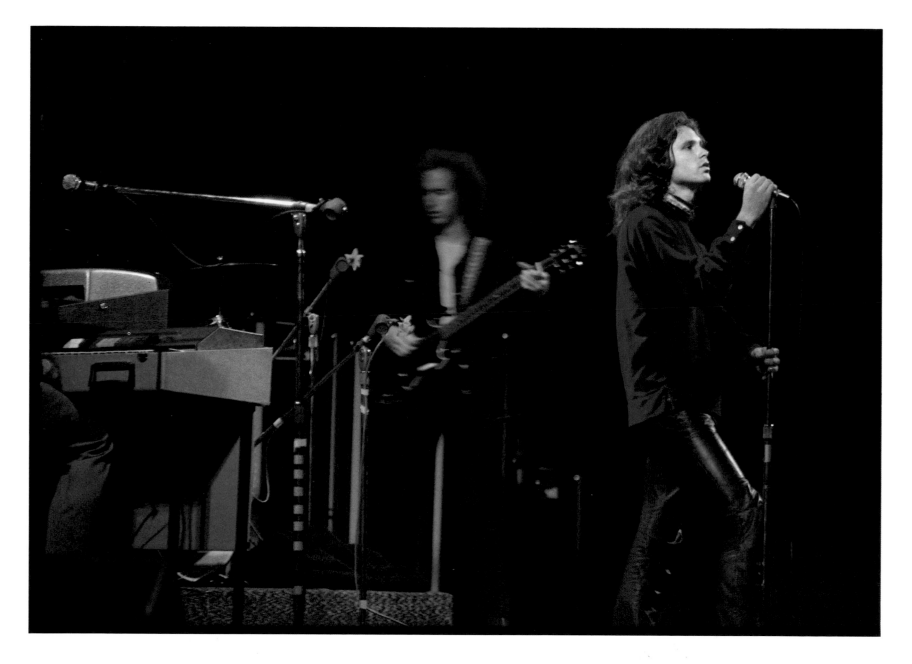

This picture of The Doors was taken at the Fillmore East in March 1968.

There were parents outside the auditorium that night looking for their runaway children

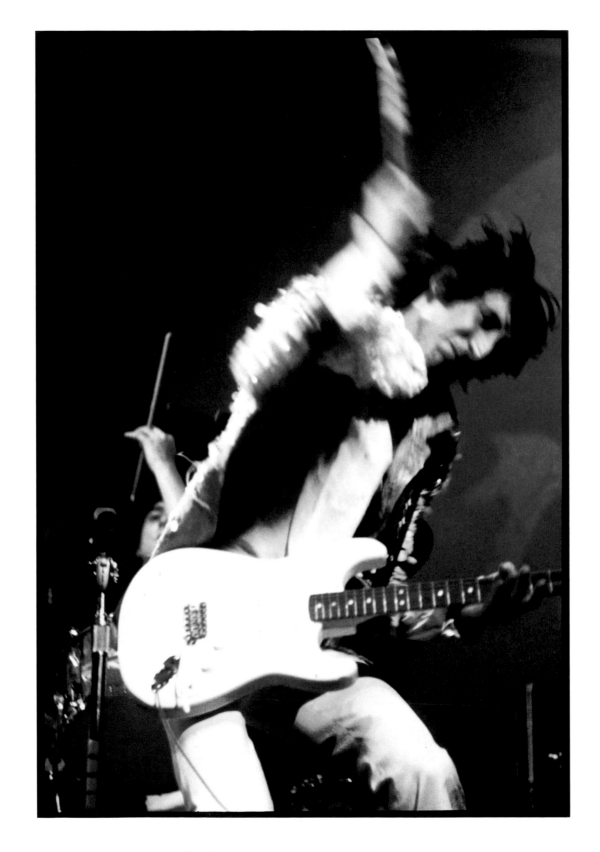

THE WHO PLAYED THE FILLMORE EAST A LOT.

THIS IS PETE TOWNSHEND JUST ABOUT TO SMASH A MICROPHONE STAND

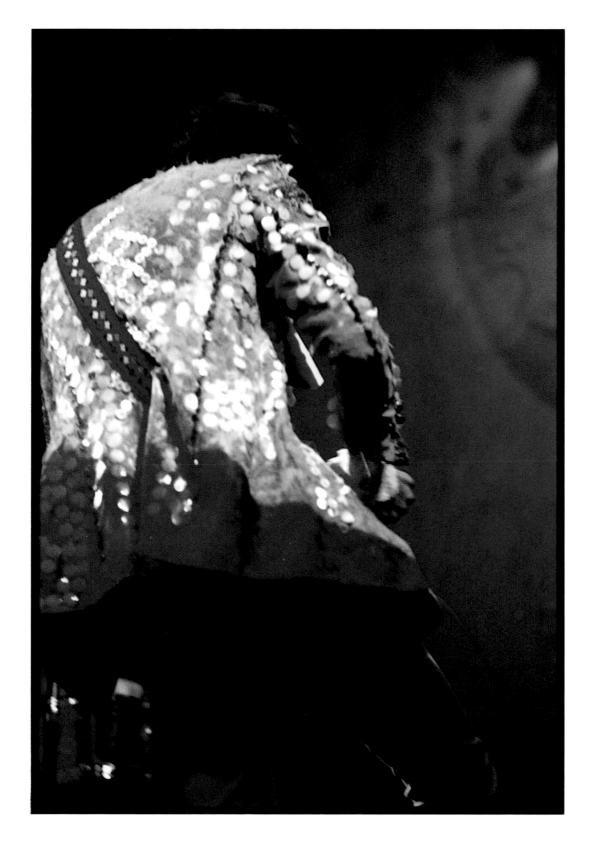

PETE TOWNSHEND WITH HIS BACK TO THE AUDIENCE WEARING HIS PEARLY KING JACKET. THE
JOSHUA LIGHT SHOW AT THE FILLMORE EAST WAS THE MOST MAGICAL THING YOU'LL EVER SEE

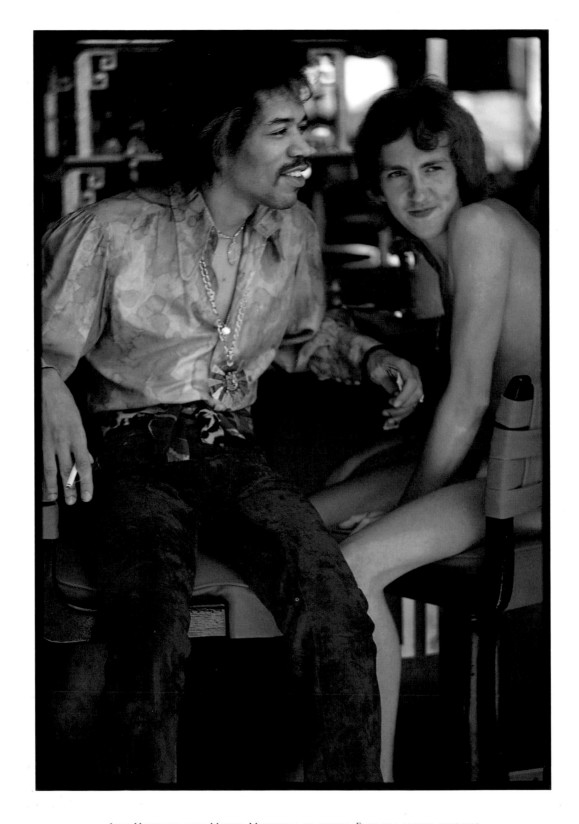

JIMI HENDRIX AND MITCH MITCHELL IN THEIR FLORIDA HOTEL DURING

THE MIAMI POP FESTIVAL IN MAY 1968. THE WEATHER WAS BEAUTIFUL AND THEY WERE

SITTING AT AN OUTDOOR BAR DURING THE AFTERNOON

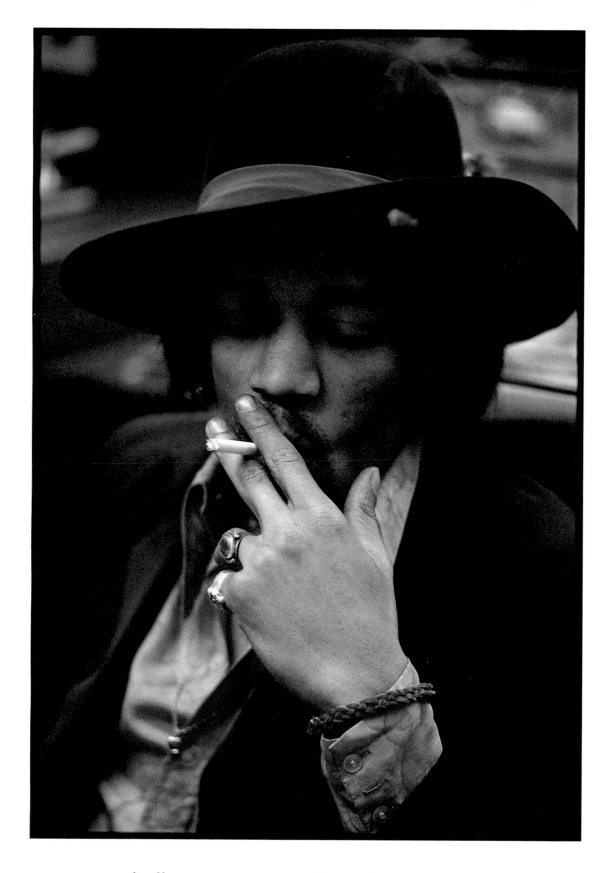

JIMI HENDRIX AT A SESSION AT THE RECORD PLANT IN NEW YORK

79

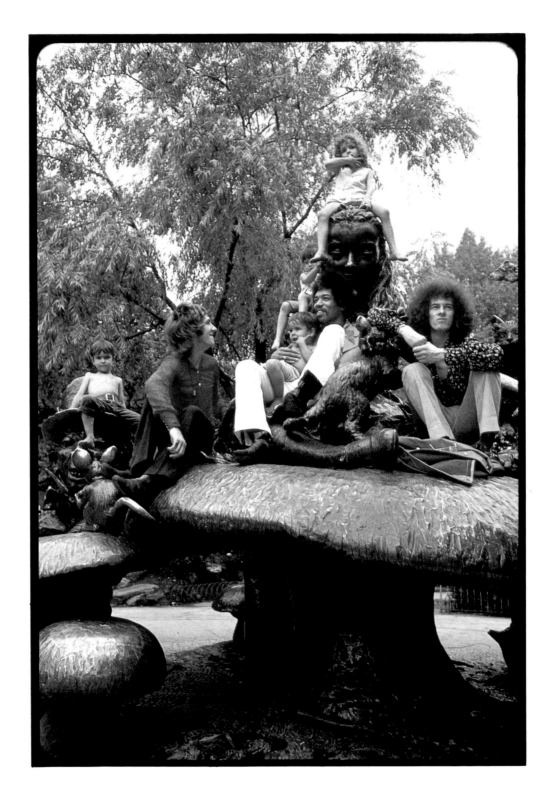

MITCH MITCHELL, JIMI HENDRIX AND NOEL REDDING IN CENTRAL PARK ON THE
ALICE IN WONDERLAND SCULPTURE. IT WAS TOO LATE FOR THE *ELECTRIC LADYLAND*
COVER BUT WE THOUGHT WE'D TAKE A PICTURE ANYWAY. THE CHILDREN HAD NO
IDEA WHO JIMI WAS AND WE JUST PICKED THEM AT RANDOM FROM THE PARK

DAVID CROSBY AT HOME IN LOS ANGELES. I TOOK IT IN THE BATHROOM

BECAUSE I LIKED THE STRONG YELLOWY LIGHT

THIS WAS TAKEN ON THE GRASS OUTSIDE THE BEVERLY HILLS HOTEL. TINY TIM ALWAYS WORE THIS PALE

MAKE UP AND THE GIRL WAS A MODEL FROM MY EDITORIAL SHOOT FOR *MADEMOISELLE*

ARLO GUTHRIE WITH TWO MODELS FROM *MADEMOISELLE* AND A BROKEN LEG. WE WERE
ON OUR WAY TO A PARK ON THE WEST SIDE OF MANHATTAN WHEN I SAW THIS BUILDING
BEING PAINTED WITH AMAZING COLORS SO WE STOPPED TO TAKE SOME SHOTS

JUDY COLLINS DRESSED UP FOR AN EDITORIAL FASHION SHOOT IN MALIBU UNDER THE

WHARF. SHE HAD THE MOST BEAUTIFUL EYES

MICHAEL J. POLLARD HAD BECOME A WELL-KNOWN ACTOR THROUGH *BONNIE AND CLYDE*. HERE

HE IS TRYING ON A JACKET HE'D GOT FROM THE APPLE BOUTIQUE IN LONDON WHEN THE BEATLES

CLOSED IT DOWN AND GAVE THE ENTIRE STOCK AWAY FOR FREE

DAVID CROSBY, STEPHEN STILLS AND GRAHAM NASH TOGETHER BEFORE THE

CAMERA FOR THE FIRST TIME, LONDON 1969

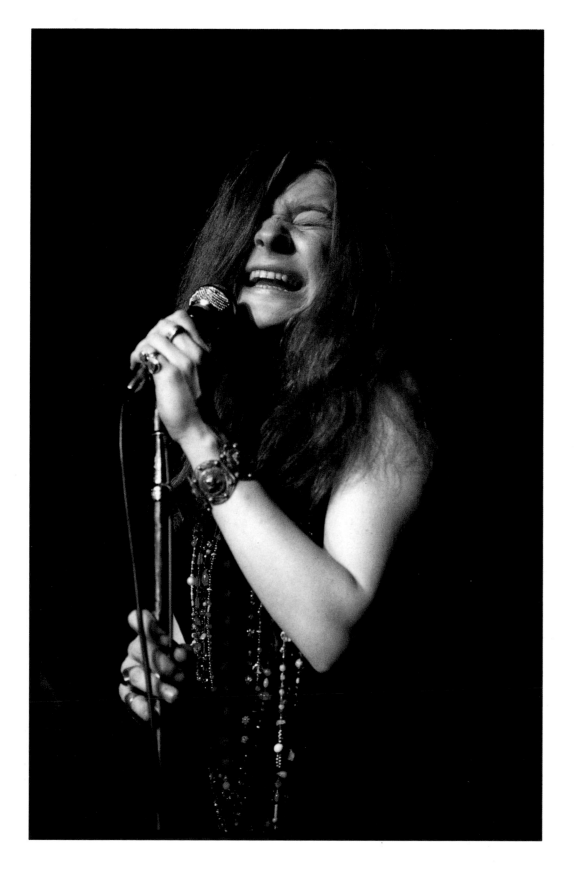

JANIS JOPLIN AT THE FILLMORE EAST SINGING "BALL AND CHAIN"

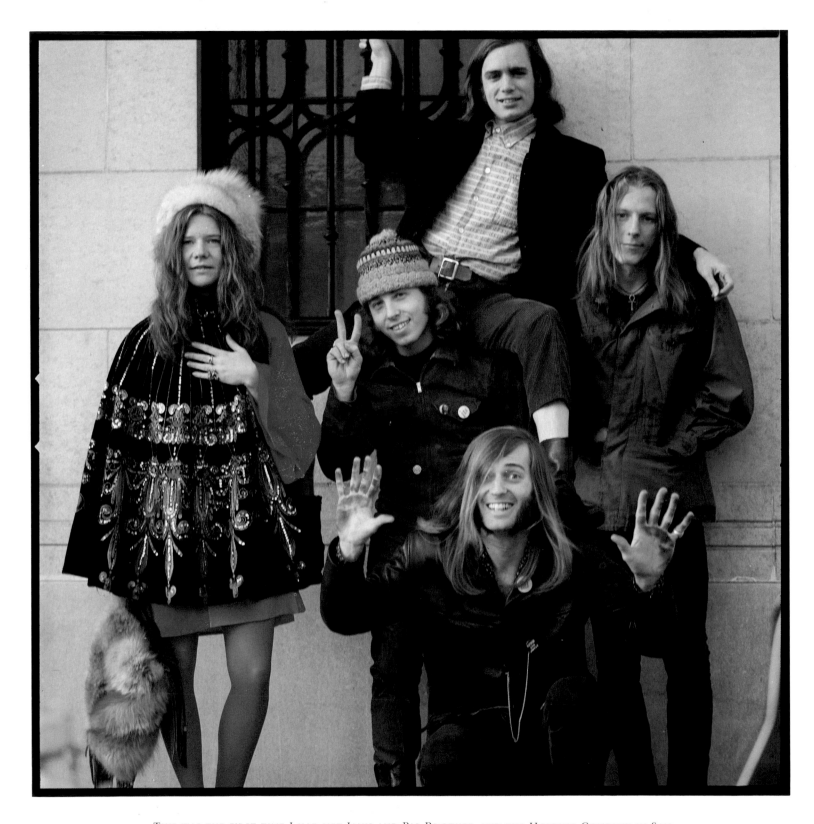

THIS WAS THE FIRST TIME I HAD MET JANIS AND BIG BROTHER AND THE HOLDING COMPANY IN SAN

FRANCISCO. THAT'S SAM ANDREW IN THE FRONT, JIM GURLEY TO THE RIGHT, DAVE GETZ FLASHING A

PEACE SIGN AND PETER ALBIN ON HIS SHOULDERS

WEST COAST

BIG BROTHER AND THE HOLDING COMPANY

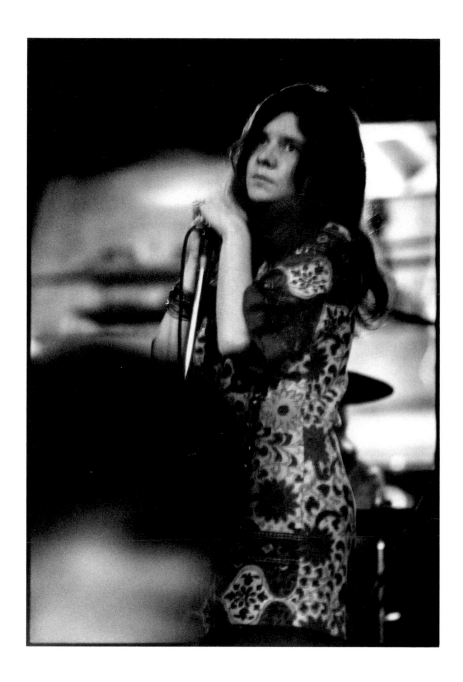

My first encounter with Big Brother was when Janis Joplin was their singer. I did pictures of them near their home in San Francisco doing crazy things in the street. That's where the shots of Janis with the cigarette and the fur hat were taken.

I really loved them as a group. Janis became the star, and therefore I started taking individual photos of her because I knew that's what the magazines wanted.

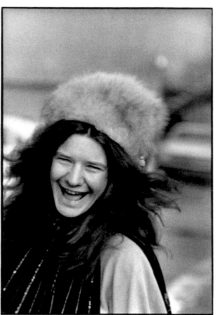

Janis and I became friends but we were never close. We were very different people; she was a pretty tough broad and I was a pretty sensitive broad. The chemistry wasn't there. I was much more friendly with the guys in the band – Sam Andrew, Dave Getz, Peter Albin and Jim Gurley. They had a great social life, whereas I felt that Janis had no real friends.

You could tell just by being around her that she felt insecure. She didn't think she was attractive, and after gigs the boys were always going off with girls and she was left alone. I felt sorry for her. She would probably have liked a man to take her out to dinner.

When I was asked by *Mademoiselle* to take a picture of Big Brother and the Holding Company together with a model, Janis wouldn't do it. She didn't want to be photographed next to a model because she thought it would accentuate her plainness. In order to boost her confidence she would drink a lot before she went

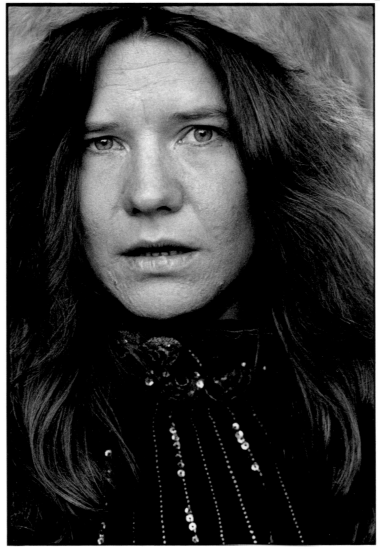

90

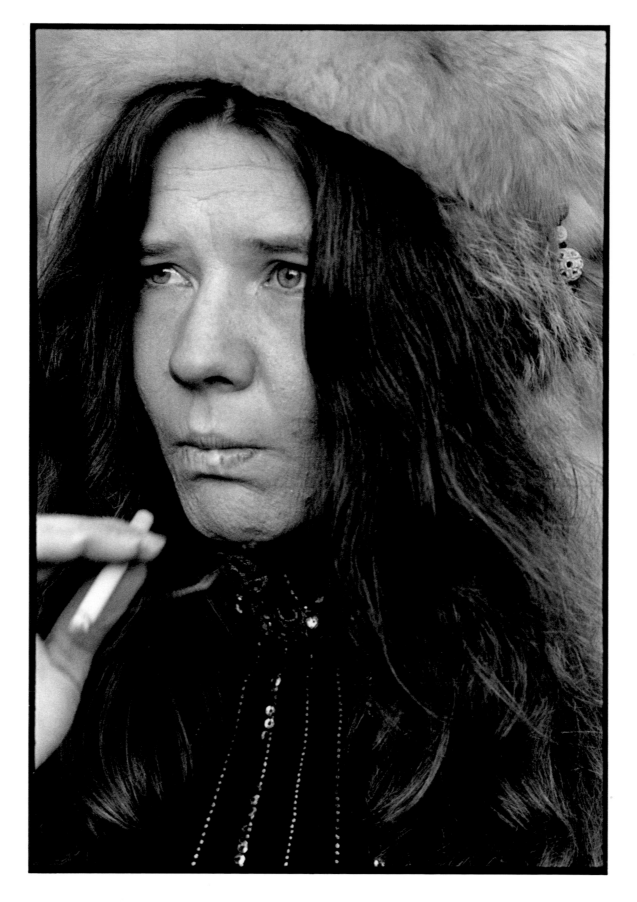

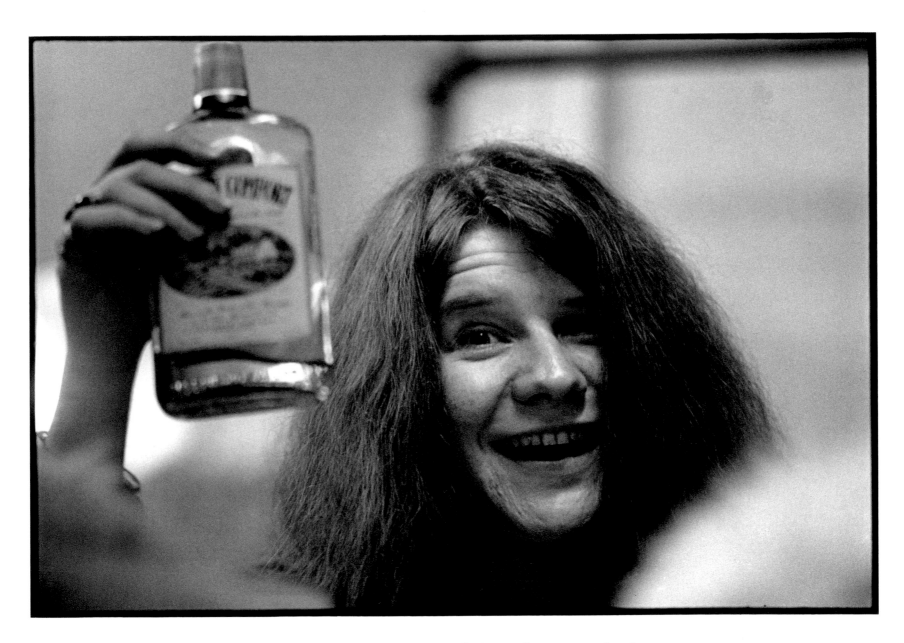

JANIS JOPLIN DISPLAYING A SOON TO BE EMPTIED BOTTLE OF SOUTHERN COMFORT IN A LOS ANGELES DRESSING ROOM

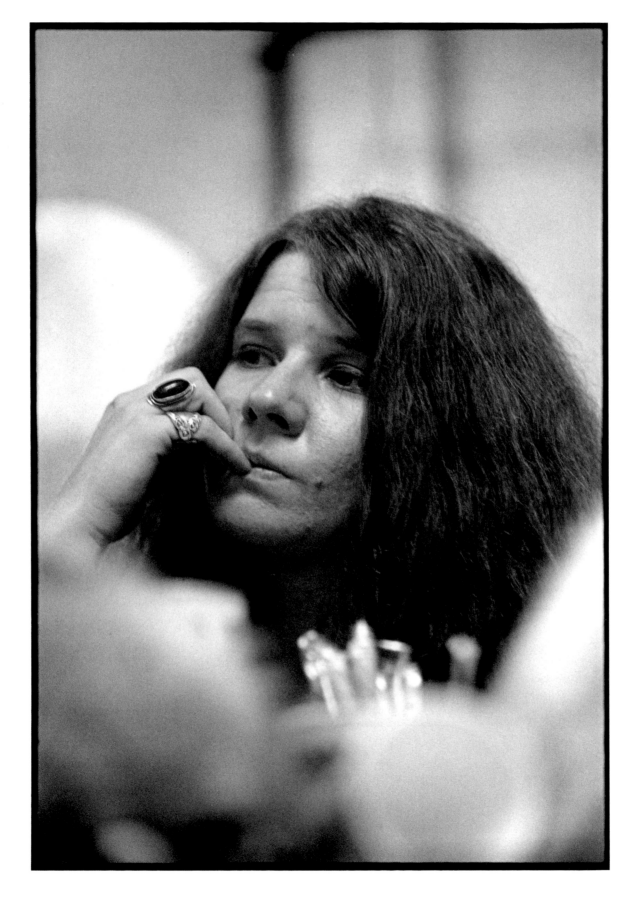

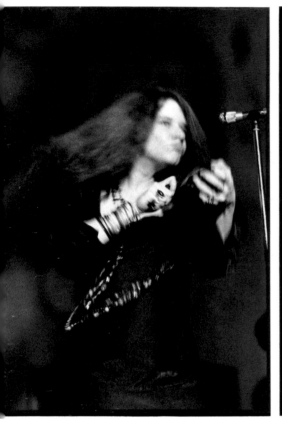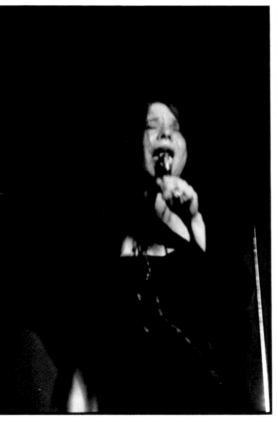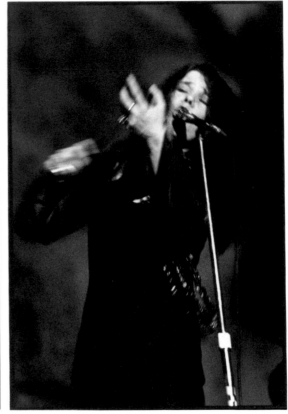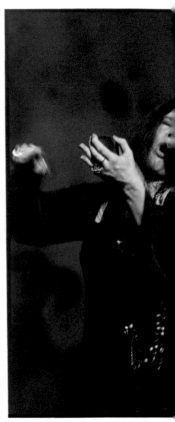

on stage. I took one photograph of her brandishing a bottle of Southern Comfort in Los Angeles, and I remember she drank it all before she did the concert.

When she got on stage she became an incredible blues belter. She would stomp all over the place and put a lot of Texas energy into it. She desperately wanted to please the crowd and their approval gave her the confidence that didn't come to her naturally.

It was as if the whole band had suddenly found themselves on the up escalator. Everything was happening for them without them fully realizing why. But as soon as Janis was off-stage the energy level dropped. She needed people around her to give her praise. You can see in her face the tensions she was experiencing.

But feeling insecure didn't make her demure. She was a real Texan girl with coarse language who made no attempt at being glamorous. When we first met she was into LSD, but after a while I could tell she was also taking heroin because her skin was starting to get terrible. People change when they start taking heroin.

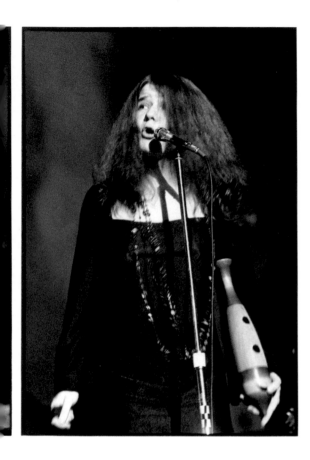

JANIS JOPLIN IN CONCERT WITH BIG BROTHER
AND THE HOLDING COMPANY AT THE
FILLMORE EAST IN 1967

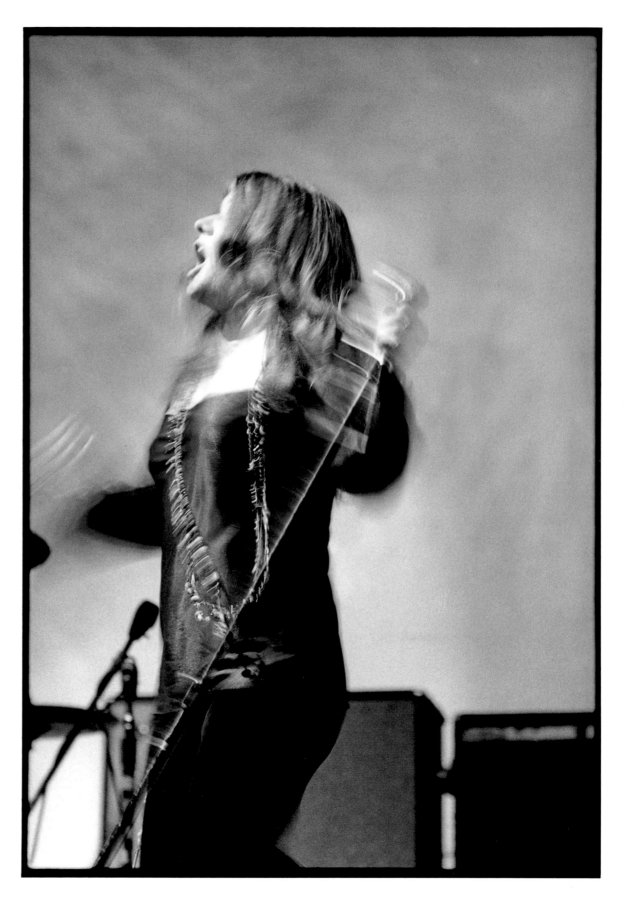

COUNTRY JOE AND THE FISH

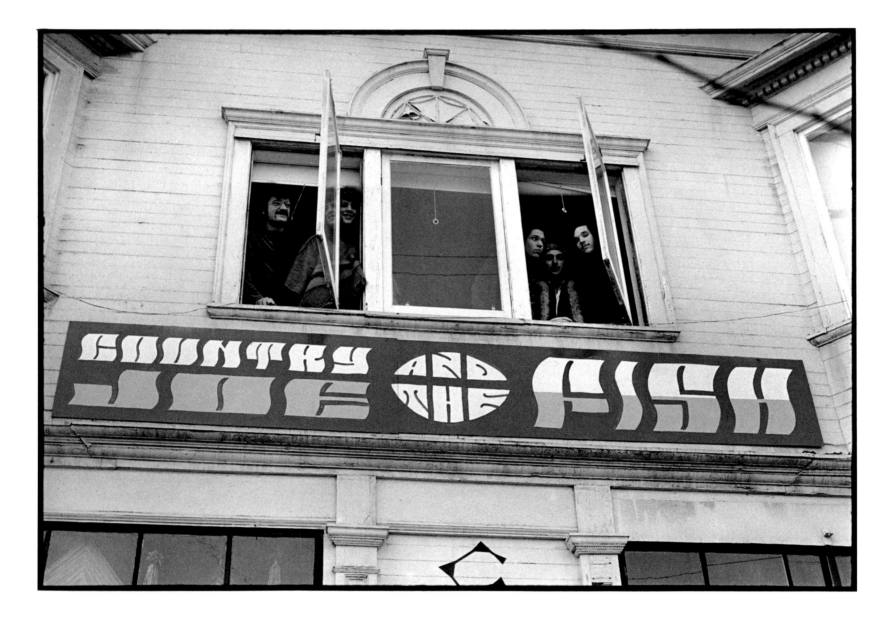

COUNTRY JOE McDONALD AND THE FISH LOOKING DOWN OUT OF THE WINDOWS OF THEIR SAN FRANCISCO OFFICE

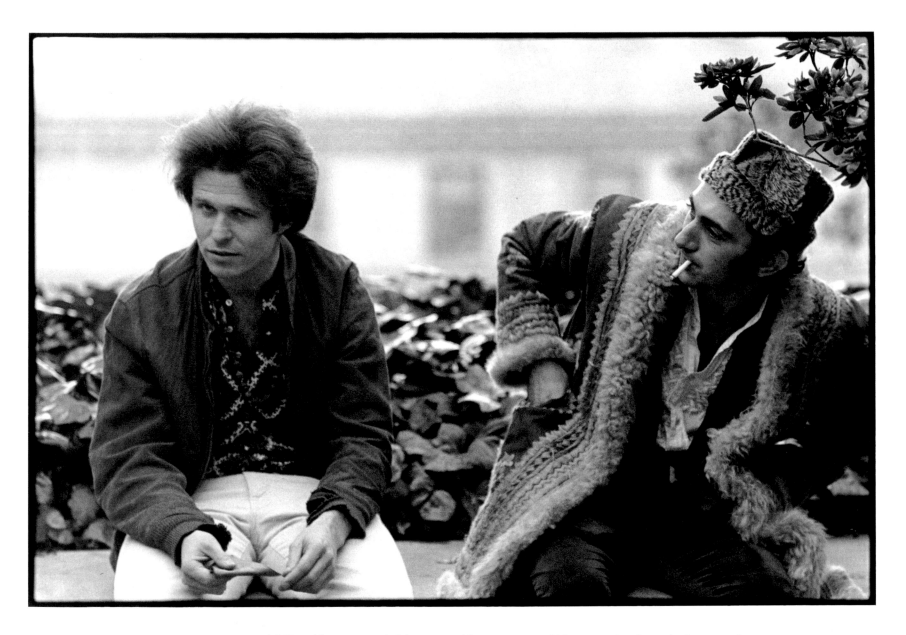

Joe McDonald was a very bright man and he formed Country Joe and the Fish with guitarist Barry Melton. They were part of the West Coast psychedelic scene, but their lyrics were more socially conscious than most. A lot of people knew them from their anti-Vietnam war song "I Feel Like I'm Fixin' To Die."

When they came to the Fillmore East they would have movies about the horrors of war projected on a screen behind them while they were playing.

They were serious about the causes they believed in, but great fun. I went to San Francisco and took pictures of them hanging out of the windows of their office, and at a local amphitheater where I shot a stills sequence.

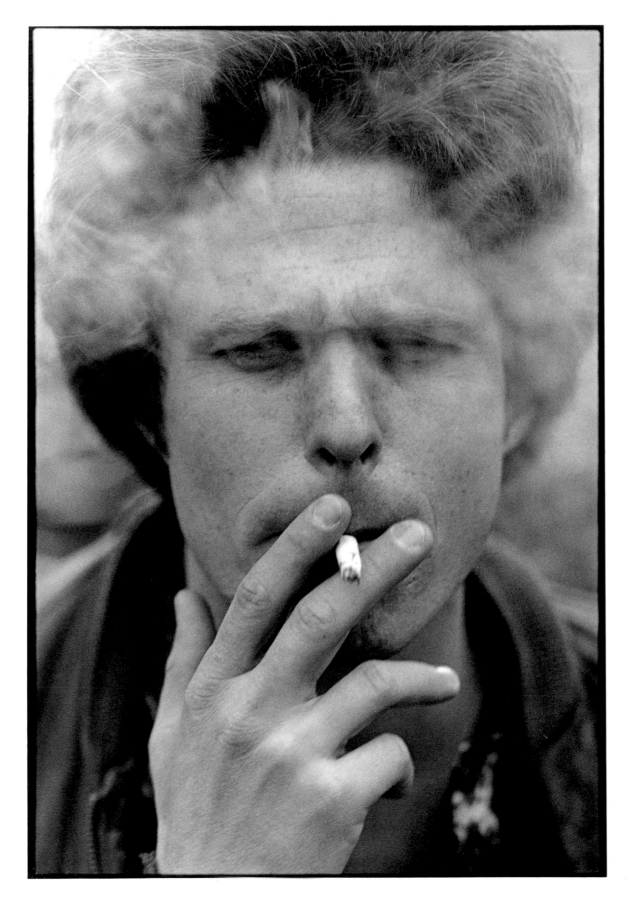

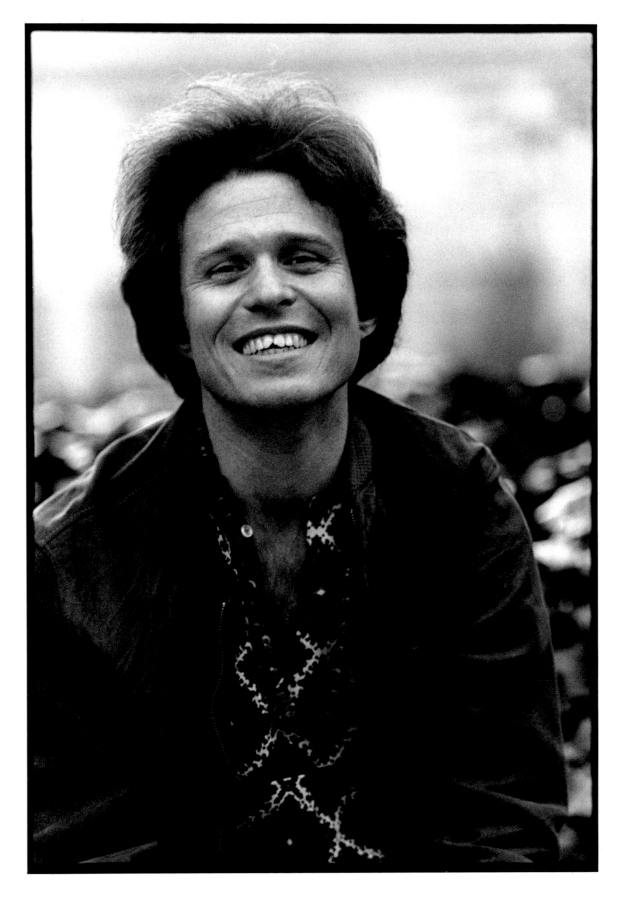

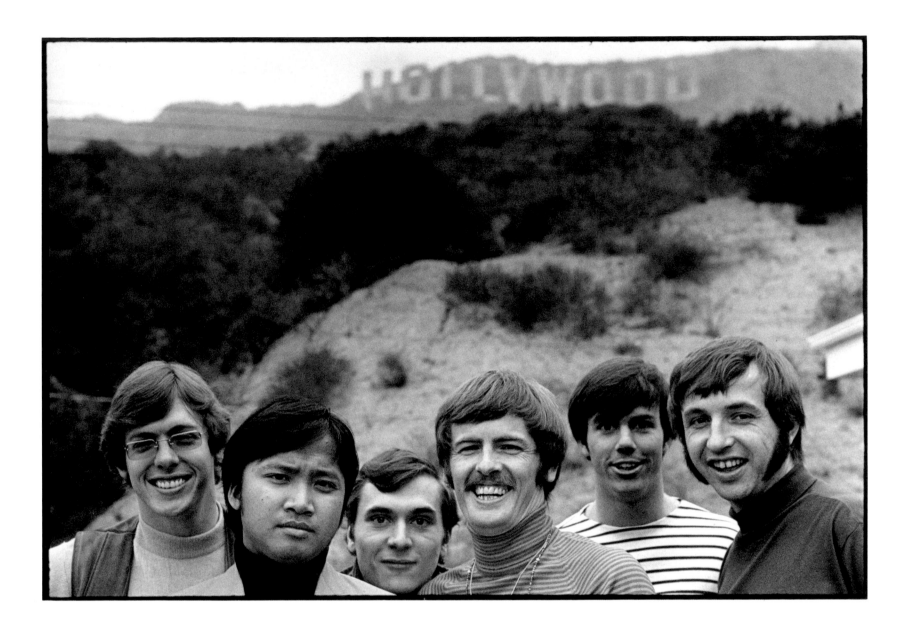

THE ASSOCIATION

Unlike most other Californian bands, The Association were very straight, very clean. They weren't exactly like The Beach Boys but they had the same pure harmonies, and in 1967 they were really happening with singles like "Windy" and "Never My Love."

The first time I photographed them was in Los Angeles at a house one of them owned. It was quite near the Hollywood sign, and so I used it as background in some of the pictures.

The last time I worked with them was in New York, when they were staying at the Warwick Hotel. I had them play around in bathtubs and showers because the bathroom happened to have the best available light.

I wonder where they are today?

THE YOUNGBLOODS

Although they came from New York and had enjoyed a huge local hit with Dino Valenti's "Get Together," when I photographed The Youngbloods they were living in Marin County. I went to see them at a gig in San Francisco and then we drove out to beautiful Marin County where we took the photos. There were huge fungi growing around, and I remember we were breaking pieces off and carving faces in them.

NICO

NICO WITH DANNY FIELDS, MY JOURNALIST FRIEND WHO TURNED ME ON TO SO MANY NEW ACTS

I didn't really get to know Nico well but I thought she had a great face and I liked photographing her.

Although I had seen her singing with The Velvet Underground I had never taken pictures. These photos were taken when she was meeting with David Anderle who was then head of Elektra's office in Los Angeles.

I remember that David asked me if he could have some prints of my photos to hang in his office. I gave him a few including some of Brian Wilson of the Beach Boys.

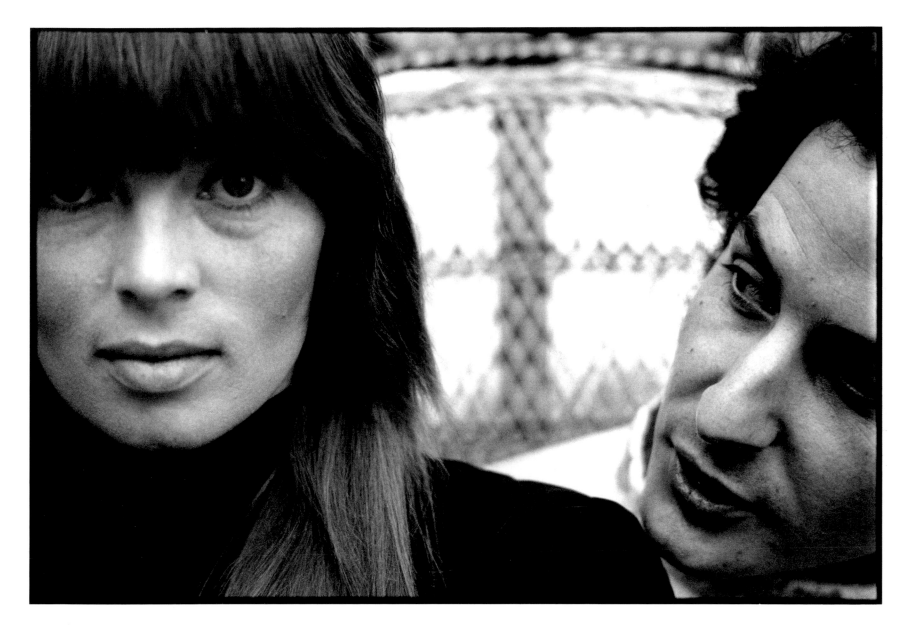

NICO WITH DAVID ANDERLE, ELEKTRA RECORDS' MAIN MAN IN LOS ANGELES

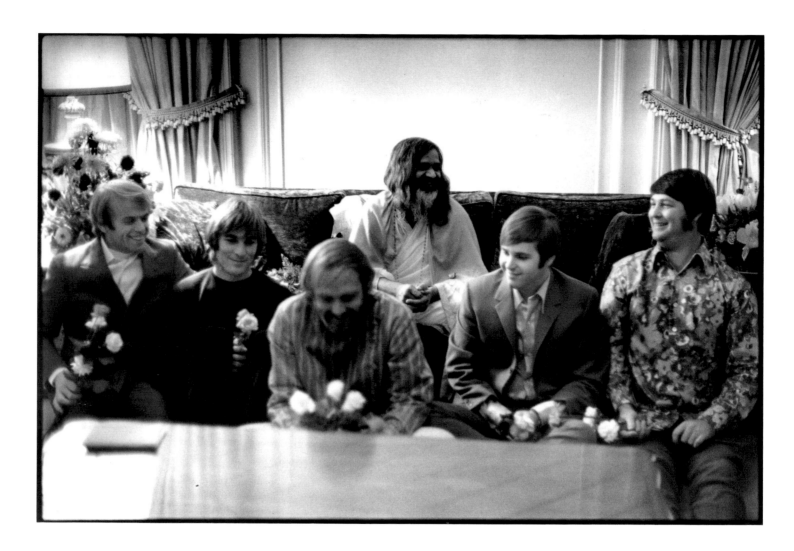

THE BEACH BOYS

I suppose the Beach Boys were the first group I ever met. They played one night at a fraternity house when I was at the University of Arizona, and were put up in the apartment next to mine. All I remember is the fact that they seemed to ooze Southern California.

The next time I saw them, I was a photographer and working on a book project. I went out to Los Angeles and we all met up at Brian Wilson's house. I couldn't believe the number of delicatessen refrigerators that Brian

had around. He obviously liked his food.

Pet Sounds was the first Beach Boys album I bought and it has remained a favorite ever since.

I later met them in New York in January 1968, when I had to take some pictures of them with the Maharishi Mahesh Yogi, who was holding court at the Plaza and giving lectures to local doctors and psychiatrists. The Maharishi was an opening act on their tour that year.

I remember that it was on the same day in 1968 that I was going to hear Bob Dylan at

Carnegie Hall. I told the Maharishi that it was going to be a wonderful concert and that he should go. He said, "I don't go to see people. People come to see me."

I don't think Dennis Wilson was too involved in the whole Transcendental Meditation thing. He was the best-looking guy in the group and was really into fun. He was the only one at the Plaza who lit up a joint. When you were with the Maharishi, you weren't supposed to do things like that.

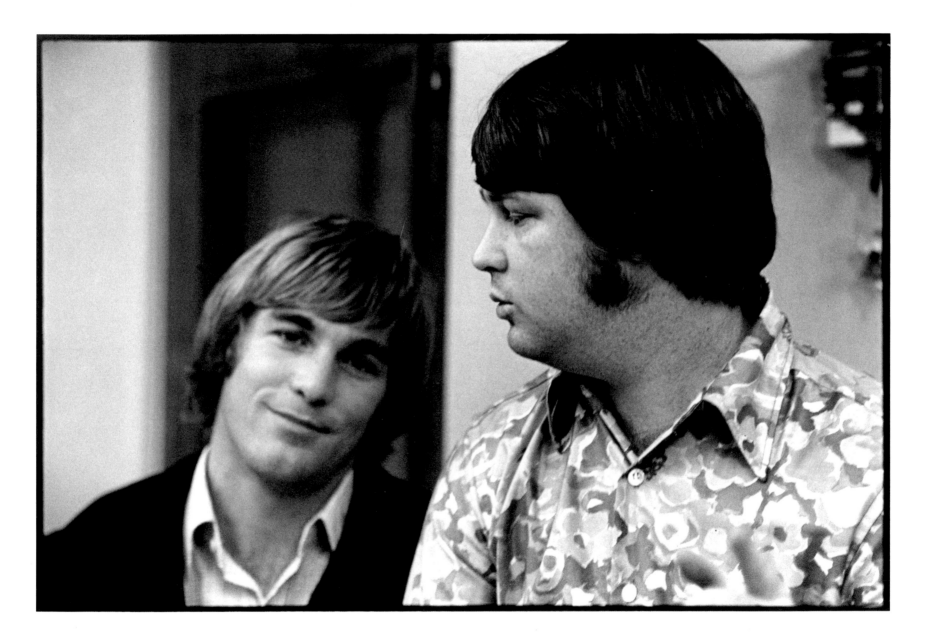

BEACH BOY BROTHERS DENNIS AND BRIAN WILSON SITTING ON A KITCHEN COUNTER AT BRIAN'S HOUSE

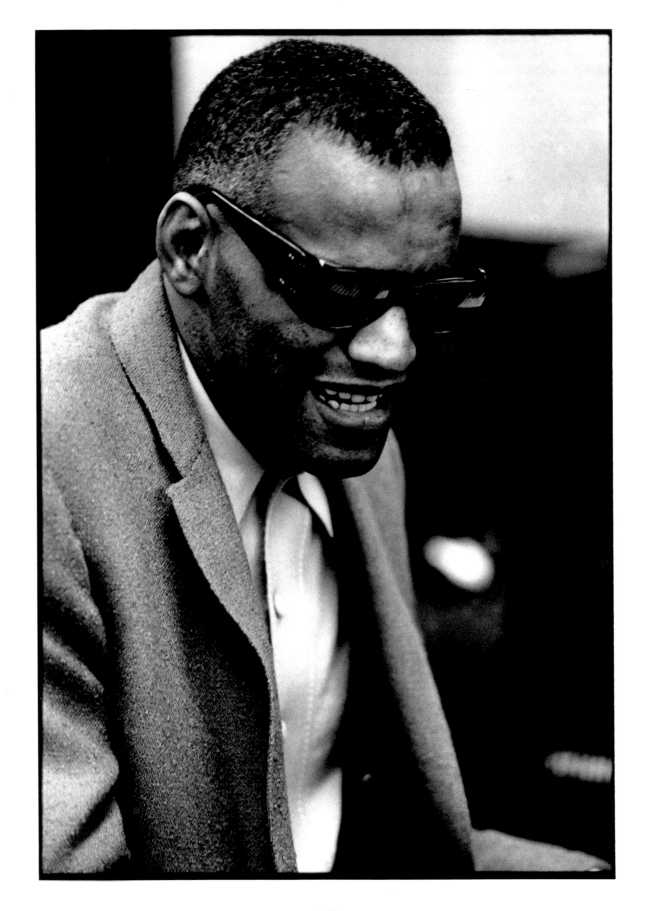

RAY CHARLES

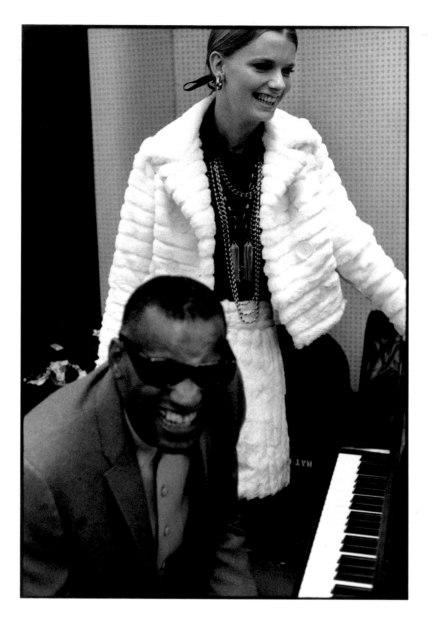

Mademoiselle magazine wanted to do a spread on "models and musicians," where I would do a fashion shoot with musicians in the same picture as the girls. I did them with people like Tiny Tim, Jefferson Airplane, the Jimi Hendrix Experience and Arlo Guthrie.

Ray Charles was one of my heroes from the Fifties. I had seen him play at Yale University when I was a teenager, and I used to take his *What'd I Say* album to different cocktail parties and stick it on the sound system.

I met him at his office in Los Angeles and he sat at his piano and played along, while the model stood next to him and I started taking photos.

When I knew I had got enough of Ray and the model for the editorial, I put on my 135mm lens. Although they thought I was still taking the same picture, I was actually just taking Ray playing and singing – the model was no longer in the frame.

Those pictures I just took for myself. I did that a lot during those "models and musicians" shoots. I came for the work and then I got the pleasure.

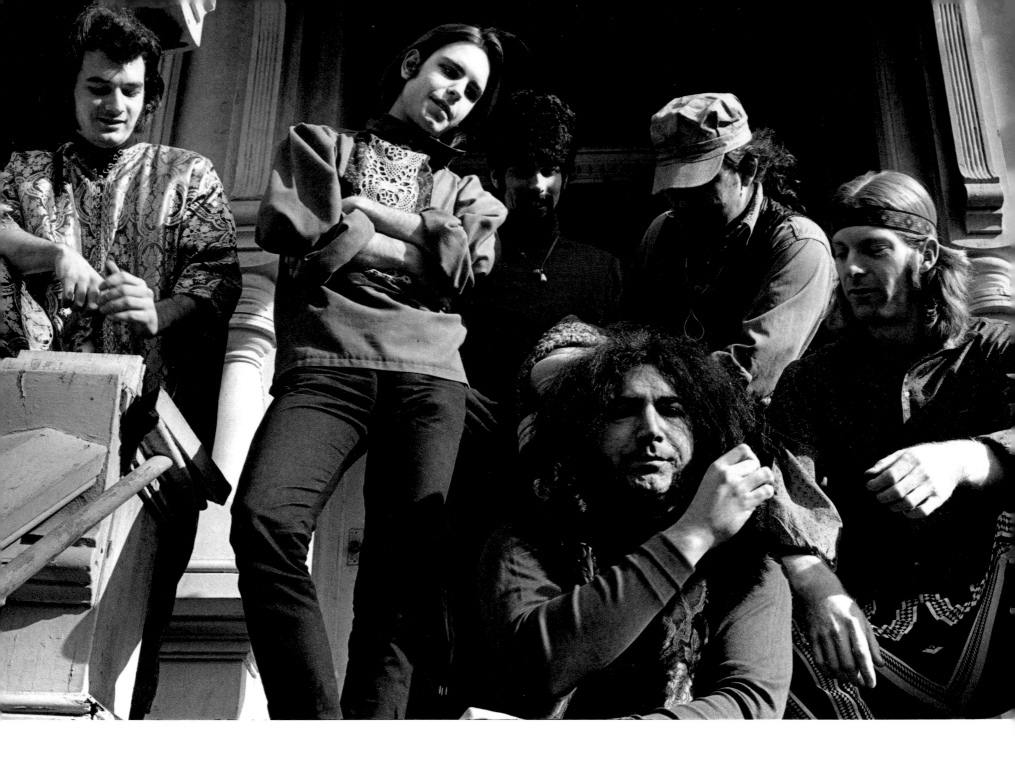

THE GRATEFUL DEAD

The Grateful Dead lived in a huge Victorian house at 710 Ashbury Street, right in the heart of Haight Ashbury. It was a bit sloppy, with posters and flags hanging everywhere inside and people hanging around waiting for something to happen, but this was their office as well as their home, and a lot of people thought it was the spiritual center of all that was happening in San Francisco.

This was the time of giant rock festivals in Golden Gate Park, of light shows, underground newspapers, communes and shops openly selling drug paraphernalia. Some of the first clinical experiments with LSD in America had happened in California where it wasn't made an illegal drug until October 1966, and so I think it was no accident that the first psychedelic rock emerged from San Francisco.

When I started taking photos of The Grateful Dead they were all a bit stiff. I needed a group shot for *Rock And Other Four Letter Words*, so I got them to stand outside the front door. Then, in order to get some movement, I told them to come towards me down the steps. That got them all going. It ended with them all tumbling and laughing, which was exactly the sort of loose feeling I wanted to create.

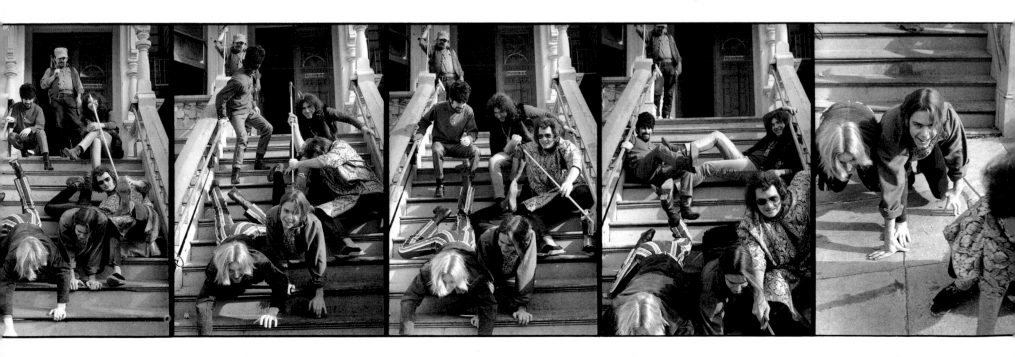

Bob Weir shaking his hair loose at
the Grateful Dead headquarters in
Haight Ashbury

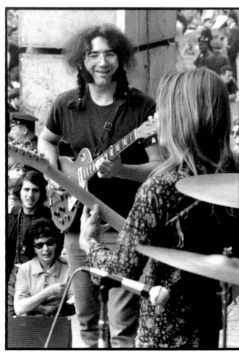

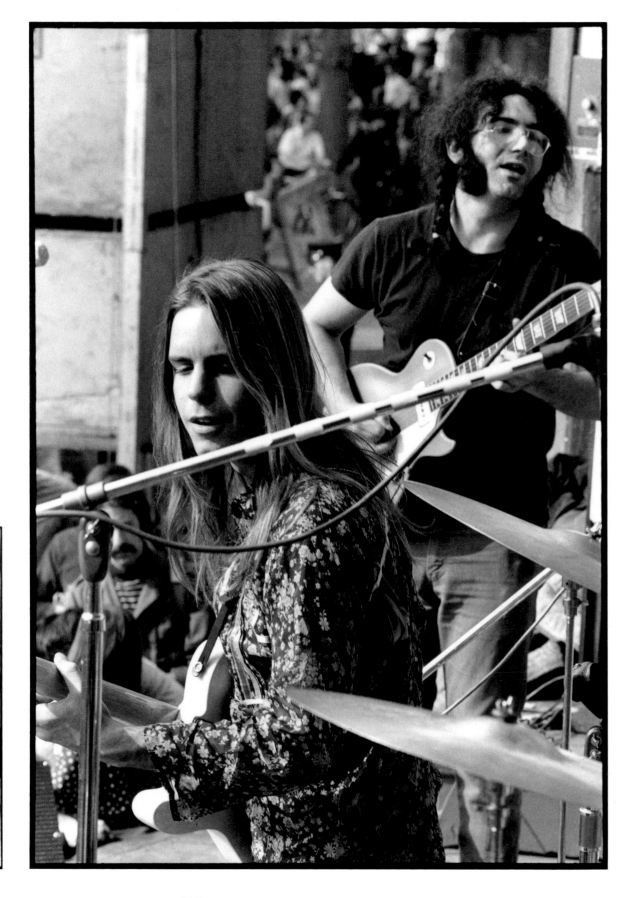

115

After that we went round the back of the house where there was a fire escape and I took a series of pictures of them opening the door and climbing down the fire escape. I seem to remember they were throwing firecrackers at the time and generally acting like children.

At the end of this sequence I took Bob Weir aside. He had a band holding his hair back and I asked him to pull it out and shake his hair loose while I shot another sequence. The large picture of Bob is the last of this sequence.

This was all at a time when young people were becoming fed up with middle-class values. They were no longer content just to go to school, get good grades, be greedy and win. They were tired of right-wing oppression from their parents and of the American government's involvement in Vietnam. They wanted peace and kindness in the world.

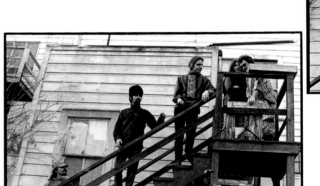

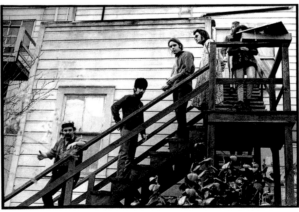

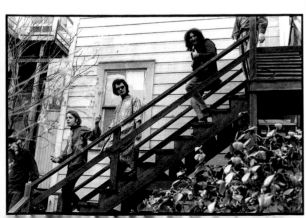

Many kids dropped out, left home and tried alternative ways of living. San Francisco had a long history of tolerating liberal lifestyles and it became a magnet to these young people.

Haight Ashbury was originally a low-rent area of the city where students looked for accommodation, but by 1966 it became known as the hippy enclave. When I went there to see The Grateful Dead it was already in decline. Lots of kids had heard about "flower power" and had run away from home thinking it would all be love and innocence, but the business people had already got in and turned hippydom into a fashion. Local bus companies were organizing "Hippy Hops" for tourists, and the media had descended in droves.

By the late Sixties most of the key people had moved away. The Grateful Dead settled down in Marin County.

JEFFERSON AIRPLANE

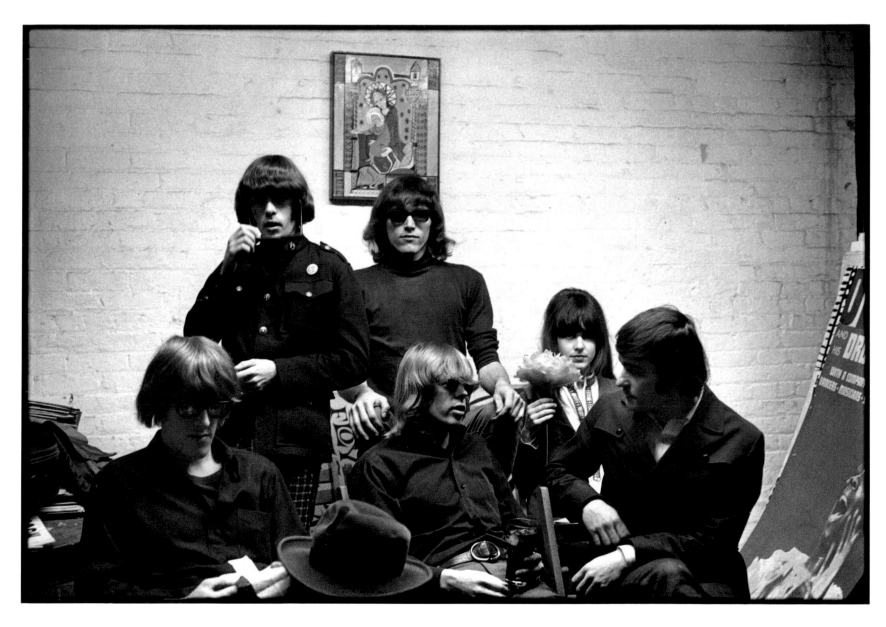

The Jefferson Airplane were second only to The Grateful Dead in the San Francisco of the late Sixties. They lived in a colonial-style house overlooking Golden Gate Park, which had huge white columns and became known as the Airplane Mansion. Their music had the sprawling quality associated with inspiration created by psychedelic drugs but they also wrote catchy songs like "Somebody To Love" and "White Rabbit" which became pop hits.

When I first met them they were being managed by impressario Bill Graham, who had just bought another San Francisco venue called Winterland, and it was here that I photographed them during an afternoon rehearsal. This is where I got the shot of Grace Slick fooling around on Spencer Dryden's drum kit. She was going out with Spencer at the time.

I photographed bass player Jack Casady and guitarist Marty Balin at Central Park when they were on with The Grateful Dead, and then the whole group backstage at the Café Au Go Go.

The Airplane typified the feeling of freedom that was in the air at the time. Because they were musicians, this meant that they were excused the rituals of a nine-to-five existence.

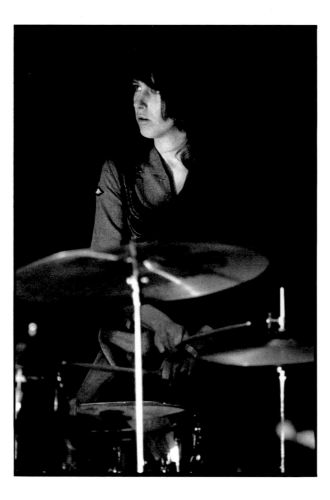

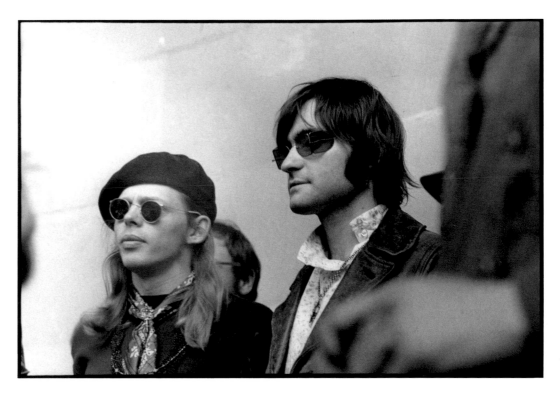

BELOW: JACK CASADY (LEFT) AND MARTY BALIN (RIGHT) WATCHING THE GRATEFUL DEAD IN CENTRAL PARK

ARETHA FRANKLIN

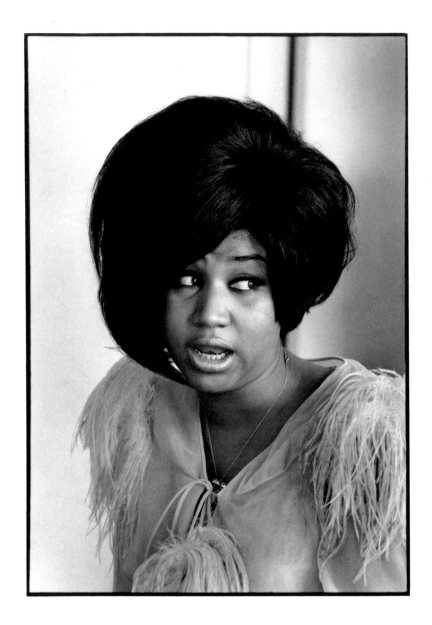

For the *Mademoiselle* fashion spread Aretha was wearing a wig and had a fancy dress on, but when I met her earlier in her hotel room she had looked completely different. With the other magazine editors I sat with her as she got ready, and she began to unburden herself. She told us that her husband – who was also her manager – was giving her a hard time and she was very depressed. She was having to pay her band out of money she kept in a brown envelope. You could really feel the strain she was under, and she was in tears as she talked to us.

A lot of black musicians were being forced to earn their living in the white world and were having to "whiten up" to do so. I think Aretha was later able to come to terms with her Afro-American identity as the Civil Rights movement changed things towards the end of the Sixties.

Somehow or other she managed to pull herself together for the photos. She fixed the wig, put on a brave face, and by the time we got outside to do the pictures we were no longer discussing her problems.

She has come a long way since then.

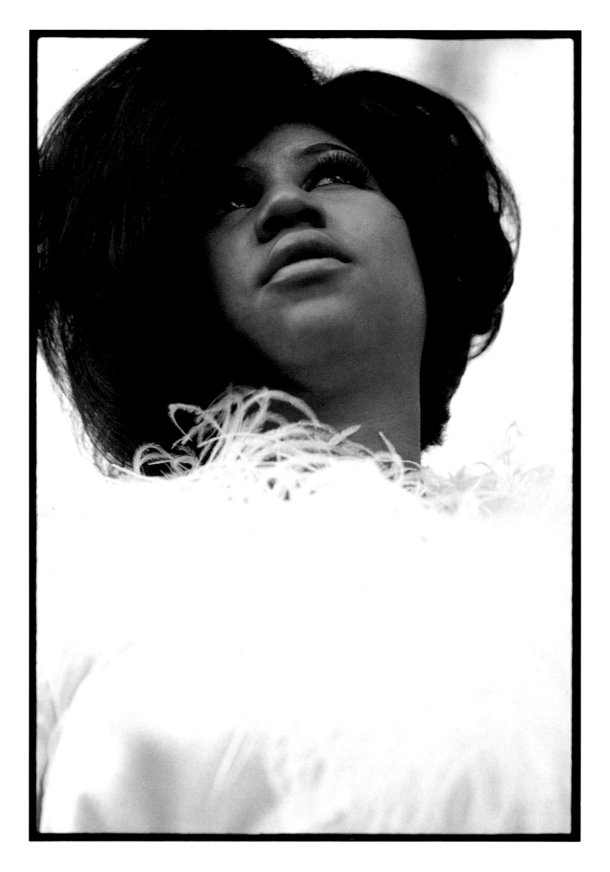

ARETHA FRANKLIN MODELLING FOR *MADEMOISELLE* IN LOS ANGELES

NICO IN THE GARDEN OF ELEKTRA RECORDS IN LOS ANGELES

A WEEK AFTER OUR DAUGHTER MARY WAS BORN IN AUGUST 1969 TWIGGY CAME OVER TO

SEE HER AND I TOOK THIS PICTURE IN THE GLASS HOUSE AT THE BOTTOM OF OUR GARDEN

GRACE SLICK AND JEFFERSON AIRPLANE'S DRUMMER SPENCER DRYDEN WHO SHE WAS GOING

OUT WITH AT THE TIME. THIS WAS TAKEN ON A BALCONY OF THE GROUP'S HOME WHICH

OVERLOOKED GOLDEN GATE PARK

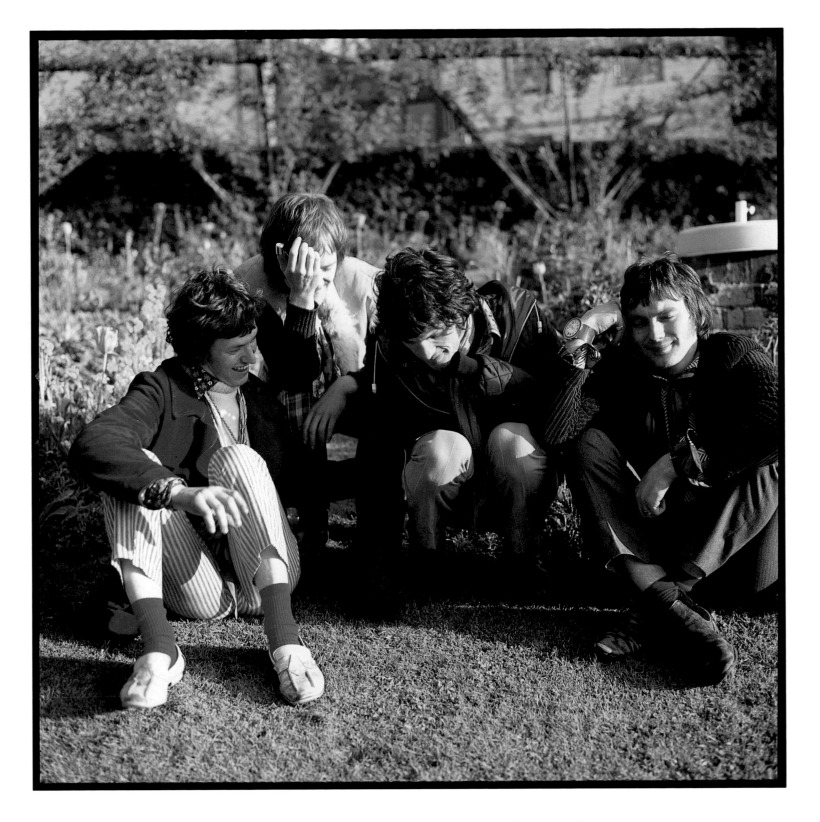

STEVIE WINWOOD, DAVE MASON, JIM CAPALDI AND CHRIS WOOD IN BERKSHIRE, ENGLAND WHERE

THE POPPIES GROW SO PRETTY

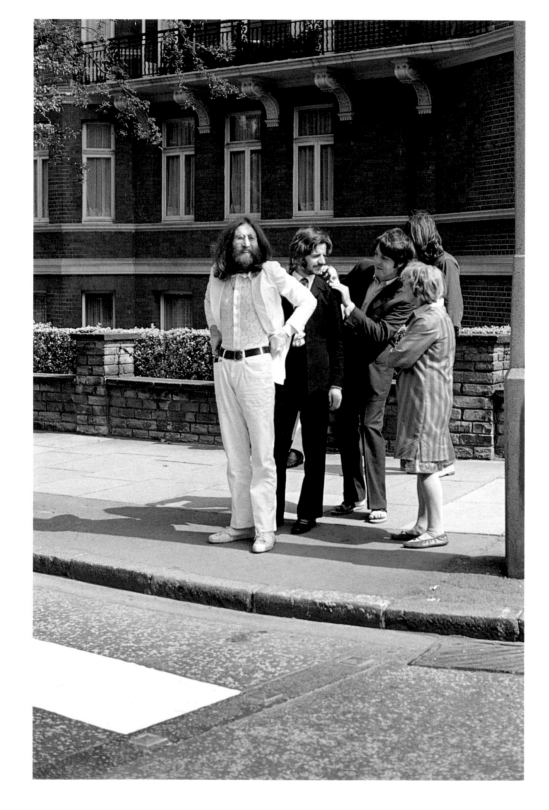

Iain Macmillan was taking the cover photo for the Abbey Road album

and I was Paul's girlfriend taking pictures for my own use

126

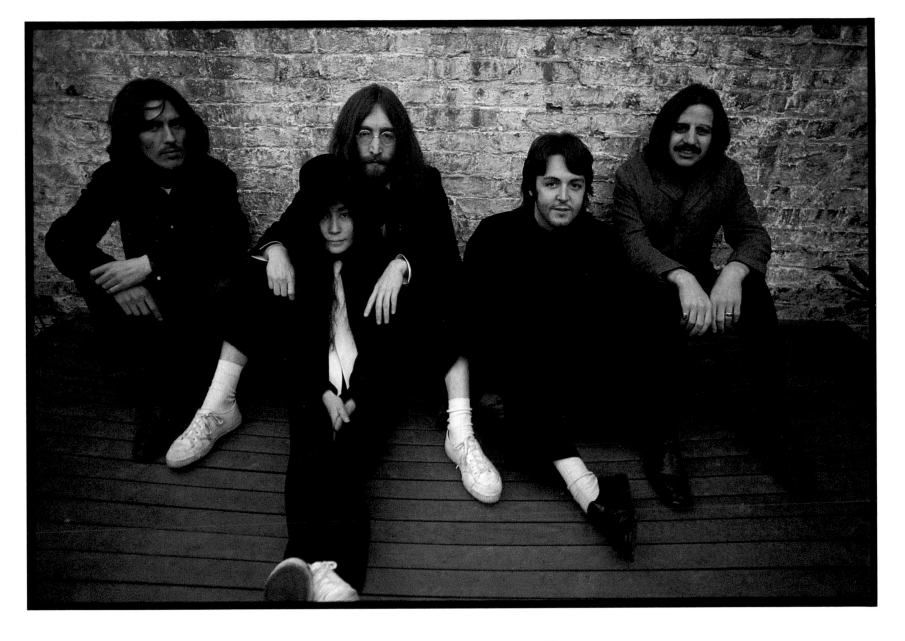

ONLY JOHN AND PAUL PLAYED ON *THE BALLAD OF JOHN AND YOKO* BUT THEY NEEDED A

GROUP SHOT FOR A SLEEVE TO GO WITH THE SINGLE WHICH HAD GEORGE'S SONG

"OLD BROWN SHOE" ON THE B SIDE. PAUL ASKED ME TO TAKE IT

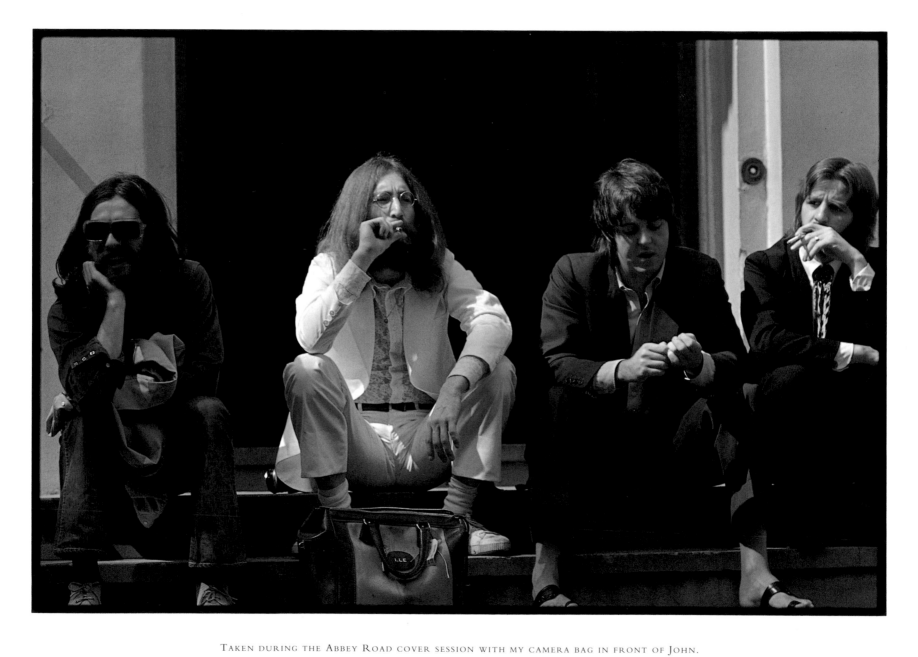

TAKEN DURING THE ABBEY ROAD COVER SESSION WITH MY CAMERA BAG IN FRONT OF JOHN.

I CALL THIS PHOTO "THE FOUR STRANGERS." THE MUSIC WAS STILL WONDERFUL

BUT THE PRESSURE OF BUSINESS HAD TAKEN OVER

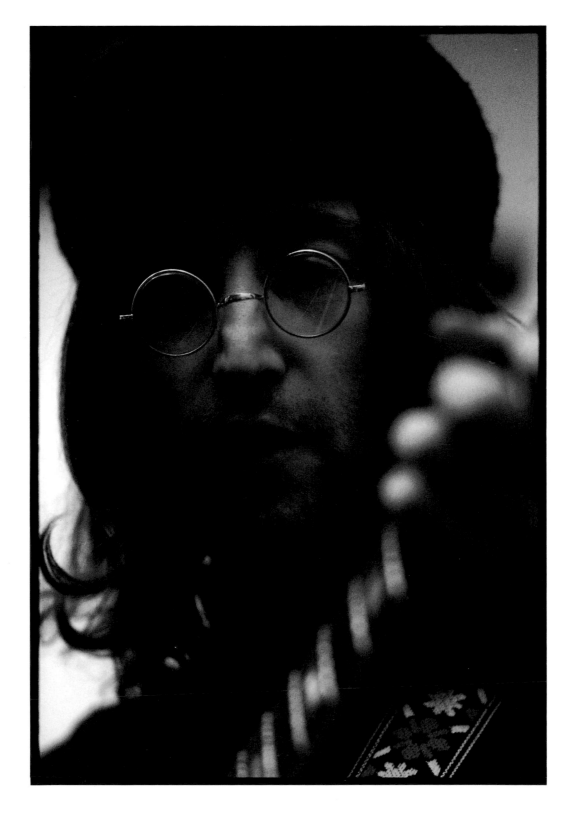

John playing on the *Let It Be* album at Apple Studios

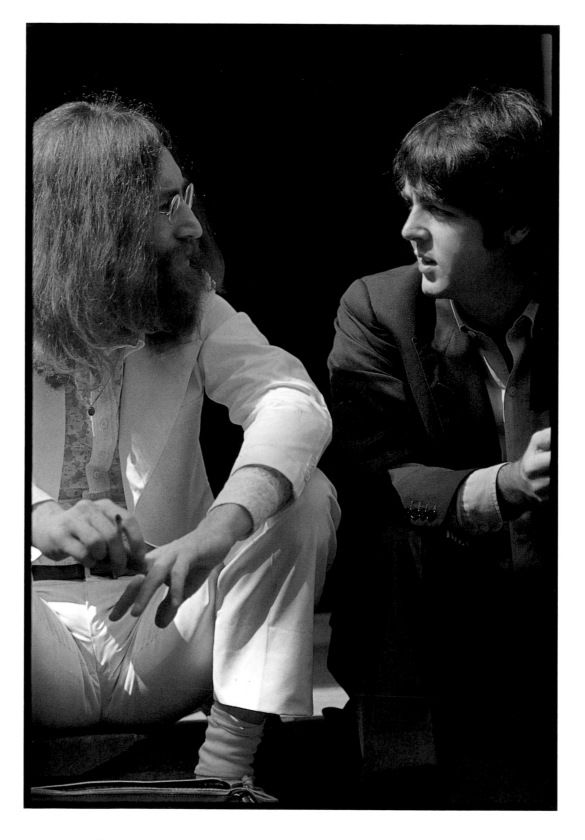

JOHN AND PAUL WERE STILL THE GREATEST OF FRIENDS BUT NOW THEY HAD THE WEIGHT OF THE
WORLD ON THEIR SHOULDERS

TAKEN IN OUR LIVING ROOM AROUND THE TIME OF *THE BALLAD OF JOHN AND YOKO*

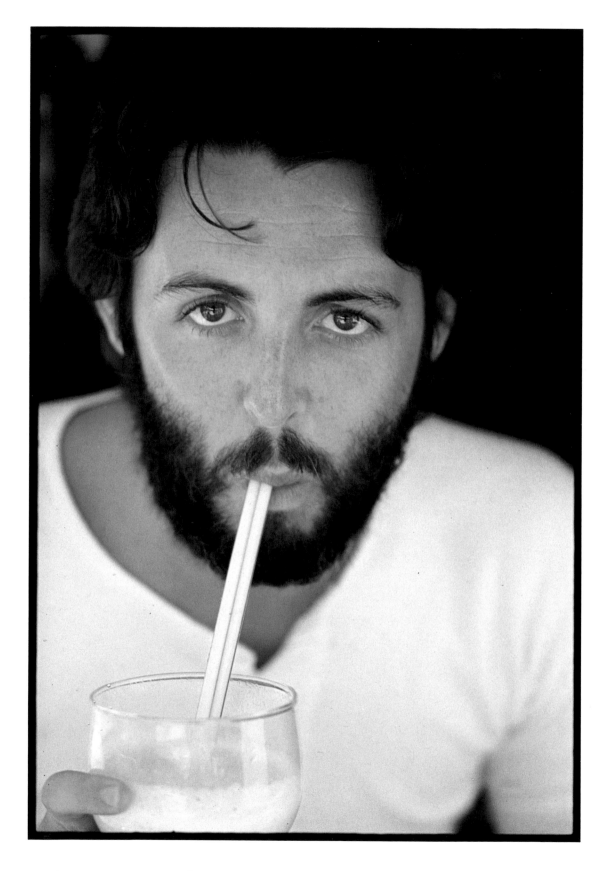

I took this picture of Paul drinking during a holiday we had in the South of France

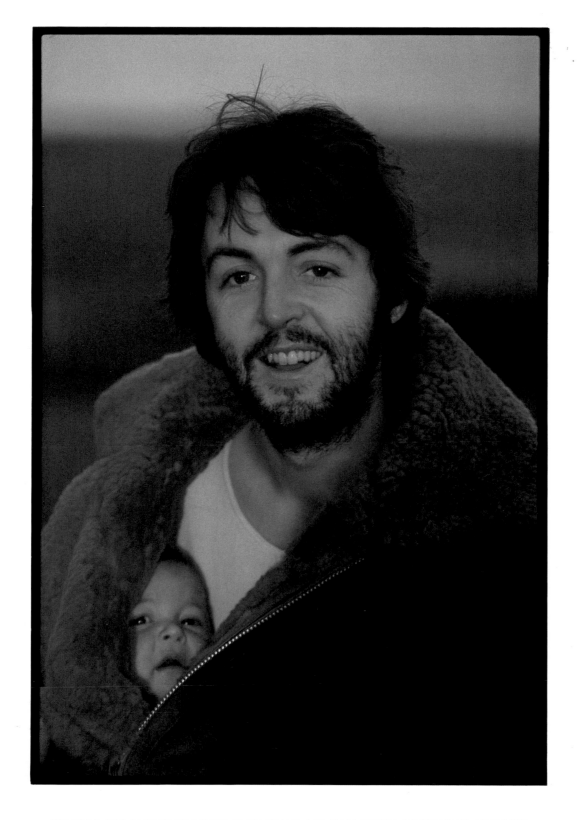

WE WERE JUST BACK FROM RIDING IN SCOTLAND AND PAUL WOULD ZIP MARY UP INSIDE HIS

JACKET. SHE WAS ALL CUDDLY AND WARM AND THE SUN WAS THAT BEAUTIFUL

4 O' CLOCK PINK SCOTTISH SUN

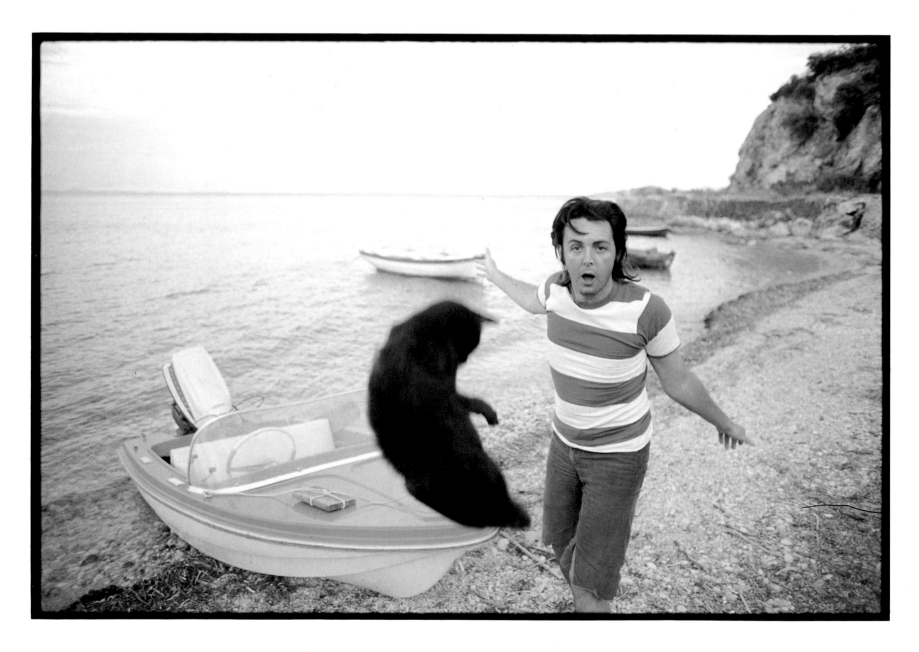

On holiday in Corfu when I was pregnant with Mary

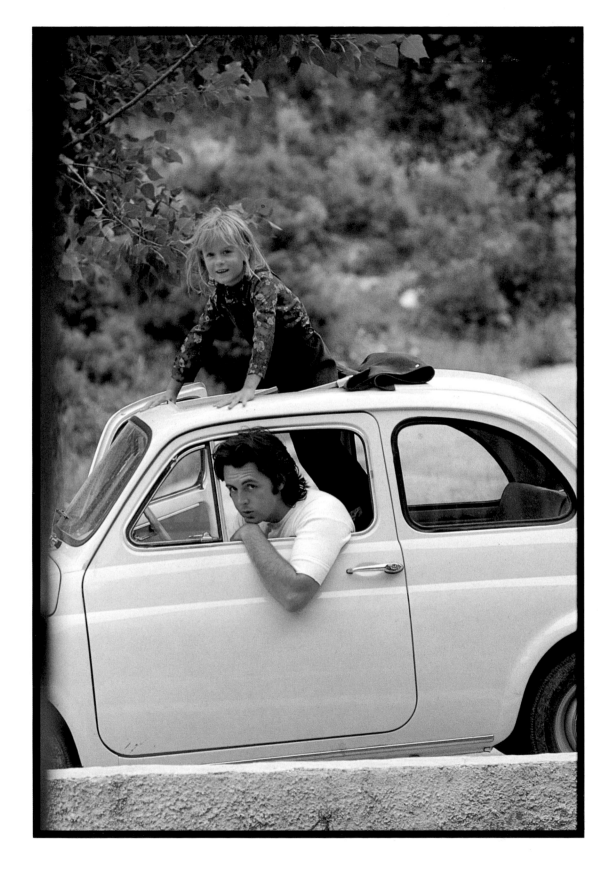

PAUL WITH HEATHER IN GREECE

135

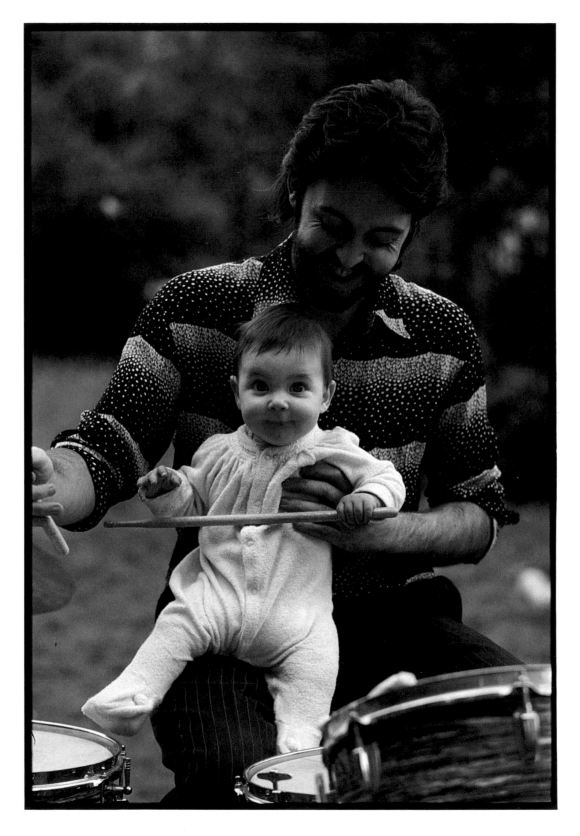

PAUL WITH MARY PLAYING RINGO'S DRUM KIT IN OUR GARDEN AROUND THE TIME HE WAS

RECORDING THE *MCCARTNEY* ALBUM ON WHICH HE PLAYED ALL THE INSTRUMENTS

E N G L A N D

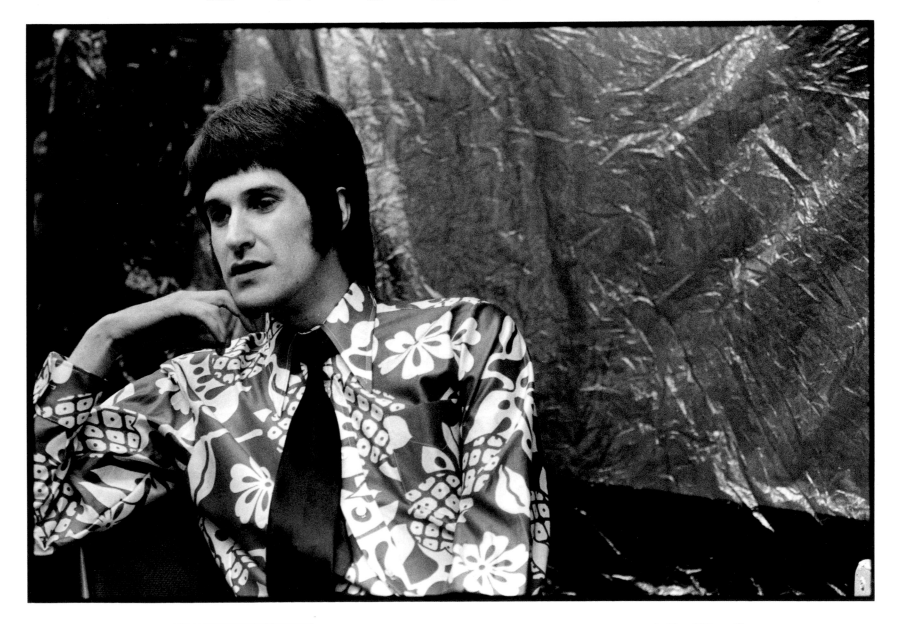

T H E K I N K S

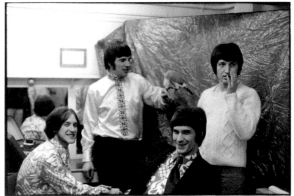

I met the Kinks at the TV program *Top of the Pops*. I think "Waterloo Sunset" was their latest single at the time. When I arrived they were just finishing off a session with Harry Hammond, who was a well-known British show business photographer, and he had set up a shiny green background which I kept in my photographs.

I loved their music and their Mod look which was so Sixties' British. I had expected them to be all sweetness and light, but they were actually quite cheeky. They were very much London lads.

TRAFFIC

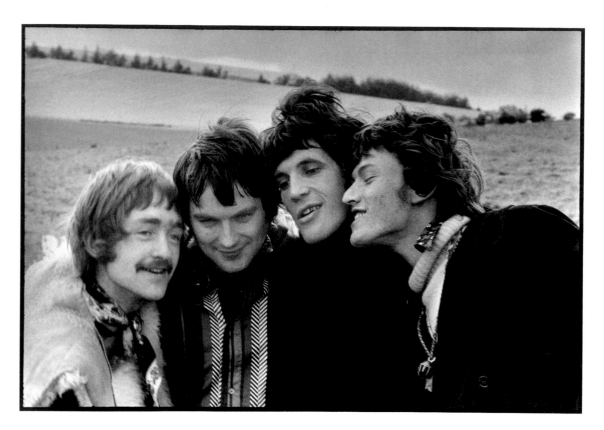

When I first came to England there were two acts that I really wanted the chance to photograph – the Beatles and Stevie Winwood. I had loved Stevie's voice and organ playing ever since I first heard "Keep On Runnin'" by The Spencer Davis Group. So, when I arrived in London I visited Island Records with my portfolio and said I was interested in photographing Stevie. Initially they were negative, saying that he had formed a new group called Traffic, who were rehearsing in a country cottage, and wouldn't be doing any press until their album was released. Then the assistant to the record company's managing director said that she really liked my work and that I would be the first person to take pictures of them.

One of their roadies drove me down to a farm on the Berkshire Downs where the band were living and rehearsing. The weather was cold and clear, and the cottage they were living in was at the end of a dirt track.

Although I hadn't even seen a picture of Stevie Winwood at that point, he more than lived up to my expectations. I took some group photos and then individual shots of him, Chris Wood, Jim Capaldi and Dave Mason. When we had finished those we went out into the fields running down hills, picking flowers and walking along a deserted railway track taking pictures.

When we came back to the cottage that evening they played an impromptu set in the front room where they had their equipment. We had brought them a copy of *Sgt Pepper*, which they hadn't yet heard, and when they played it they were saying, "Oh my god! The Beatles have done it again!," because they had apparently been trying to do some things on their album not realizing that the Beatles had got there first.

Even though I was the first to photograph Traffic, I never actually thought about selling the pictures because there was no demand for them in America at that time. Later they toured the States and we met up many times in New York and I took lots more pictures of them.

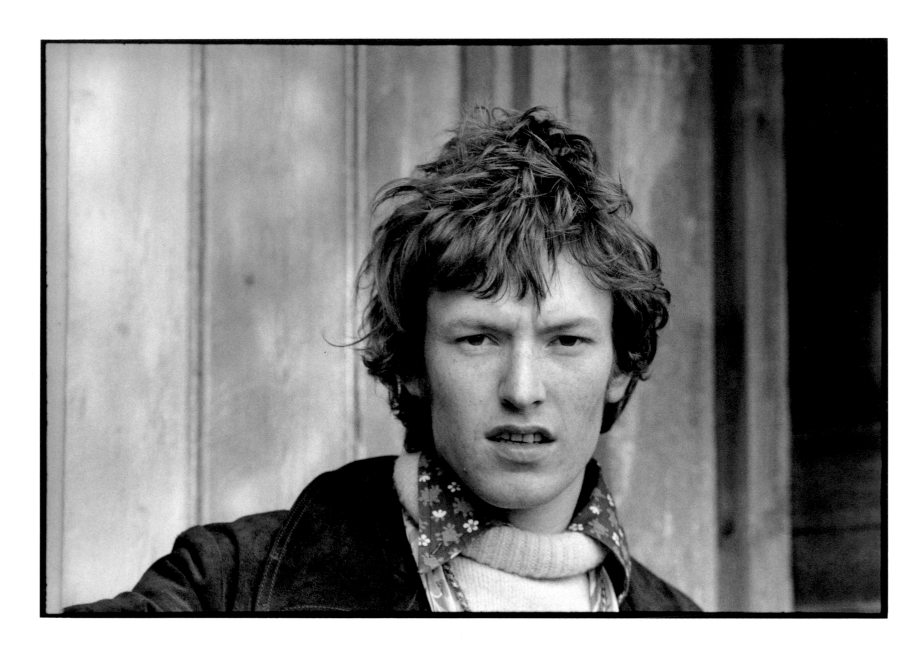

LEFT: DAVE MASON, CHRIS WOOD, JIM CAPALDI AND STEVIE WINWOOD ON THE BERKSHIRE DOWNS WHERE THEY WERE REHEARSING

THEIR DEBUT ALBUM *MR FANTASY*

THE HOLLIES

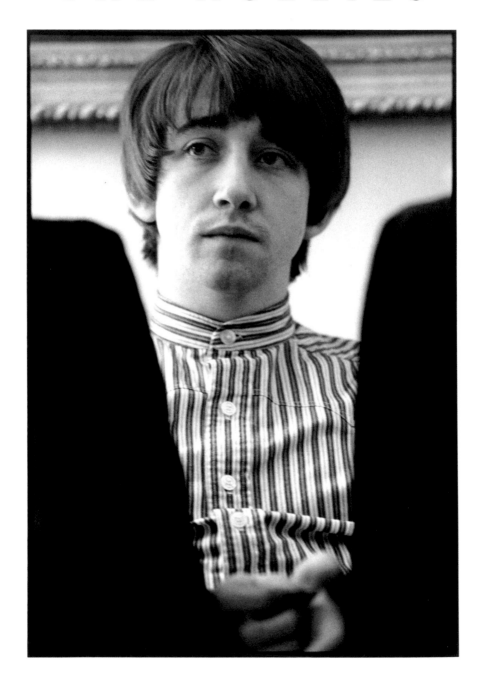

This was when I first met Graham Nash who was to become a friend of mine. It must have been because of this session that I later got asked to take some of the first group photos of Crosby, Stills and Nash.

I liked The Hollies and these pictures were taken either at Graham's flat or at Tony Hicks's place. I think Graham was getting a little frustrated with the limitations of The Hollies at the time because by then he'd become interested in the experimental rock that was coming out of San Francisco and New York.

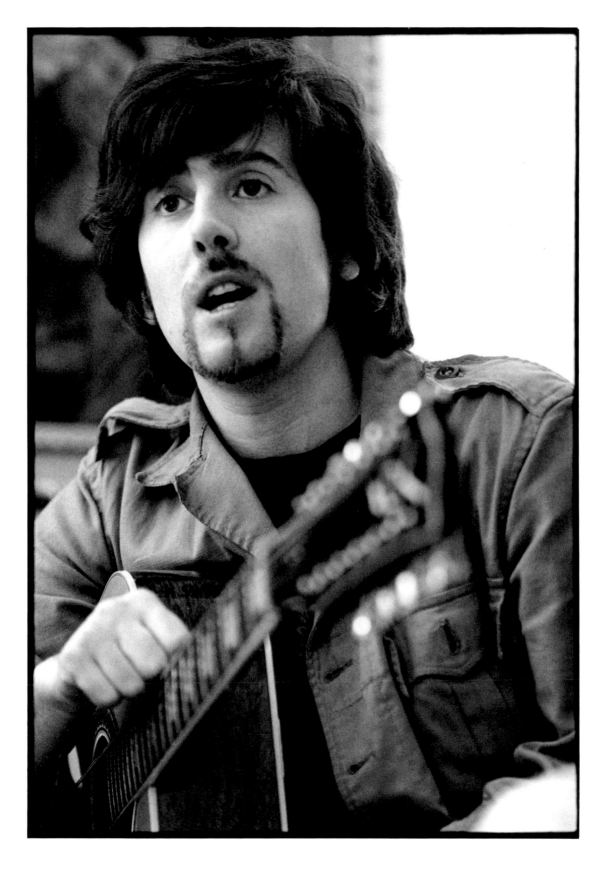

TONY HICKS FRAMED BY HIS KNEES (LEFT) AND GRAHAM NASH (ABOVE)

141

MICKIE MOST

At the time I took these photographs Mickie Most was best known for having produced Donovan and Herman and the Hermits, although he'd once been a pop star himself before he went on to build his own record company, RAK Records.

I took these pictures while he was being interviewed by journalist J. Marks in London because I wanted someone to illustrate the business side of the music business. With his telephone and cigar he seemed to epitomize the sharp young industry figure of the day.

THE BEATLES

I loved The Beatles right from the start. I saw them when they made their American TV début on the *Ed Sullivan Show* in February 1964, I bought their first album when I was living in Arizona, and I saw them, along with 56,000 others, when they played what was at the time the largest outdoor concert in history, at Shea Stadium, New York, in August 1965.

As I said earlier, when I came to London in 1967 The Beatles and Stevie Winwood were the two acts I was determined to photograph. Having already taken the first pictures of Traffic in Berkshire, that left only The Beatles.

I took my portfolio over to Brian Epstein's office and left it with his assistant, Peter Brown. While I was waiting for his response I happened to meet Paul at a club called the Bag o' Nails in Kingly Street, London where I had gone with Eric Burdon and some other friends to see Georgie Fame and the Blue Flames.

Paul walked in after we had arrived and came and sat at the table right next to us. It was one of those "our eyes met" situations. As I was about to leave Paul came over and invited me to

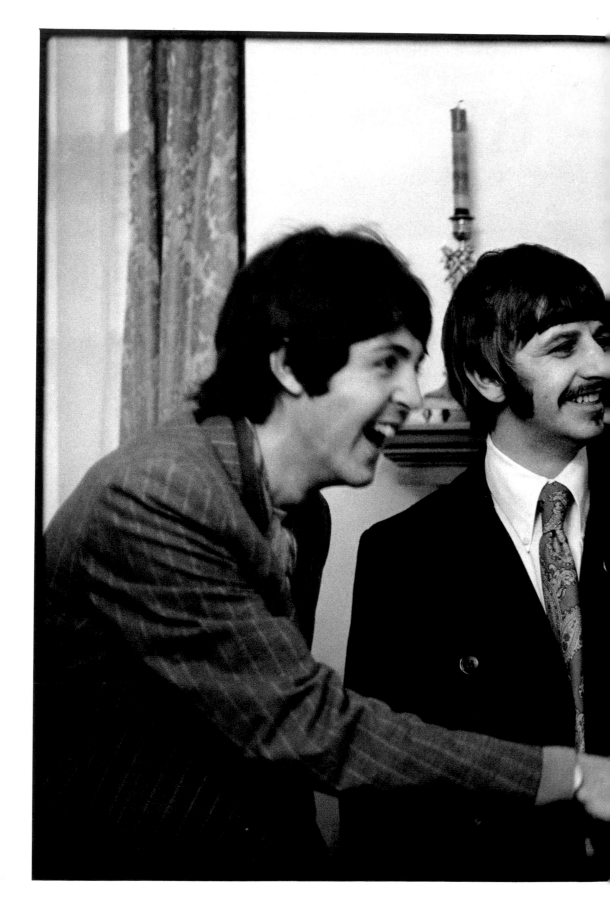

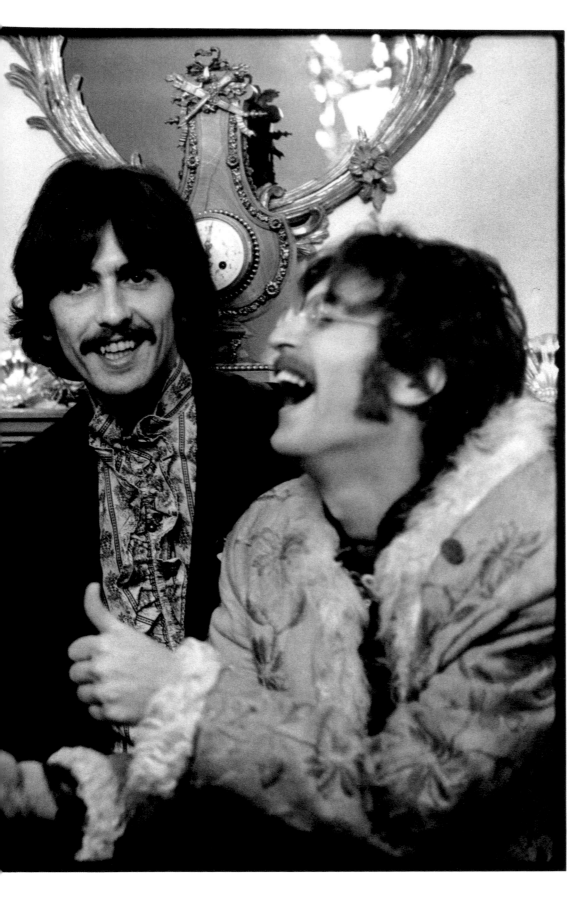

go with him to The Speakeasy which was not too far away in Margaret Street. That was where we all heard "Whiter Shade Of Pale" for the first time and fell in love with it; we all thought it must be by Stevie Winwood, but it turned out to be Procol Harum.

The next morning I was off photographing The Move and didn't know whether I would ever see Paul again. However, Peter Brown got back in touch and said that Brian had liked my portfolio and invited me to a press launch for *Sgt Pepper* at Brian's home. Peter also said that Brian wanted to buy copies of two of my photos – one of Keith Moon wearing a lace cravat and one of Brian Jones at The Rolling Stones boat party.

So I went to the press launch where *Sgt Pepper* was played for the first time to the media, to take my first photographs of The Beatles. Because I was so used to working almost exclusively with black-and-white I didn't have any color film with me, and had to get some from another photographer. I eventually sold a color print of The Beatles from this session for $100 and I thought that I had it made!

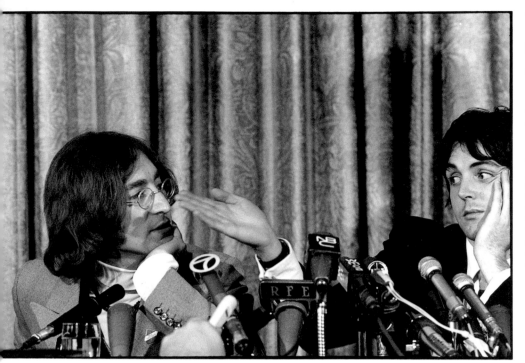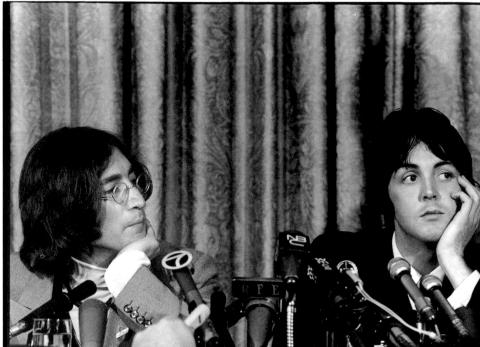

Even though I visited England in between times, I didn't see Paul again until he came to New York with John in May 1968 for a press conference at the Americana Hotel. It was here that they announced the formation of Apple, which was to be not only a record label and a clothing store, but a company that would promote new writers, inventors, film makers and painters.

I was amazed at the mediocre questions they were asked that day. "When are you getting your hair cut?," "What does that badge mean that you're wearing?" No one seemed remotely interested in the creative or business side of their new venture. It was just the same old Beatle questions. Paul was very nervous about it all, and the pictures I took capture their bemusement and the inane level of the questions.

It was at the Apple press conference that my relationship with Paul was rekindled. I managed to slip him my phone number. He rang me up later that day and told me they were leaving that evening but he'd like it if I was able to travel out to the airport with him and John. So I went out in their limousine, sandwiched between Paul and John, and it was at the Pan Am terminal, in the VIP lounge, that I took the picture on the right of them both, together with their New York attorney Nat Weiss (with the hat) and Greek inventor Alexis Mardas, better known to them as "Magic Alex," who was supposed to be creating wonderful gadgets for Apple.

I traveled back to Manhattan in the limousine with Nat Weiss and The Beatles' road manager, Neil Aspinall, while they played the *Sgt Pepper* album on a tape. Then the three of us went out to dinner. Neil and Nat mostly talked business, and I became aware that Neil was an honest and caring man. I found that refreshing because I was on the point of wanting to move out of taking photographs for the music business because of the deception and pressure.

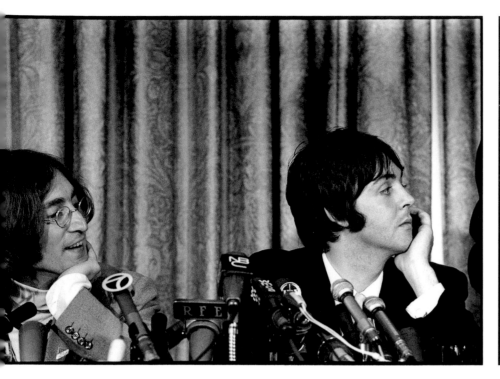

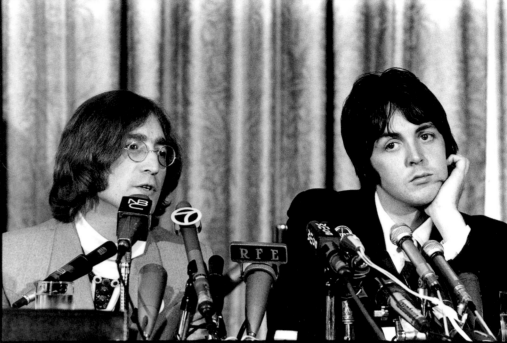

The next time I heard from Paul was the following month when he left a message with my answering service saying that he was on his way to LA to do some Apple business and attend the Capitol Records Convention with his school friend Ivan Vaughan, and he wanted me to join him. I had just got back from taking pictures of Jimi Hendrix at the Drake Hotel when I picked up the message, and I later spoke to Paul and arranged to meet at the Beverly Hills Hotel where he was staying. We had a great weekend together, but then he went back to London, I went back to New York, and we didn't speak for what seemed like a long time.

ABOVE: JOHN AND PAUL FIELDING QUESTIONS AT THE APPLE PRESS CONFERENCE IN NEW YORK, MAY 1968

LEFT: JOHN AND PAUL AT THE PAN AM TERMINAL WITH NAT WEISS BETWEEN THEM AND ALEX MARDAS BEHIND

Then in September 1968 Paul rang me out of the blue and asked me if I fancied coming over to England. He said The Beatles were recording an album and that I should just show up. I was still carefully preserving my independence so I waited a while and then bought my own ticket and boarded a plane for London. I just wanted to see what would happen.

The evening I arrived I went straight to Paul's house and when Paul came back home early in the morning he told me that they had just recorded a song of John's called "Happiness Is A Warm Gun," which he was thrilled with.

From then on I started going over quite regularly to Abbey Road where they were recording what became known as *The White Album*. I was just Paul's girlfriend then and I didn't want to intrude too much. I was very shy and I didn't want people to think I was taking advantage. That's why I never took as many photographs as I could have done.

When I did take pictures it was just for myself. I could have pushed to be the stills photographer on *Let It Be*, but I never thought about it. In fact, the only time I did an official Beatles photo was when Paul called me up at the last minute from the studio, and said that EMI needed a cover for the sleeve of *The Ballad Of John And Yoko*. I took a color portrait of the group with Yoko. I had really wanted The Beatles on their own, but Yoko just sat there, and being a timid newcomer I simply didn't have

the heart to tell her it was group members only.

Many of the songs on *The White Album* had been written while they were in India earlier that year at the Maharishi's ashram. I remember them recording "Honey Pie" live with an orchestra at Trident Studios in Soho. Mal Evans, The Beatles' road manager, brought a hash cake in that night, and I ate a piece of it, and because it was so strong I thought I was on LSD.

When the album was finished Paul started talking to the artist Richard Hamilton about the cover. This was very important because *Sgt Pepper* had increased everyone's expectations of album-cover art. Richard wanted to to take things in another direction. Instead of making something more colorful and detailed, he reverted to a minimalist white with an embossed title and a serial number which would make every copy

GEORGE MARTIN LOOKS ON AS THE BEATLES WORK OUT AN ARRANGEMENT FOR ONE OF PAUL'S SONGS

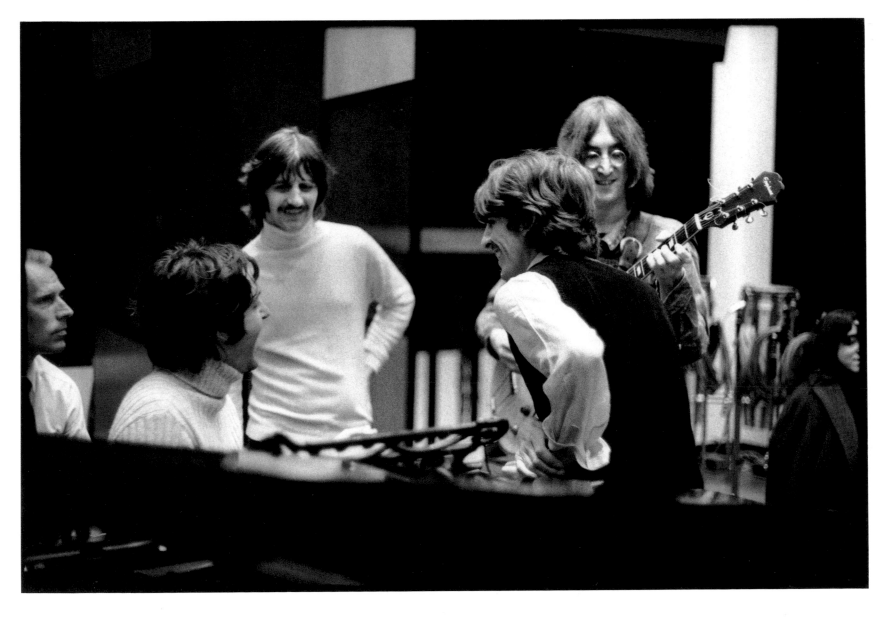

149

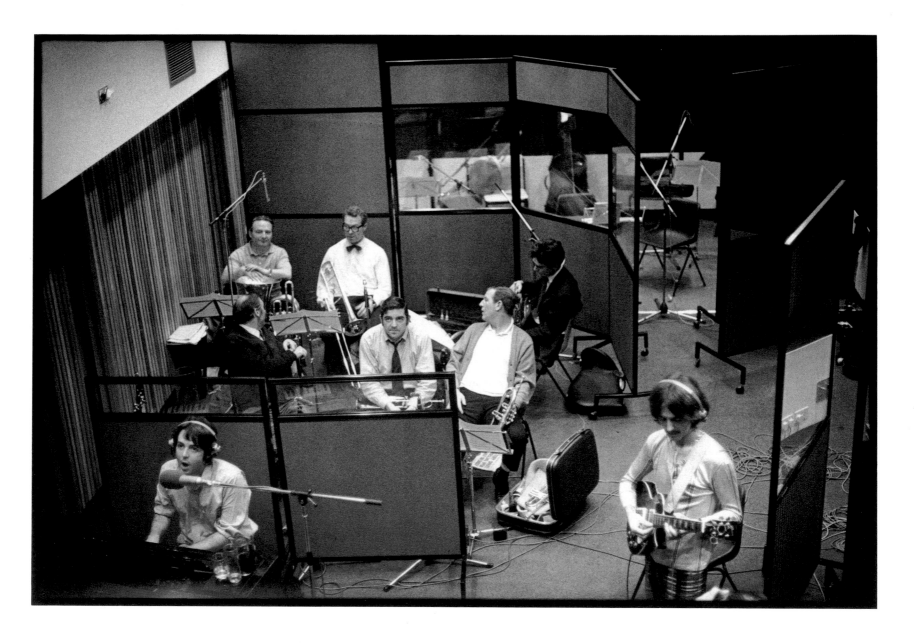

ABOVE: RECORDING "HONEY PIE" FOR
THE WHITE ALBUM AT TRIDENT STUDIOS
IN LONDON

LEFT: RINGO'S HAND ON THE TAPE
MACHINE AT ABBEY ROAD

unique. Inside the sleeve they wanted to put a poster which would have the lyrics printed on it. Paul and Richard had decided to get all of us to put their pictures in a box and they would choose a selection to put on the poster. I put in some I had taken of Paul in the bath and they were used.

Every day for two weeks Paul drove out to Richard's house and they worked together on ideas. Richard was well into white at that time. I

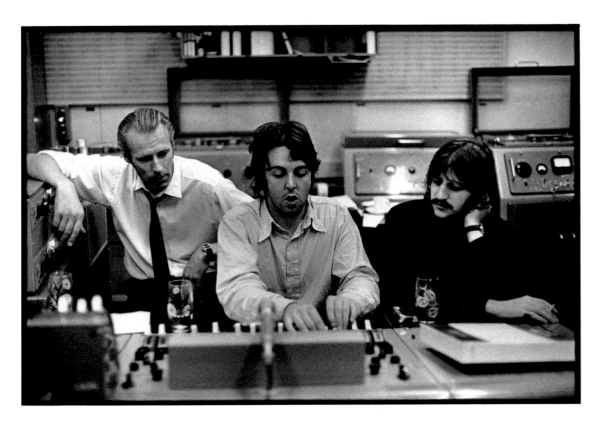

PAUL MIXING *THE WHITE ALBUM* WITH GEORGE MARTIN AND RINGO (ABOVE), AND JOHN
AT THE MIXING CONSOLE

remember Paul telling me that Richard would put pictures up and then he would paste white paper over some areas so as to create even more white space.

This was probably one of the last times The Beatles were happy together as a group. *Let It Be* and *Abbey Road* were recorded in quite quick succession, but by then the friendships that had held them together were under heavy strain.

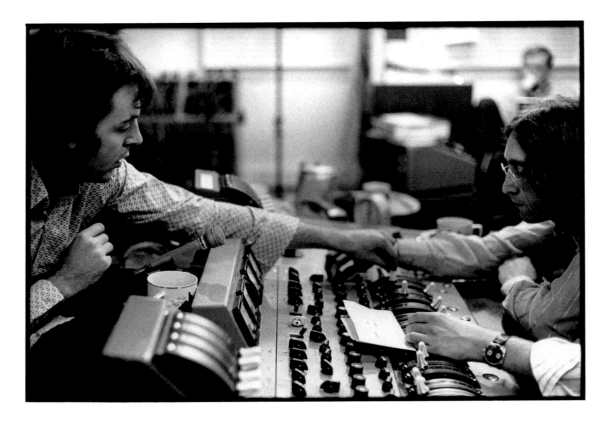

I love these two pictures I took of Paul and John during the *Abbey Road* sessions because they show the closeness that they shared. They were putting together the medley for the second side of the record. Paul had asked John for undeveloped songs, and so John threw in "Mean Mr Mustard" and Paul put in "She Came In Through The Bathroom Window." I remember Paul at home working out on that notepad the ways in which he could join these fragments together. The pictures I took are of the moment he showed the notes he had made to John to get his comments.

I think people have always got it wrong about Paul and John being such opposites. In my opinion, when it came to creativity, they weren't that different. They both had a tough side and a sensitive side. When Paul's tough side showed through, as it did on songs like "Helter Skelter" and "Why Don't We Do It In The Road," people assumed it was John; and when John's sensitive side showed through on a song like "Good Night," people assumed it was Paul.

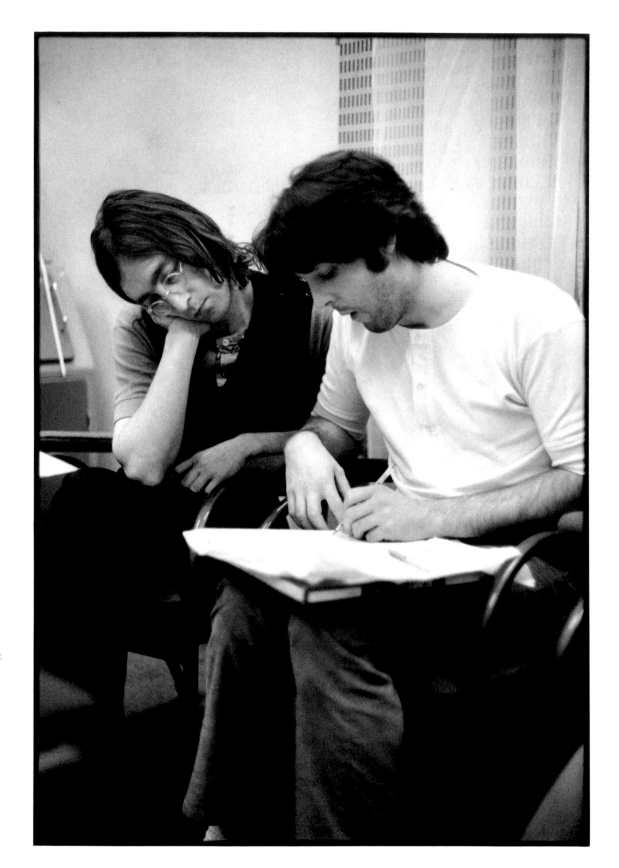

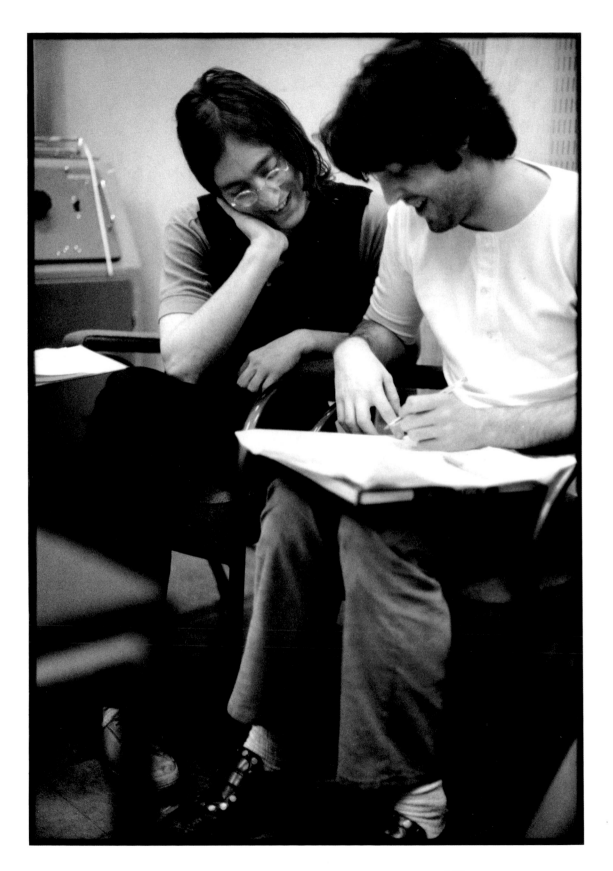

George Martin once said about John that he shouted the loudest; if he discovered something, he would let everyone know. Paul was quieter about his interests. It's a fact that a lot of John's far-outness came from Paul's first explorations into the world of avant-garde film and theater, which he was getting into while John was living a domestic life out in Weybridge. But it was the great balance of John and Paul that made The Beatles the group they were.

Abbey Road had a lot of their great songs on it. John came in with "Come Together" and it sounded like a Chuck Berry song, but Paul gave it that bass line which totally changed it and gave it that fabulous swampy feeling. When they did Ringo's song, "Octopus's Garden," they all blew into water through straws to produce the sound of an ocean bed. Paul didn't finish writing "Maxwell's Silver Hammer" until just before the session. That was at the time he was interested in the 19th-century French playwright Alfred Jarry, the author of *Ubu Roi*, and it was from his work that Paul discovered the word "pataphysical."

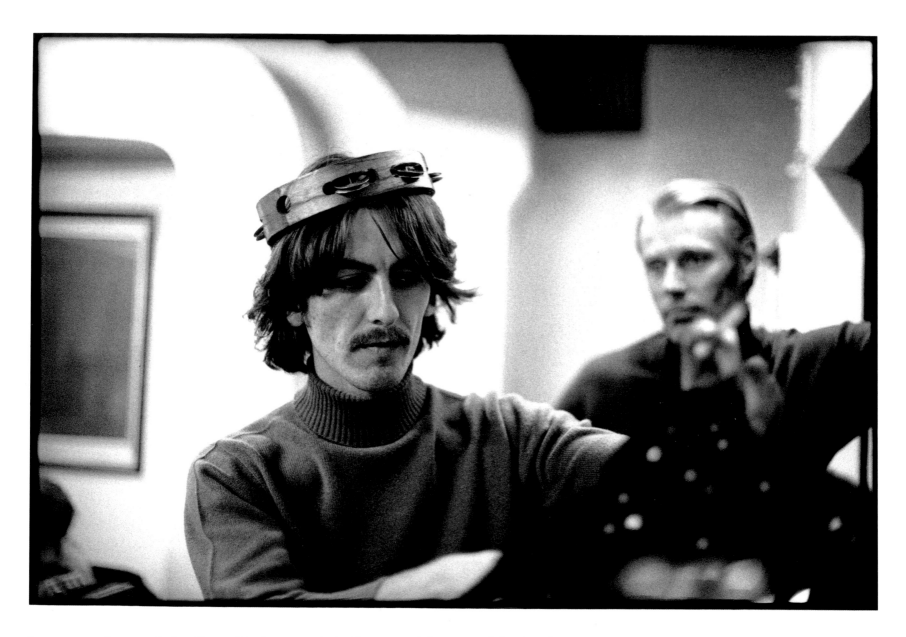

I was never quite sure whether George Harrison liked me taking pictures of him, because he usually had such a serious face. But one day he saw me pointing my camera at him, and he started hamming it up by putting tambourines on his head, so I guess he didn't mind. I remember him coming in with "Savoy Truffle," which he had written around the names of the chocolates in a Good News selection box.

I must say I never really got to know George. We talked a lot and I went down to his house in Esher for meals, but looking back I can't remember what we talked about. I suppose I was so busy getting to know Paul.

George Martin I loved. I thought he was a real gentleman as well as a great producer. There are certain people one can look up to as father figures and love in a funny way. For me there are three people like that: one is Dr Donald Hill, the father of a friend of mine; one is the guitarist Chet Atkins; and the other is George Martin.

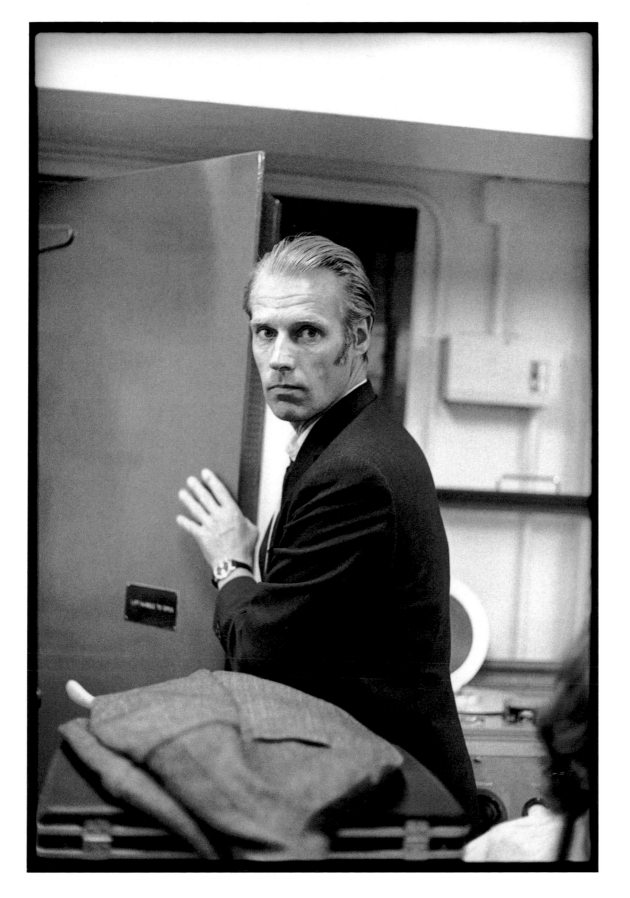

When Paul was producing the *Postcard* album for Mary Hopkin, he used a group of six young session musicians who each played different sized recorders on one of the tracks. There were twin girls called Jeanne and Marguerite Dolmetsch, whose family are well known for making musical instruments, and Paul, Brian, Peter and Christine Blood. The two families were unrelated then but Brian Blood later married Marguerite Dolmetsch and now heads up the Dolmetsch company

The Bloods were very clean and serious. They almost looked almost as though they had been plucked straight from the Victorian era. The young man with the glasses in these pictures was Paul Blood, then a seventeen-year-old schoolboy but now a cancer specialist living in Canada. I thought at the time that he had beautiful fingers.

I never cared whether someone was famous or not. If they were interesting I photographed them. I still have the same attitude.

SESSION MUSICIAN PAUL BLOOD

After the death of Brian Epstein The Beatles needed someone else to manage their affairs. I remember John telling me that the only person Yoko liked was a New York manager, Allen Klein, who already owned The Rolling Stones. John then persuaded George and Ringo to follow him, but Paul held out because he thought The Beatles were big enough at that point not to have to hire the traditional Mister Twenty-Per-Cent.

I instinctively recoiled when I met Klein. Being from New York myself and having heard of his dealings in the music business, I realized

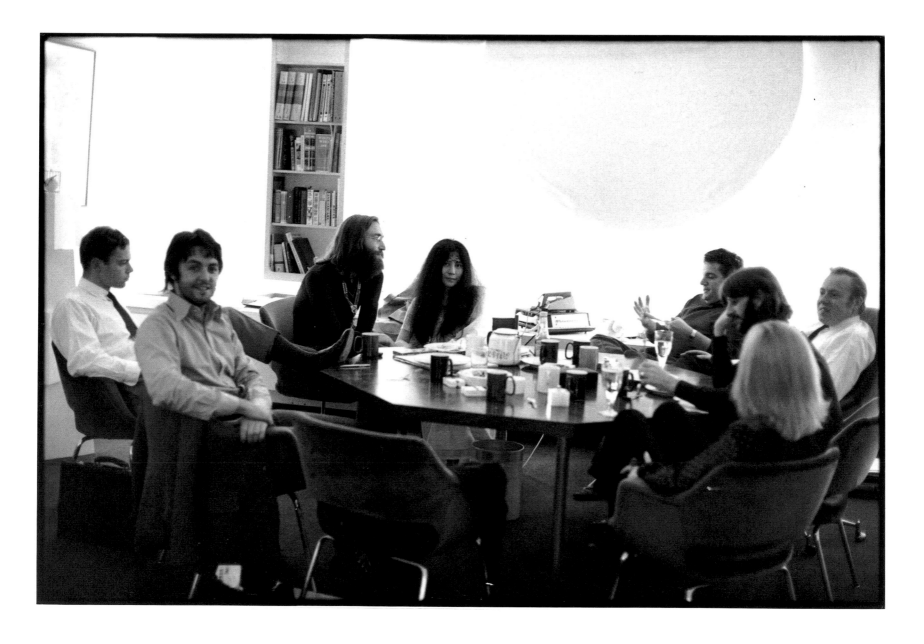

DECIDING THE FATE OF THE BEATLES: MY BROTHER JOHN EASTMAN, PAUL, JOHN, YOKO, ALLEN KLEIN, RINGO AND HIS WIFE MAUREEN, AND PETER HOWARD

that he would be bad news for The Beatles. He tried to get each Beatle on his side, and in doing so he set them against each other.

Northern Songs owned the rights to all The Beatles songs, and at that time the group could have bought back all the shares they didn't own to gain control of their catalog, but Klein blew it. It was heart-breaking really. John and Paul were total innocents and got well sewn-up.

I think it was at this point that the rot set in. This was when they realized that they were no longer four free-spirits making music together in a rock and roll band, but rather were a business enterprise that was going to have to write songs to fulfill contractual obligations.

There was one big meeting where Allen Klein and his lawyer, Peter Howard, met up with Paul, John and Ringo to talk about Northern Songs. I don't know where George was that day. My brother, John Eastman, who Paul wanted to be his business manager, sat there with his feet up on the table wondering what on earth it was that Klein was trying to sell them.

You can tell how uninvolved I felt, by the fact that I was still taking pictures. I knew there was a terrible irony in that these people who had wanted love and peace were now reduced to fighting it out around an office table; but I can't say I was aware that history was in the making.

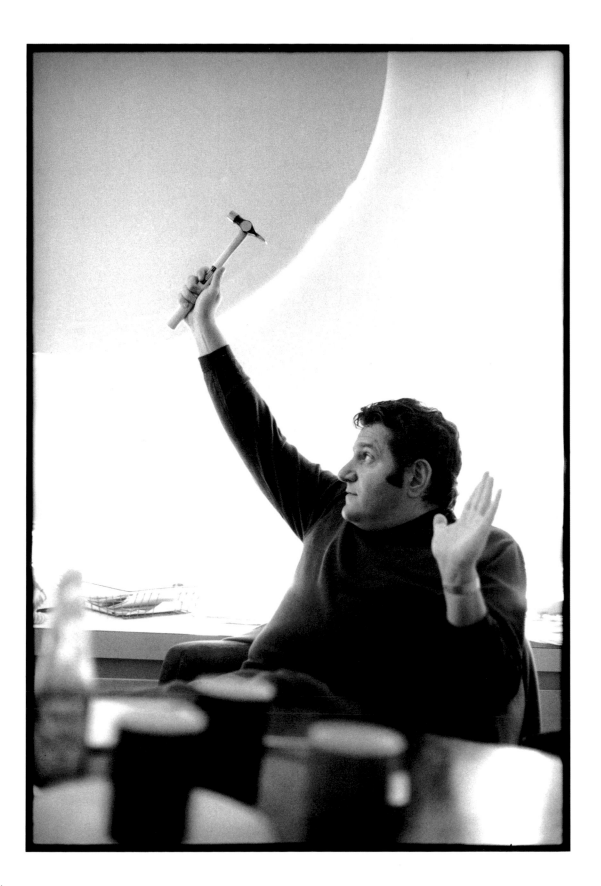

SELLING THE BEATLES

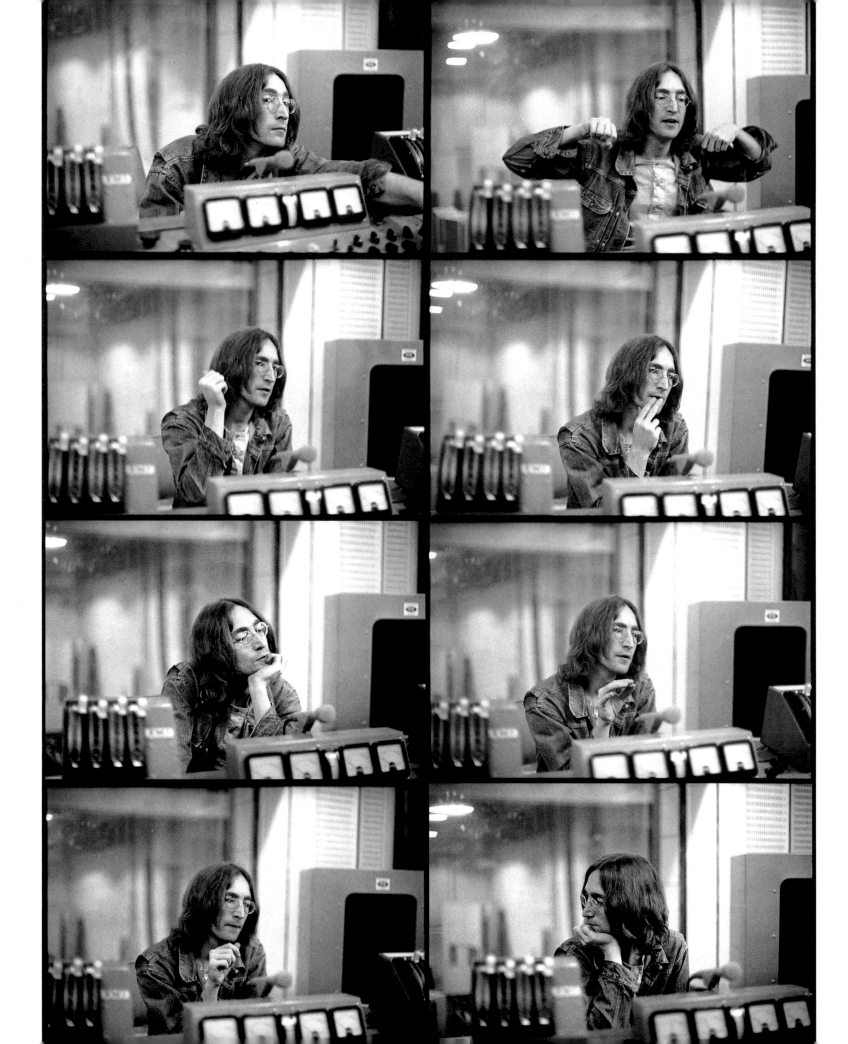

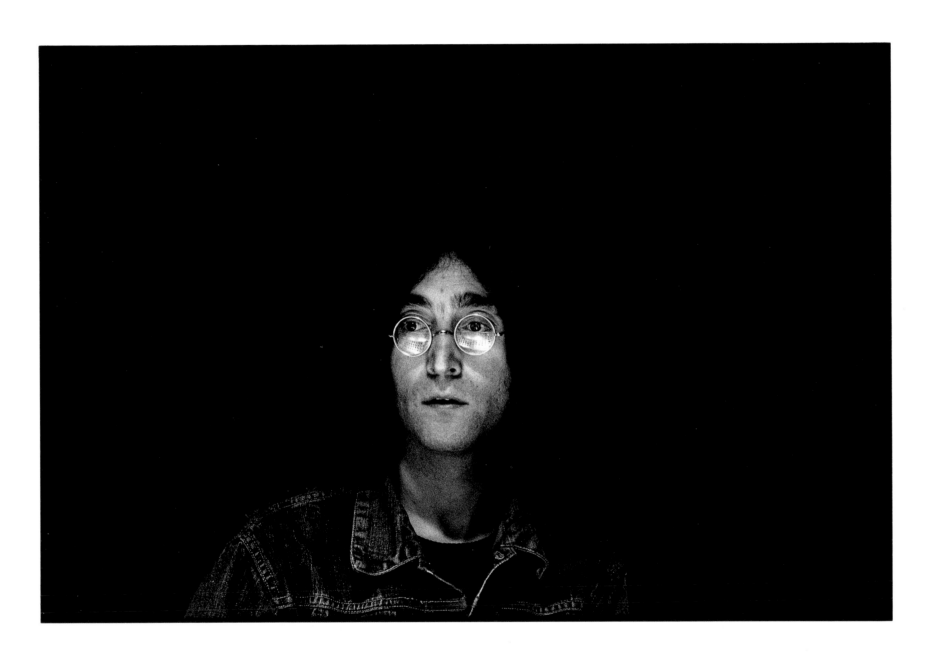

John listening to a playback during the recording of *The White Album*

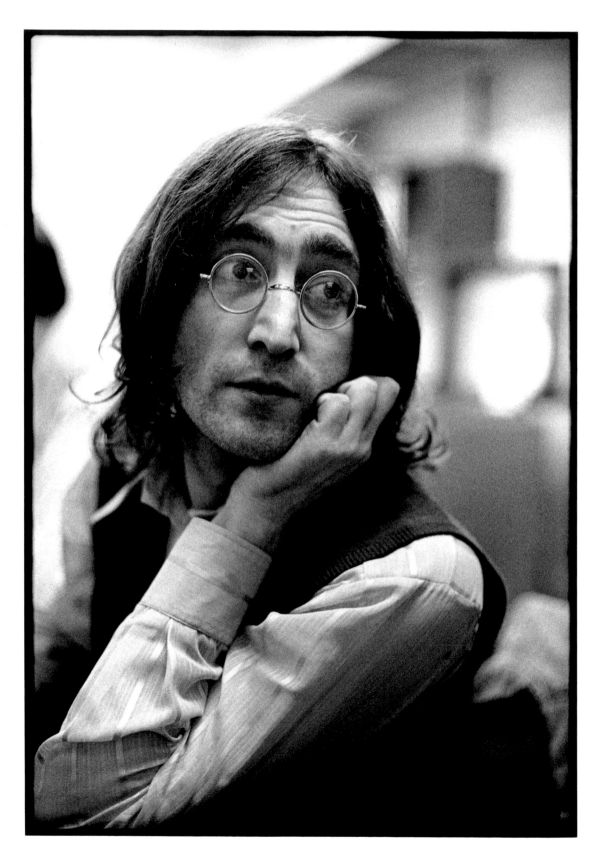

In retrospect it's strange to think that back in 1965 John was my favorite Beatle. I can even remember sitting in a car in New York one night and thinking that if I could meet just one person in the world I would like it to be John Lennon, because he seemed so confident and so artistic. When I did eventually meet him he was totally lacking in confidence and was very nervous. It showed me that people are often not what they seem at first.

I had been one of those people who thought John had all the answers, but of course he didn't. He was as vulnerable as we all are, and had also had to put up with all the stress and strain of his fame. I think it was too much for him, and went on for too long. He was still a great human being, though.

By the time I had arrived on the scene the old songwriting partnership was not what it had once been. I think the arrival of Yoko had a great effect on that. Paul and John weren't really seeing each other outside of the studio, and other than when they wrote the *The Ballad Of John and Yoko* I can't remember seeing them actually writing together.

John was often interested to see the pictures I had taken. I once took a beautiful color photograph of him and Yoko, which they absolutely loved, so I gave it to them as a gift. Yoko later told me that unfortunately the transparency got stolen from their home along with a number of other things.

The end came when Paul went to a group meeting at Apple, and suggested that The Beatles played little gigs under a different name. I can remember John's response to this. "Well, I think you're daft," he said, "Anyway, I've already quit the group. I told Allen that I wouldn't tell you until after we signed the new Capitol Records deal."

They decided that they wouldn't tell the press immediately, but would keep it quiet, and try to work it out. Finally, after a few months of torture, Paul announced that the truth of the matter was that The Beatles had broken up. Because he made the actual announcement it sounded as though he'd been the one to split the group up. In fact, I think John was quite mad that the assumption was that Paul had taken the step of disbanding The Beatles himself.

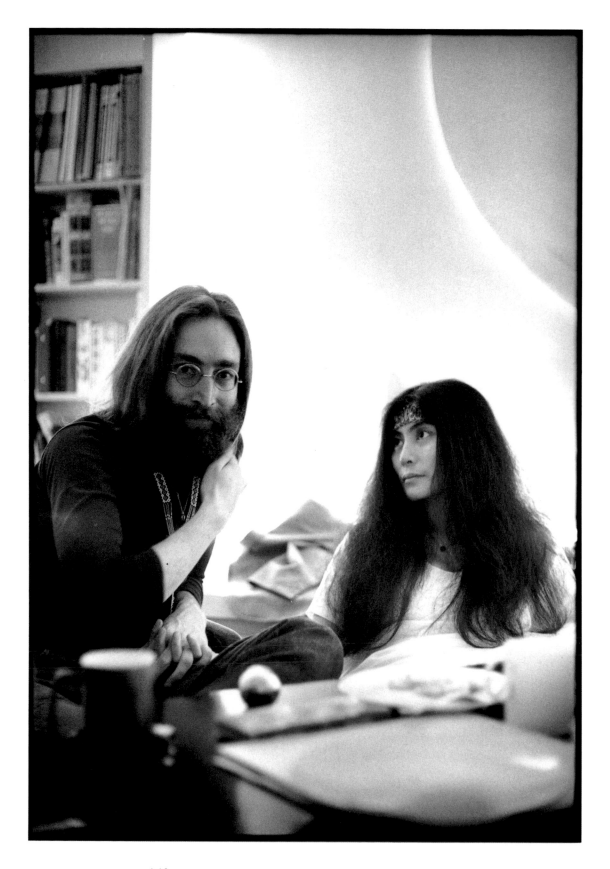

PAUL

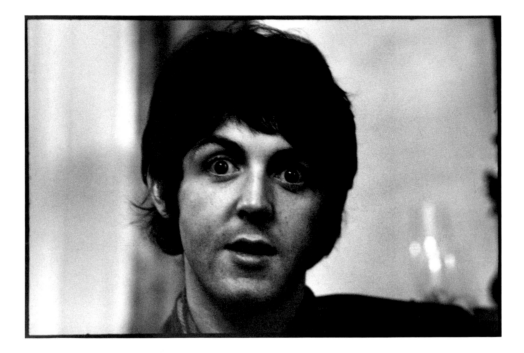

Fortunately, through all this, Paul and I had each other, and we were having a very romantic time. We both liked nature, and we would drive out of London and get deliberately lost, just for the fun of it.

Paul loved all that because his whole life was becoming too regimented. He was supposed to be on form all the time, smiling for the fans, politely answering questions for the press, and being told where he had to be and at what time. With me he could just relax, because I didn't expect him to be anything. And the whole idea of deliberately getting lost was so exciting to someone who had for all his adult life been living by a timetable and moving between concert hall, hotel and recording studio.

He had bought a farm in Scotland on the advice of his accountant, but he had never really been interested in it. It was a very poor hill farm. It had three rooms, it was derelict and there were rats everywhere. The place was basically disgusting, but it did have 250 acres of land, and Paul bought it at a time when property prices were reasonably low.

So he said to me, "Let's go up to my farm. You may not like it but let's go anyway." We went up there and I fell in love with it. It was like living in a John Steinbeck novel. It had hardly any furniture, the bed was a mattress on top of some potato boxes, but it had peace. The Atlantic ocean and its beaches were close by. There were deer and pheasants, and the hills were covered in heather. It was a complete escape from all the pressures of business.

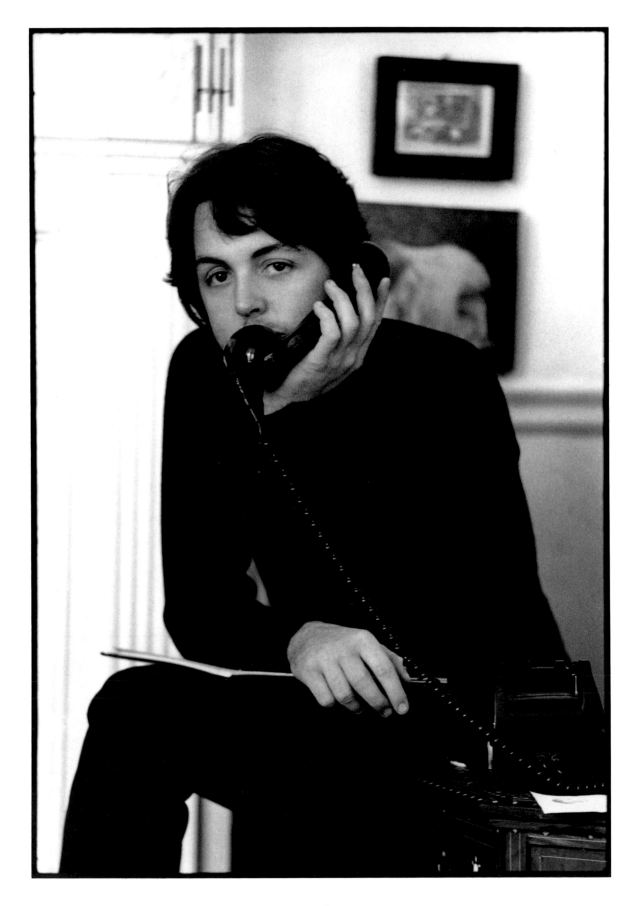

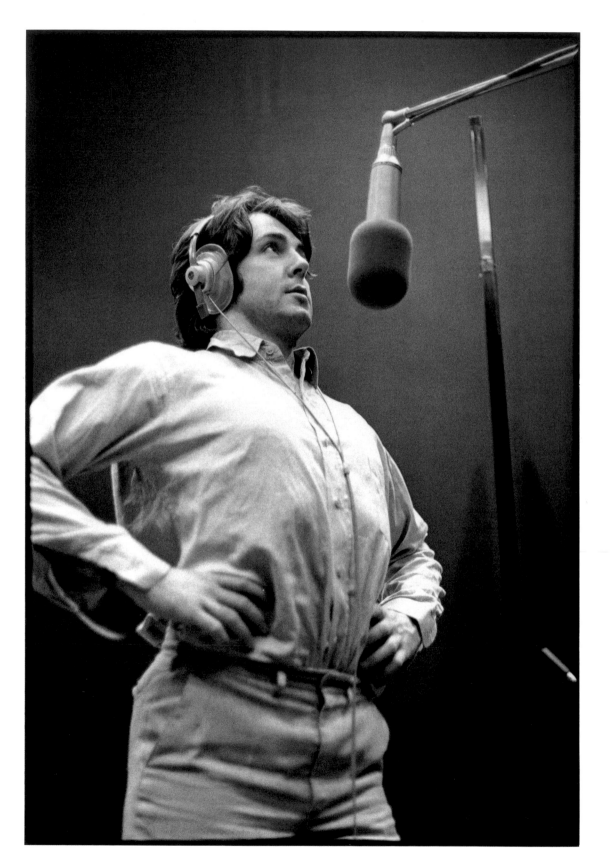

This photograph of Paul with the headphones on was taken at Abbey Road when he was recording "Martha My Dear" for *The White Album*. The picture with the guitar sums up the equipment he was using at the time and the funkiness of the situation. That Epiphone was used a lot on *Sgt Pepper* and I think the picture was taken in the control room of Abbey Road.

Towards the end of 1969 Paul was starting to get the songs together that would go on the *McCartney* album. He had a Studer 8-track tape machine brought to our London home, and he began recording directly on to tape without a mixing desk.

There was a set of drums knocking about the house so he used that. He would overdub guitars, and it all came together very organically. It was very experimental and basic. In fact, on the track "Lovely Linda," which was one of the first he did this way, you can hear the squeak of the garden door opening and closing.

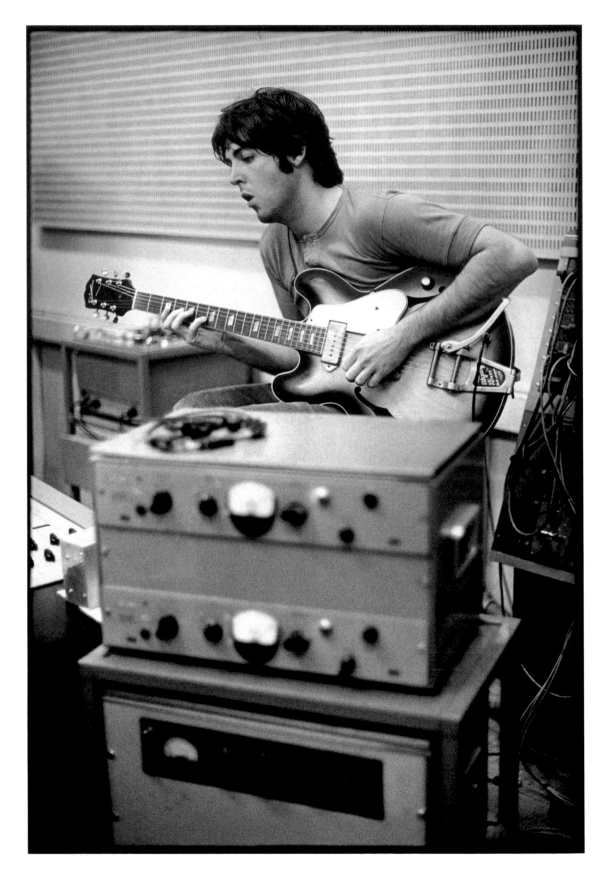

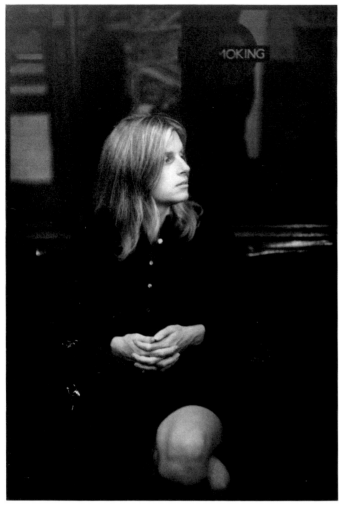

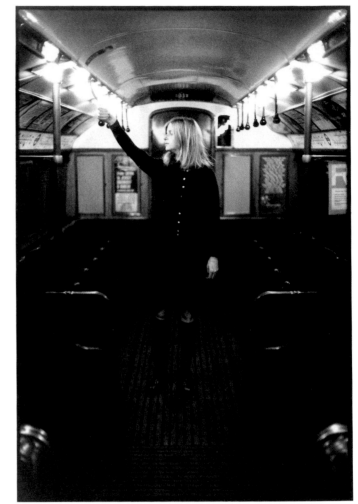

Because I was coming straight from an ordinary
life in New York, where I rode the subway and
took crosstown buses, that's how we did it
together in London. Paul had always been into
public transport anyway, and when they were
filming *Let It Be* he would jump on the tube
and take the District Line out to Twickenham
every day.

Nobody bothered him. It's only when you
announce yourself that people know who you
are. If you just go and you don't put out that aura
of fame, you find people are so involved with
themselves that they're not aware of you. People
miss some of the greatest things.

We used to love putting Paul's Old English sheepdog, Martha, in the back of the car and going down to Regent's Park. I had lived in New York for three years, and when I arrived in England I thought London had the most beautiful parks with trees and blossoms. We used to try and walk Martha every day in the park, and I usually took my camera with me.

I had been a great animal lover ever since childhood and Paul was a lover of nature. I was much more extreme. When I was a kid I used to save lots of animals by bringing them home. I'd pick up injured sparrows, woodpeckers or squirrels, and look after them until they got better. Then I'd let them go back to the wild.

It was autumn when we went for a holiday
traveling along the coast of Devon and Cornwall.
This was Paul showing me Britain. It was cold
and windy, and, as you can see from the sea-
front photographs, the waves were rolling in very
high. We stayed in small hotels in places like
Torquay and St Ives, and at the time British
hotels were very old-fashioned and basic.

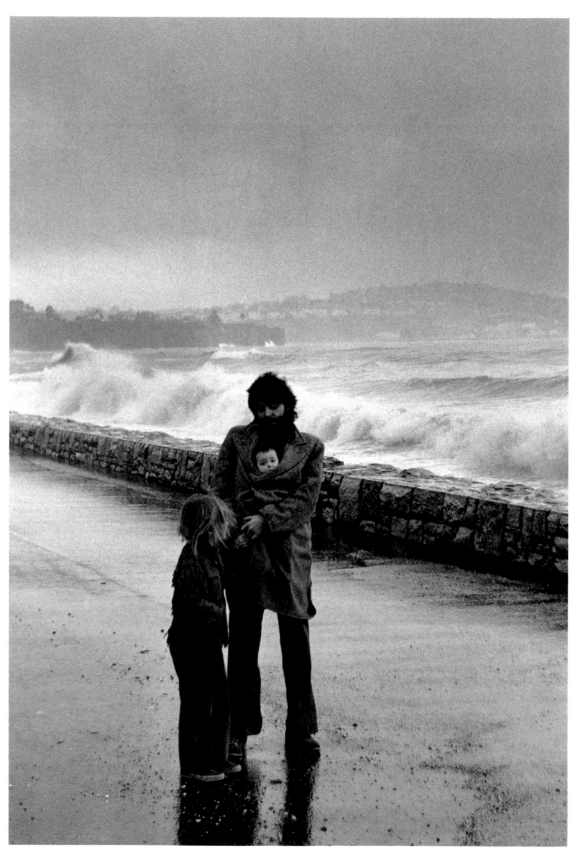

We would often go up to Liverpool to see Paul's father. Paul has always loved the city and took great delight in showing me his childhood haunts. If we wanted to get away for a minute we drove down to the docks to places that he knew. He showed me where Ringo and George had lived, where he and John had met, and although the Cavern was no longer there, the places where he had played long before that.

Paul showed me the shop where he bought his first guitar. He loves doing that. He loves still talking about it all and remembering The Beatles and his childhood.

173

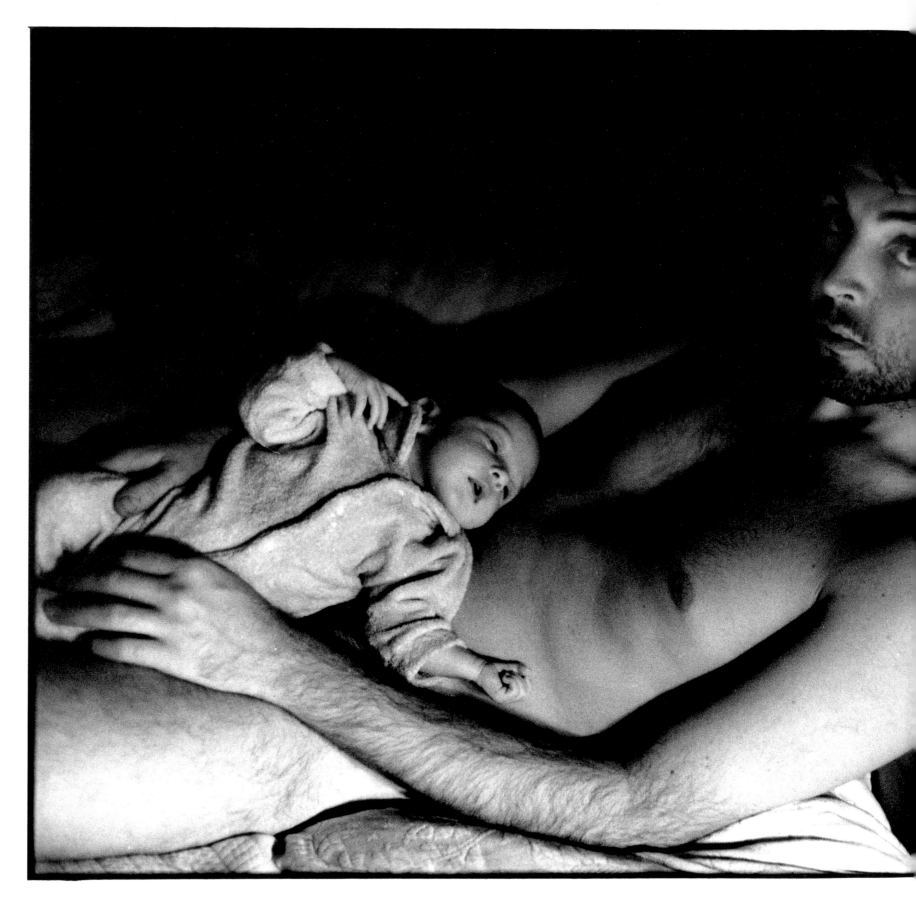

When I was in New York with Paul during 1968 I remember we were out walking in the Village area, and Paul saw a sign that said "Buddhist Weddings," and he said, "Let's go and do it," and I went, "No way!" I just wasn't thinking about getting married. I was worried about losing my independence.

Our relationship just grew. I think Paul finally proposed to me in Portugal. At the time I didn't really think of the consequences of "marrying a Beatle," because I'm a leap-before-you-look type of person. I didn't realize that it would mean that I would go from being a voyeur to being someone who was going to be stared at.

It didn't occur to me that there were people who thought Paul belonged to them. I couldn't connect with that way of thinking, and if I don't connect, then it doesn't exist for me. There were a lot of people starting to be very cruel about me back then, but I sort of blanked it out.

Our daughter Mary was born in August 1969. The picture of her laying on top of Paul was taken in Scotland on a makeshift bed constructed out of old potato boxes. It was called "Sharp's Express" because that was what was written on the side of the boxes. The only light was coming from the window. I took this picture for myself, for the beauty and the magic of it.

The photo overleaf of Paul walking up a dirt track with Heather was taken on one of those days when we went out and got deliberately lost. We parked our car and just started walking to see what we would find. It sums up the carefree feeling Paul and I were able to share in those days of tough business and bad feelings. Paul liked me because I was very much a free spirit and followed my own instincts.

I'm into nature and the seasons and blossoms and snowflakes, and I'm not keen to follow the line that everyone else is following. I'm into Life.

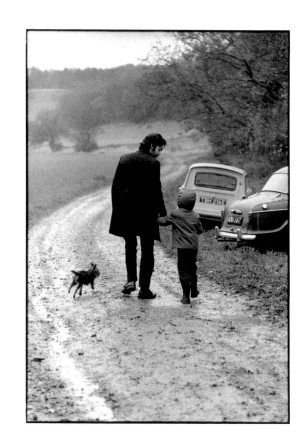